COME AS YOU ARE

ART OF THE 1990s

Alexandra Schwartz

WITH CONTRIBUTIONS BY

Huey Copeland
Jennifer A. González
Suzanne Hudson
Frances Jacobus-Parker
Joan Kee
Kris Paulsen
Paulina Pobocha
John Tain

COME AS YOU ARE

ART OF THE 1990s

MONTCLAIR ART MUSEUM
in association with
UNIVERSITY OF CALIFORNIA PRESS

This publication accompanies the exhibition *Come as You Are: Art of the 1990s*, organized by Alexandra Schwartz and presented at the Montclair Art Museum, February 8–May 17, 2015.

EXHIBITION TOUR

Montclair Art Museum
Montclair, New Jersey
February 8–May 17, 2015

Telfair Museums
Savannah, Georgia
June 12–September 20, 2015

University of Michigan Museum of Art
Ann Arbor, Michigan
October 17, 2015–January 31, 2016

Blanton Museum of Art, The University of Texas at Austin
Austin, Texas
February 21–May 15, 2016

Come as You Are: Art of the 1990s is made possible with generous grants from The Andy Warhol Foundation for the Visual Arts and Furthermore: a program of the J. M. Kaplan Fund.

Major funding is provided by the Susan V. Bershad Charitable Fund, Inc., Holly English and Fred Smagorinsky, Tracy Higgins and James Leitner, Karen G. Mandelbaum, Sarah Peter, Ann and Mel Schaffer, Denise and Ira Wagner, Margo and Frank Walter, and the Judith Targan Endowment Fund for Museum Publications.

Additional support is provided by the exhibition's Leadership Committee: James Cohan Gallery, New York/Shanghai; Eileen and Michael Cohen; the Barbara Lee Family Foundation; Metro Pictures, New York; and Andrea Rosen Gallery.

The publisher gratefully acknowledges the generous support of the Art Endowment Fund of the University of California Press Foundation, which was established by a major gift from the Ahmanson Foundation.

Library of Congress Cataloging-in-Publication Data
Come as you are (Montclair Art Museum)
 Come as you are : art of the 1990s / Alexandra Schwartz.
 pages cm
 Issued in connection with an exhibition held at the Montclair Art Museum.
 ISBN 978-0-520-28288-9 (hardback)
 1. Art, American—20th century—Exhibitions. I. Schwartz, Alexandra. II. Montclair Art Museum. III. Title.
 N6512.C58128 2014
 709.73′07474931—dc23
 2014021152

Produced by Marquand Books, Inc., Seattle
www.marquand.com

Editor: Holly La Due

Designer: Zach Hooker

Typesetter: Tina Henderson

Proofreader: Carrie Wicks

Color management by iocolor, Seattle

Printed and bound in China by C&C Offset Printing Co., Ltd.

Front cover: detail of plate 9; frontispiece: detail of plate 40; page 8: detail of plate 11; page 24: detail of plate 5; page 34: detail of plate 34; page 44: detail of plate 44; page 54: detail of plate 51; page 64: detail of plate 57; page 74: detail of plate 8; page 84: detail of plate 17; back cover: detail of plate 46.

Contents

FORE-WORD

LORA S. URBANELLI

Director
Montclair Art Museum

Since its founding exactly a century ago, the Montclair Art Museum has been a passionate supporter of contemporary art. When we opened our doors in 1914, works by artists such as Childe Hassam—one of America's most prominent contemporary painters at the time—hung in the galleries, and since then, MAM has consistently exhibited and acquired recent art. In 2010, we strengthened our commitment with the appointment of our first designated curator of contemporary art, and our subsequent establishment of a new and vibrant contemporary art program.

Come as You Are: Art of the 1990s is the largest and most ambitious contemporary art exhibition ever to be mounted by the Montclair Art Museum. Continuing MAM's tradition of first-rate scholarship, it spotlights a pivotal moment in the recent history of art. Chronicling the "long" 1990s between 1989 and 2001—from the fall of the Berlin Wall to 9/11—the exhibition examines how the art of this period both reflected and helped shape the dramatic societal events of the era, when the combined forces of new technologies and globalization gave rise to the accelerated international art world that we know today. In so doing, it continues MAM's long-standing commitment to the study and exhibition of socially engaged art.

We are proud that *Come as You Are* will tour nationally in 2015–16, traveling to the Telfair Museums, the University of Michigan Museum of Art, and the Blanton Museum of Art at the University of Texas at Austin; we are also honored to co-publish this major catalogue with the University of California Press. It has been a pleasure and a privilege collaborating with these institutions and their staff, and we thank them all for their enthusiastic partnership in this project.

Come as You Are: Art of the 1990s is made possible with generous grants from The Andy Warhol Foundation for the Visual Arts and Furthermore: a program of the J. M. Kaplan Fund. Major funding is provided by the Susan V. Bershad Charitable Fund, Inc., Holly English and Fred Smagorinsky, Tracy Higgins and James Leitner, Karen G. Mandelbaum, Sarah Peter, Ann and Mel Schaffer, Denise and Ira Wagner, Margo and Frank Walter, and the Judith Targan Endowment Fund for Museum Publications. Additional support is provided by the exhibition's Leadership Committee: James Cohan Gallery, New York/Shanghai; Eileen and Michael Cohen; the Barbara Lee Family Foundation; Metro Pictures, New York; and Andrea Rosen Gallery.

We would like to thank Alexandra Schwartz for bringing this fresh historical perspective to one of the most vibrant, chaotic, and difficult periods in recent history, and for her wonderful work as MAM's first curator of contemporary art; MAM's staff for their extraordinary work on the design, installation, and execution of all sides of *Come as You Are*; and our Board of Trustees for their dedication and support of this exhibition and our new contemporary art program more generally. Without the determined grace, generosity, and vision of Carol and Terry Wall, and the long-held passion and energy of collectors Ann and Mel Schaffer, MAM's contemporary program could not have taken hold. All of us on the staff and board are deeply grateful for their dedication to this mission.

We are also indebted to the many lenders to the exhibition for their generosity; to the galleries who assisted with details large and small; and last but certainly not least, we are all here to celebrate the artists themselves, who create for us the profound insight and historical reflection that only the arts can provide.

Lenders to the Exhibition

1301PE Gallery
Doug Aitken
Andrea Rosen Gallery
Janine Antoni
Alex Bag
bitforms gallery
Blanton Museum of Art, The University
 of Texas at Austin
Marieluise Hessel Collection, Hessel
 Museum of Art, Center for Curatorial
 Studies, Bard College
Sherry and Stuart Christhilf
Bill Cisneros
Eileen and Michael Cohen
Currier Museum of Art
Carlos and Rosa de la Cruz
Mark Dion
Jeanne Dunning
Martin and Rebecca Eisenberg
Electronic Arts Intermix
Erie Art Museum
Felix Gonzalez-Torres Foundation
The Frances Young Tang Teaching
 Museum and Art Gallery,
 Skidmore College
Andrea Fraser
Greene Naftali Gallery
Alvin Hall
Hannah Higgins and Joe Reinstein
George Horner
Hort Family Collection
Indianapolis Museum of Art
JODI

The JPMorgan Chase Art Collection
Luhring Augustine Gallery
Marc Foxx Gallery
Marian Goodman Gallery
Daniel Joseph Martinez
The Metropolitan Museum of Art
Montclair Art Museum
Prema Murthy
Museum of Contemporary Art, Chicago
The Museum of Contemporary Art,
 Los Angeles
Museum of Fine Arts, Boston
Museum of Fine Arts, Houston
Mark Napier
Peter Norton
Mendi + Keith Obadike
Gabriel Orozco
Pepón Osorio
Laura Owens
Philadelphia Museum of Art
Regen Projects
Roberts & Tilton
Nicholas Rohatyn and Jeanne Greenberg
 Rohatyn
Ronald Feldman Fine Arts
A. G. Rosen
Ann and Mel Schaffer Family Collection
Tanya Bonakdar Gallery
Diana Thater
Mark Tribe
Walker Art Center
Andrea Zittel
Marina Zurkow

CHAO-TIC, IN-PUT

ART IN THE UNITED STATES, 1989–2001

ALEXANDRA SCHWARTZ

The 1993 Biennial Exhibition at the Whitney Museum of American Art . . . is a pious, often arid show that frequently substitutes didactic moralizing for genuine visual communication. It could easily be subtitled "The Importance of Being Earnest." It could also be called the Reading While Standing Up Biennial: the art is often heavy with text, even without the simplistic artists' statements featured on many labels and the reading room, where one can peruse the latest books of cultural and sociopolitical theory.

Nonetheless, this Biennial is a watershed.

—Roberta Smith, "At the Whitney, a Biennial with a Social Conscience," *New York Times*, March 5, 1993[1]

Twenty years after its publication, Roberta Smith's barbed yet ambivalent review of the 1993 Whitney Biennial stands as a startlingly acute summary of one of the most controversial, but indisputably rich, periods in the recent history of art. In assessing the exhibition, Smith felt not quite happy with the featured artists' "earnest" engagement with current "cultural and sociopolitical theory," but acknowledged the importance not only of their exceptional concern for societal issues but of the exhibition's foregrounding of these issues in such a prominent institution. From today's perspective, what came to be known as the most "political" of Biennials remains a landmark in the recent history of art, regarded by some as a near-utopian period when art, "social conscience" (call it politics), and humanist discourse (call it theory) not only intersected but shared an extremely public stage.

I am one of those people who remember this moment with reverence, even nostalgia. I was an undergraduate at the time, taking a course on contemporary art, and a visit to the Biennial was on the syllabus. Hearing from the professor about the debates surrounding it sparked my curiosity, and the exhibition itself confounded and captivated me and, as it turned out, proved to be a crucial juncture in my intellectual formation. The '93 Whitney Biennial provoked conversations—in the mass media, the art world, the academy, and, crucially, among museum visitors—concerning the most complex societal issues of gender, sexuality, race, and class: today the debates around this exhibition continue to resonate with—and are still regularly referenced by—artists, critics, and art historians.[2] As fraught as these conversations often were, the exhibition created a rare occasion when artistic discourse penetrated public discourse on a broad scale, when the merging of art and life—the utopian aspiration of the historical avant-gardes—seemed to happen in the current day. I now realize that this exhibition, made

1. Roberta Smith, "At the Whitney, a Biennial with a Social Conscience," *New York Times*, March 5, 1993, http://www.nytimes.com/1993/03/05/arts/at-the-whitney-a-biennial-with-a-social-conscience.html?pagewanted=all&src=pm.

2. The reception of the 1993 Whitney Biennial was extensive, and today the exhibition has a long historiography. Among the first and most influential (and controversial) discussions of the show was "The Politics of the Signifier: Roundtable on the Whitney Biennial," a published conversation between Hal Foster, Rosalind Krauss, Miwon Kwon, Silvia Kolbowski, and Benjamin H. D. Buchloh, (*October* 66 [Autumn 1993]: 3–27). More recently, Elisabeth Sussman wrote an account of the exhibition, first presented at the 2004 College Art Association Annual Conference and subsequently published as "Then and Now: Whitney Biennial 1993" (*Art Journal* 64, no. 1 [Spring, 2005]: 74–79). Most recently, the 2013 New Museum exhibition *NYC 1993: Experimental Jet Set, Trash, and No Star* sparked a new spate of writing, including Jerry Saltz, "On '93 in Art," *New York Magazine*, February 3, 2013 (http://nymag.com/arts/art/features/jerry-saltz-1993-art/). The first interview I conducted in researching *Come as You Are* was with Elisabeth Sussman, the leader of the '93 Biennial's curatorial team, who notably stressed the importance of the curators' engagement with new developments in critical race and postcolonial theory (spearheaded by Thelma Golden), as well as her own dialogue with the art historian Benjamin Buchloh, in formulating her ideas for the show (Elisabeth Sussman, interview with the author, January 13, 2011). Many artists in *Come as You Are* also invoked the '93 Biennial during my conversations with them about the period.

possible by the commitment of its artists and curators to social engagement, the complexity of their questions, and the urgency of their voices, shaped my own career as a curator and art historian.

The twentieth anniversary of the '93 Whitney Biennial was on my mind when I first conceived of this exhibition in 2010. In the years of research and preparation that followed, my belief in the importance of a historical survey of the 1990s has grown, not simply in order to better understand this particularly messy, vibrant, complicated span of years, but as an attempt to track a period of time when the links between art and sociopolitical, economic, and especially technological change were strong and complex. As numerous scholars have observed, the combined factors of the fall of the Berlin Wall in 1989, the digital revolution, and the forces of globalization that were ongoing throughout the decade led to a radical transformation in political, economic, and social structures that ultimately affected every corner of an increasingly global society. Inevitably, these changes profoundly altered creative practice, including the visual arts.

The "Long" Nineties

Come as You Are: Art of the 1990s is the first major museum survey to historicize art made in the United States during this pivotal decade. Showcasing approximately sixty-five works by forty-five artists, the exhibition includes installations, paintings, sculptures, drawings, prints, video, sound, and digital art. The demarcation of any historical period is debatable and, to some degree, arbitrary, and I have chosen to examine a "long" 1990s that spans from 1989 to 2001, and is bookended by two intractable landmarks: the fall of the Berlin Wall and 9/11. The exhibition is organized around three principle themes: the "identity politics" debates, the digital revolution, and globalization. Its title refers to the 1992 song by Nirvana (the quintessential nineties' band, led by the quintessential nineties' icon, Kurt Cobain); moreover, it speaks to the issues of identities and difference that were complicated by the effects of digital technologies and global migration. All the artists in the exhibition made their initial "point of entry" into the art-historical discourse during the 1990s, and reflect the increasingly heterogeneous nature of the art world during this time.

In attempting to construct a thorough, representative history of this decade, albeit within selected parameters, I have striven for balance in terms of the range of artistic practices exhibited, including the geographic and demographic diversity of the artists. More than ever before, during the nineties artists experimented with multidisciplinary works and hybrid forms, particularly involving

new digital media. Alongside these innovations, however, there occurred a revival in interest in more traditional artistic media such as painting. While many critics observed that this phenomenon represented, at the very least, an attempted return to order in the face of radical technological changes, some (most famously or infamously, depending on one's perspective) celebrated it as a resurgence of "beauty."[3]

My decision to base the exhibition solely on art made in the United States was complicated, especially given the centrality of globalization to the decade's history. One key reason for my embrace of this limitation is that, in my opinion, the 1990s represent the last discrete era in which it is even conceivable to do an "all-American" show. Although the march toward globalization was certainly afoot during the 1990s, this exhibition proposes that the globalization of the art world was not entrenched until the early 2000s, when the number of international art fairs and biennials skyrocketed. During the nineties much of the art produced in the United States, particularly that dealing with issues of difference in American society, remained quite distinct from that produced elsewhere, even in Europe, where reactions to the fall of Communism dominated much artistic production.[4] By the same token, while the exhibition touches on art identified with what the French curator Nicolas Bourriaud called "relational aesthetics," or what other critics have identified more generally as a new genre of participatory art, I conclude that during the 1990s these tendencies were most prevalent outside the United States;[5] therefore, while a handful of artists working in this vein who were based in the United States appear in the exhibition, the mostly European-based artists who were instrumental in pioneering this work do not.

Geographically, the exhibition seeks to represent artistic activity across the United States. While New York remained the center of the American—and arguably the international—art world during the 1990s, its dominance began to wane as the decade wore on and the art world became increasingly diffuse. Los Angeles emerged as a major center for contemporary art during this time, anchored by its art schools, the Museum of Contemporary Art, then arguably in its heyday, and a gallery scene that grew exponentially during these years. A significant number of Los Angeles artists, cultivated by the many European curators, critics, and gallerists who visited or lived in Southern California then, managed to "jump over New York" and into the European art scene.[6] The exhibition also includes work by artists based in Philadelphia, Texas, Boston, Chicago, and the San Francisco Bay Area, where the new Silicon Valley was a hotbed of Internet art. Finally, *Come as You Are* reflects the increasingly

3. Dave Hickey, *The Invisible Dragon: Four Essays on Beauty* (Los Angeles: Art Issues Press, 1993). In 2001, Hickey was awarded a MacArthur Fellowship for his art criticism.

4. I am grateful to Claire Bishop for this insight (conversation with the author, May 5, 2011). Bishop is co-founder of Former West:

A long-term international research, education, publishing, and exhibition project (2008–2014), which from within the field of contemporary art and theory: (1) reflects upon the changes introduced to the world (and thus to the so-called West) by the political, cultural, artistic, and economic events of 1989; (2) engages in rethinking the global histories of the last two decades in dialogue with post-communist and postcolonial thought; and (3) speculates about a "post-bloc" future that recognizes differences yet evolves through the political imperative of equality and the notion of "one world" (http://www.former west.org/About).

5. In his 1998 book *Relational Aesthetics* (published in English in 2002), Bourriaud defines relational art as "an art taking as its theoretical horizon the realm of human interactions and its social context, rather than the assertion of an independent and *private* [his italics] symbolic space" (Nicolas Bourriaud, *Relational Aesthetics*, trans. Simon Pleasance, Fronza Woods, and Mathieu Copeland, [Dijon, France: Les presses du réel, 2002], 14).

6. Diana Thater, interview with the author, March 13, 2013.

heterogeneous nature of the art world during this time, when many women artists and artists of color attained unprecedented prominence. The ways in which artists engaged with these societal shifts lie at the crux of the exhibition.

Amid the radical societal change that rippled throughout the 1990s, the period's defining event was arguably the digital revolution, which altered everything from everyday communication to international commerce to global geopolitics. In particular, the rise of the Internet dramatically increased the volume of visual stimuli and information circulating throughout the world, which people struggled to navigate and process. The nascent twenty-four-hour news cycle magnified a chain of events that rocked the United States during this decade, and which are recounted in detail in this volume's chronology. Among the most influential of these events were the economic recession from 1987 to the mid-1990s; the fall of the Berlin Wall in 1989; the First Gulf War; the Los Angeles riots in 1991–92; the election of Bill Clinton in 1992; the NAFTA treaty in 1994; the rise of the dot-com bubble in the mid-1990s and subsequent burst in 2000; the Y2K panic; and the terrorist attacks of September 11, 2001. Contemporary artists grappled with the effects of these events, often addressing them directly, but also situating them within the context of changes particular to the art world, such as the "culture wars" surrounding artistic freedom and censorship; the impact of new media (video, sound, and digital art) on artistic practice; and the expansion of the global art market, with its explosion of art fairs and biennials.

The linguistic concept of "chaotic input" presents a useful metaphor for thinking about the 1990s and its art.[7] Developed by the linguist Derek Bickerton, the term refers to the process by which children acquire language through synthesizing dissonant information.[8] This term also aptly describes the cacophonous culture of the nineties, and artists' attempts to make sense of it. As in all periods of acute societal transformation, the nineties saw both innovation and seeming retrenchment. The decade brought, simultaneously, radical experimentation with new media art and a return to representational painting; the rise of digital and participatory art, which operated largely outside the realm of commerce, and the prodigious growth of the global art market; a democratization of the art world, and an increased elitism. *Come as You Are* argues that amidst, and indeed because of, these paradoxes, the 1990s constituted a turning point for the institution of art itself.

The exhibition's first section examines the early 1990s (spanning 1989 to 1993), which were dominated by debates around identities and difference. At the time, these conversations were often framed

7. I am grateful to Joan Kee for suggesting this connection at the *Come as You Are* Scholars Day, Montclair Art Museum, February 3, 2012.

8. Bickerton uses the terms "chaotic input" and "linguistic chaos" to refer to how children are exposed to too many competing languages on plantations to rely on the model that any one of them provides; rather, they have to rely on an innate "bioprogram" to create the language that eventually turns into a creole. (See Derek Bickerton, *Roots of Language* [Ann Arbor: Karoma, 1981] and Bickerton, "The Language Bioprogram Hypothesis," *The Behavioral and Brain Sciences* 7 [1984]: 173–221). Bickerton's "bioprogram hypothesis" mirrors Noam Chomsky's theory of the "poverty of the stimulus," which stipulates that language must be innate given that children are able to generate sentences that they have never heard before. (See Noam Chomsky, *Rules and Representations* [Oxford: Blackwell, 1980].) I am grateful to Marlyse Baptista for her assistance with my research on this topic.

under the rubrics "identity politics" and the related "multicultur-alism," but while sometimes serving as useful shorthands, these were and remain extremely problematic terms. They refer to the groundswell of attention to issues of cultural, racial, class, sexual, and gender difference that occurred during this time, and the discourses surrounding these issues. Although the roots of these debates stemmed from the mid-twentieth-century civil rights, fem-inist, and gay rights movements, during the nineties they took on new aspects. Within the art world, they were often held in relation to the National Endowment for the Arts (NEA) controversies of the late 1980s; the ongoing AIDS crisis; renewed racial tensions sur-rounding the 1992 Rodney King beating and subsequent Los Ange-les riots, as well as the Clarence Thompson–Anita Hill hearings; and the rise of postcolonial studies within the academy. One pos-itive effect of this renewed discourse was increased prominence for many artists of color and women and LGBT artists. However, for all their complexity, these debates often became oversimpli-fied, particularly in the mass media, leading to myriad instances in which work by the artists associated with them was considered simply for its engagement with issues of "identity," rather than as complex, multivalent works of art. In a kind of vicious circle, such reductive considerations led to the further polemicization of these issues; therefore, the "identity politics" debates are ripe for histor-ical examination.

The second section chronicles the mid-1990s (1994–97), which were marked by the precipitous rise of digital technologies. Her-alded by the launch of Mosaic (later renamed Netscape), the first commercial Internet browser, in 1993, the digital revolution ulti-mately transformed all aspects of contemporary life, including the production of, discourse around, and market for art. While the rise of the Internet made it possible for artists to disseminate their work worldwide simply by creating a website, it allowed galleries, auction houses, and collectors to buy and sell work on an accel-erated, newly global scale. New technologies contributed to the increased mobility (both virtual and physical) of artists, collectors, curators, and critics, resulting in the exponential proliferation of not only global biennials and art fairs but also residencies and other international exchanges. It also led to the rise of digital art, including Internet art, a short-lived art form whose life span was essentially limited to this decade.

Finally, the third section examines the late 1990s (1998–2001), which were distinguished by the advent of globalization in the political, social, and economic realms. The key catchphrase of the turn of the twenty-first century, globalization is employed in myriad

ways, but I will use it to refer to the shrinking (or as Thomas L. Friedman would, in 2005, famously put it, "flattening"[9]) of the world that accelerated during the 1990s: the result of the growth of global capitalism following the demise of Communism, combined with the birth of the Internet and its revolution in how ideas, people, money, and objects circulate. In the art world, globalization led to both a rapid acceleration of the market and a ramping up of the star system for artists, and, in an apparent contradiction, a move from what social theorists call the "center" to the "peripheries." The art historian Terry Smith has dubbed this phenomenon "the post-colonial turn," in which artists from nations previously governed by the major European colonial powers—and generally marginalized within the art world—gained unprecedented prominence on an international stage.[10] As will be discussed later in this volume, many of the artists associated with these discourses worked outside the United States, and the first exhibitions to engage with postcolonialism likewise took place abroad.[11] However, as will also be explored, a key point of tension in this period's history rests in the relationship between so-called identity politics and multiculturalism in the United States, and postcolonialism and globalization internationally: all discourses that illuminate how artists of the nineties addressed issues of difference.[12]

THE "CONTEMPORARY" NINETIES

Yet the "contemporary art" survey that seeks to be historical presents an inherent contradiction. On the one hand, the study of contemporary art history has ballooned since the 1990s. The past twenty years have seen a proliferation of new academic and curatorial positions in contemporary art, and today the statistical majority of graduate students in art history and curatorial studies programs specialize in it. On the other hand, the contemporary is, by definition, not historical, presenting a thorny paradox for those who study it.

The problems involved with historicizing the contemporary—and those inherent in any periodization—were in fact on the forefront of cultural studies during the 1990s. The most prominent critic to tackle this issue was Fredric Jameson, who famously articulated his theory of postmodernism in his 1991 book *Postmodernism, or, the Cultural Logic of Late Capitalism*, named after his eponymous 1984 essay. In its introduction, Jameson posits that among the chief characteristics of postmodernist culture is the dominance of the market, which he links to the waning of "master" or "grand" narratives—that is to say, teleological accounts of history. In his opinion, modernist culture retained some distance

9. See: Thomas L. Friedman, *The World Is Flat: A Brief History of the Twenty-First Century, Further Updated and Expanded, Release 3.0.*, 3d ed. (New York: Picador/Farrar, Straus and Giroux, 2007).

10. In his 2009 book *What Is Contemporary Art?*, Smith proposes three key currents in art since 1989:

> The first current manifests the embrace by certain artists of the rewards and downsides of neoliberal economics, globalizing capital, and neoconservative politics.... The second current is... a postcolonial turn. Following decolonization within what were the second, third, and fourth worlds, including its impacts in what was the first world, there has emerged a plethora of art shaped by local, national, anticolonial, independent, antiglobalization values (those of identity, diversity, and critique). It circulates internationally through the activities of travelers, expatriates, the creation of new markets. It predominates in biennales.... We are starting to see that in the years around 1989, shifts from modern to contemporary art occurred in every cultural milieu throughout the world, and do so distinctively in each.... The third current is... the very recent, worldwide yet everyday occasioning of art that—by rejecting gratuitous provocation and grand symbolic statement in favor of specific, small-scale, modest offerings—remixes elements of the first two currents, but with less and less regard for their fading power structures and styles of struggle, and more concern for the interactive potentialities of various material media, virtual communicative networks, and open-ended models of tangible connectivity (Terry Smith, *What Is Contemporary Art?* [Chicago and London: University of Chicago Press, 2009], 7–8ff.).

11. As I discuss at greater length in the 1998–2001 section of this catalogue, among the most important of these exhibitions occurred as early as 1989, which saw the exhibition *Magiciens de la terre* at the Centre Georges Pompidou and La Grande Halle de la Villette, Paris, and the Third Havana Biennial; these were followed by the second Johannesburg Biennial in 1997 and *Documenta XI* in 2002, both organized by the Nigerian-born curator Okwui Enwezor.

12. I am grateful to Lowery Stokes Sims for her insights on this topic (Lowery Stokes Sims, interview with the author, June 20, 2011).

from commerce, but "in postmodern culture, 'culture' has become a product in its own right . . . modernism was still minimally and tendentially the critique of the commodity and the effort to make it transcend itself. Postmodernism is the consumption of sheer commodification as a process."[13] In many ways, and as will be discussed later in this volume, the dissolution of grand narratives is due to the waning of the authority of the Western straight white male, and the concordant rise of feminist, queer, and postcolonialist voices, in the creation of historical narratives. Herein, however, lies the rub, for he acknowledges that, despite postmodernism's emphasis on deconstructing and dispelling grand narratives, narrative structure is inherent to the very concept of history. He observes:

> The constitutive impurity of all postmodernism theory . . . confirms the insight of a periodization that must be insisted on over and over again, namely, that postmodernism is not the cultural dominant of a wholly new social order . . . but only the reflex and concomitant of yet another system modification of capitalism itself. . . . But this unforeseeable return of narrative as the end of narratives, this return of history in the midst of the prognosis of the end of demise of historical telos, suggests . . . the way in which virtually any observation about the present can be mobilized in the very search for the present itself and pressed into service as a symptom and an index of the deeper logic of the postmodern, which imperceptibly turns into its own theory and the theory of itself.[14]

For the purposes of this exhibition, Jameson's concept of postmodernism is crucial for two reasons. First, his theories, first articulated during the 1980s, helped define art criticism during the 1990s, particularly those concerning the overwhelming power of the global art market (as a subset of the neoliberal economy) since 1989, and the related concept of the work of art as commodity fetish or, to use his preferred term, "simulacrum," which he defines as "the identical copy for which no original has ever existed."[15] And second, his reflections on postmodernism's undermining of grand narratives speak powerfully to the methodological problem of attempting to construct a history of the 1990s, when, as now, the very concept of the historical narrative is subject to intense scrutiny.

In a series of recent debates about the nature and practice of contemporary art history, scholars have wrestled with the endemic ahistoricity of "the contemporary." One of earliest and the most comprehensive of these was undertaken by the journal *October* in 2009, when it issued a "Questionnaire on 'The Contemporary'" to "approximately seventy critics and curators, based in the United States and Europe, who are identified with this field."

13. Fredric Jameson, *Postmodernism, or, the Cultural Logic of Late Capitalism* (Durham, North Carolina and London: Duke University Press, 1991), ix.

14. Ibid, xii.

15. Ibid, 18.

In his introduction to the questionnaire results, the art historian Hal Foster writes, "The category of 'contemporary art' is not a new one. What is new is the sense that, in its very heterogeneity, much present practice seems to float free of historical determination, conceptual definition, and critical judgment." However, he continues, after the recent waning of "such paradigms as 'the neo-avant-garde' and 'postmodernism,' which once oriented some art and theory," one could argue that "no models of such explanatory reach or intellectual force have risen in their stead."[16] Consequently, there currently exists widespread confusion about what exactly "the contemporary" means and entails. What Foster describes as this "free-floating" quality cuts to the heart of the debate about historicizing the contemporary: whether art-historical—and, I would insist, curatorial—considerations of the contemporary are obligated to sacrifice historical contextualization in their attempt to track "the now."

Crucially for this exhibition's purposes, the debates about the contemporary are rooted in the 1990s, for the practice, production, and dissemination of new art underwent a critical shift during this decade. In his response to the *October* questionnaire, the art historian Alexander Alberro argues that the dawn of our current conception of the contemporary in fact coincided with that of this particular decade, observing:

> The years following 1989 have seen the emergence of a new historical period. Not only has there been the collapse of the Soviet Union and its satellite states and the heralding of the era of globalization, but technologically there has been the full integration of electronic or digital culture, and economically, neoliberalism, with its goal to bring all human action into the domain of the market, has become hegemonic.[17]

Suggesting that today's neoliberal economy is rooted in the fall of the Soviet Block in 1989, Alberro asserts that the effects of this seismic economic shift reverberated across every sector of contemporary society, including art.[18] This unrelenting, globalized market (in the broadest sense, as well as in the specific sense of the art market) drastically altered the way art was created, viewed, and sold.

The art historian Pamela M. Lee draws similar conclusions in her 2012 book *Forgetting the Art World*, expanding her discussion to include a call to her professional colleagues to reflect upon globalization's effects on art-historical scholarship. Arguing that the monumental shifts in the art world since 1989 require a responsive shift in contemporary art historians' approach to their practices, she writes:

16. The *October* questionnaire sought responses to the following questions:

> Is this free-floating imagined or real? A merely local perception? A simple effect of the end-of-grand-narratives? If it is real, how can we specify some of its principle causes, that is, beyond general reference to "the market" and "globalization"? Or is it indeed a direct outcome of a neoliberal economy, one that, moreover, is now in crisis? Finally, are there benefits to this apparent lightness of being? (Hal Foster, in "Questionnaire on 'The Contemporary,'" *October* 130 [Fall 2009]: 3).

17. Alexander Alberro, in ibid., 54.

18. In his consideration of the contemporary era, Alberro contends, "In the late 1980s and early 1990s, several factors came together that resulted in a seismic change that, I believe, significantly realigned the manner in which art addresses its spectator," and points to four main manifestations of these changes: one, "Globalization, which takes various forms"; two, the "new technological imaginary"; three, "the reconfigured context of contemporary art prompts a thorough reconsideration of the avant-garde"; and four, "the surprising reemergence of a philosophical aesthetics that seeks to find the 'specific' nature of aesthetic experience as such," an apparent reference to the practices of participatory art characterized by Nicolas Bourriaud as "relational aesthetics." He concludes that the latter shift signaled a change (for him, unwelcome) in the nature of spectatorship:

> The resurgence of philosophical aesthetics has coincided with a new construction of the spectator... [that emphasizes] affect and experience rather than interpretation and meaning.... I mean to argue that we have aesthetic experiences, not because of some ontological postulate, but because we have been constructed as spectators in traditions that put those values and those experiences at the center of cultural life. Furthermore, it is important to emphasize that not all of the returns to aesthetics have been content with the pursuit of essence (ibid., 55–60ff).

the activities of the art world's horizon are indivisible from the activities of globalization itself. As such, we need to bridge the apparent distance maintained by its two orders of representation: between what the art world *does* (including its institutional rituals of self-reflection) and what it *exhibits as* "globalism." . . . We need to force the question of our own embeddedness in this world: how to confront the relation between globalization and contemporary art when we are both object of, and agent for, such processes.[19]

As Lee points out, the economic and geopolitical ramifications of globalization affect everyone, including its critics, and it is crucial that historians strive for a measure of distance and self-reflectivity in constructing their critiques of global contemporary art.

In his 2013 book *What Was Contemporary Art?*, the art historian Richard Meyer examines the problems of "the contemporary," and the contemporary art historian, from a historiographic perspective. Asserting that "The peculiar hybrid that is contemporary art history . . . exists in the space between criticism and scholarship, between contemporary art and history,"[20] he reminds us that, until recently, work on contemporary art was considered strictly the realm of criticism. The so-called thirty-year rule within academic art history dictated that art created more recently than this is too recent for historical scrutiny (at least for doctoral dissertations). However, in the past decade this rule has eroded, the line between art criticism (as a journalistic practice) and history (as a scholarly practice) along with it. Like Lee, Meyer stakes a claim for maintaining some distance in art-historical scholarship; he argues for the importance of placing even recent art within a broader historical context. The chaotic nature of our globalized, market-driven era is such that, he warns, "The spectacular immediacy of the contemporary art world threatens to overwhelm our ability to think critically about the relation of the current moment to the past."[21] Therefore, he suggests, the best course of action is for the contemporary art historian "to slow down, take a deep breath, and consider histories prior to our own";[22] in other words, to look closely at the past, with the benefit of the archival research and temporal distance upon which traditional art history is based, and seek to relate it to our own time.

A striking aspect of these debates on the contemporary lies in the fact that, although exhibitions play a large part in these discussions (Meyer's book, in fact, is primarily a study of the work of Alfred Barr, the founding director and curator of the Museum of Modern Art), most of its theorists are academics, rather than curators. Here the *October* questionnaire is again revealing, for

19. Lee, *Forgetting the Art World*, 16–17.

20. Richard Meyer, *What Was Contemporary Art?* (Cambridge, Mass. and London: The MIT Press, 2013), 259.

21. Ibid., 281.

22. Ibid.

although it includes entries by the curators Kelly Baum, Okwui Enwezor, Mark Godfrey, and Helen Molesworth, Foster notes in his introduction that "very few curators responded" to the survey.[23] (He does not reveal how many were invited to participate.) The lack of curatorial voices in the theorizing of contemporary art history is especially remarkable given the sheer number of curators working in this field today, and the proliferation of exhibitions of recent art occurring every year. The reasons for this discrepancy are unclear, but might be partially explained by the fact that many contemporary curators are not art historians, and therefore do not always think in the same terms as their academic counterparts.

THE "HISTORICAL" NINETIES

Recently, a major current in contemporary curatorial practice resembles something akin to artistic practice, with curators organizing group exhibitions based on wide-ranging formal or conceptual connections, often without the historical contextualization that is a given in exhibitions of earlier art.[24] Such models can provide insights that historical exhibitions cannot; in particular, they help circumvent so-called grand narratives by offering unorthodox, non-teleological accounts of contemporary art. While there have always been scholarly exhibitions on recent art—during the 1990s and 2000s, the Museum of Contemporary Art, Los Angeles's remarkable run of exhibitions chronicling major movements including Minimalism, Conceptualism, performance art, and Art and Feminism perfected this practice[25]—the number of art survey exhibitions that attempt to construct a rigorous historical framework through which to consider contemporary art are currently few and far between.

Come as You Are argues for the value of using the tools of art-historical scholarship—primary and secondary research, consideration of artworks within the sociopolitical context of their making, formal analysis—to examine the art of the recent past. Any effort to chart a history of a given era runs the risk of becoming reductive, of veering into the territory of the grand narrative or the oversimplified periodization. However, it is my hope that this exhibition's attempt to put the contemporary within the context of history—to make it simultaneously strange and newly knowable by considering it in relationship to the past—both provides a detailed account of a critical era in American art and culture, and offers some perspective on today's panoply of global artistic production. The issues examined in the exhibition—particularly its three central themes of identities and difference, digital technologies, and globalization—dominated the 1990s, yet remain some of the most

23. Foster, 3n1.

24. In summer 2013, the Paris Palais de Tokyo mounted *Nouvelles vagues*, a series of exhibitions by curators under the age of forty, selected from an open call for exhibition proposals by a jury of established international curators. Its press release offered a useful definition of this new genre of curatorial practice:

> This event is a unique opportunity to emphasize the emergence of this new definition of the curator, a position that has flourished alongside the artist for the past decades. This essential figure, who organizes exhibitions across the globe, is neither an art dealer nor an institutional curator. He or she does not belong to the academic establishment nor feels subjected to the rules of the art market. Instead, here is a free spirit, a maverick looking for new directions, a nomad who knows no boundaries and is always searching for original poetic, aesthetic and political adventures. Working alone or as part of a group, the curator creates original, temporary environments in which artists from different backgrounds come together around shared goals, ideas and visions. No longer the mouthpiece of a period or a movement, no longer the theorist of a new chapter of art history, they thrive on the challenge of working side by side with the artists (http://www.e-flux.com/announcements/nouvelles-vagues-new-waves/).

25. For an insightful consideration of these MOCA exhibitions, see Helen Molesworth's response to *October's* "Questionnaire on 'The Contemporary'": 111–16. These exhibitions include *Reconsidering the Object of Art: 1965–1975*, organized by Ann Goldstein and Anne Rorimer (1995); *Out of Actions: Between Performance and the Object, 1949–1979*, organized by Paul Schimmel (1998); *A Minimal Future? Art as Object, 1958–1968*, organized by Ann Goldstein (2004); and *WACK: Art and the Feminist Revolution*, organized by Cornelia H. Butler (2007). Other recent exhibitions on this model include *The Pictures Generation*, organized by Douglas Eklund for the Metropolitan Museum of Art (2009), and *This Will Have Been: Art, Love and Politics in the 1980s*, organized by Molesworth for the Museum of Contemporary Art, Chicago (2012).

pressing concerns in art today. Investigating these issues' historical roots may also help us better understand our own moment (as history always should).

While this exhibition makes a case for the 1990s as a time of rupture, it should be noted that the decade was also, like any period, marked by continuities with the past. The historical circumstances defining the 1990s were determined by those of the 1980s, 1970s, and before, as well as by larger epistemological currents coursing throughout the twentieth century. In his seminal study *Farewell to an Idea: Episodes from a History of Modernism*, published on the brink of the twenty-first century in 1999, the art historian T. J. Clark takes a retrospective glance at the twentieth century, his main preoccupation being the fate of modernism, the defining cultural product of modernity. According to conventional wisdom, modernity had, by the turn of the twenty-first century, long since been supplanted by postmodernity, modernism by postmodernism. Clark, however, argues that:

> It is just because the "modernity" which modernism prophesied has finally arrived that the forms of representation it originally gave rise to are now unreadable. . . . Postmodernism mistakes the ruins of those previous representations, or the fact that from where we stand they seem ruinous, for the ruin of modernity itself—not seeing that we are living through modernity's triumph.[26]

For him, postmodernity is not the end but rather the apotheosis of modernity; he suggests that the globalized, technologically overdetermined state of the postmodern world represents, perhaps paradoxically, the culmination of modernity's success. In other words, the sense of disorientation permeating the end of the twentieth century was simply a heightened version of that which has always characterized modernity, and which, in turn, has always been driven by new technologies, from the industrial revolution in the nineteenth century to the digital revolution in the twentieth and twenty-first. This recognition—that the present is a continuation of the past, that postmodernity is part and parcel of modernity, that the 1990s were shaped by the 1980s, and so on—underscores the urgency of this exhibition's effort to understand the contemporary through the simultaneous estrangement and clarity that the "long view" of history provides.

As Clark also points out, both modernity and modernism were defined by the capitalist market, which opens up vast possibilities for risk, and thus for both great innovation and crushing destruction.[27] Nothing could be more true of contemporary art, particularly during the erratic and transitional 1990s. This presents

26. T. J. Clark, *Farewell to an Idea: Episodes from a History of Modernism* (New Haven and London: Yale University Press, 1999), 2–3.

27. Clark writes: "Markets offer hugely increased opportunities for increased calculation and speculation on futures. That is why they rule the world. But they do so only if players are willing to accept that conduct *is* calculus and speculation, and therefore in some fundamental way hit or miss" (his emphasis; ibid., 11).

another pitfall for the historian of contemporary art for, as Pamela Lee has ruefully acknowledged, "the worse excesses of our field do involve grotesque and often market-driven speculation."[28] But here I would again maintain that striving toward critical distance on the recent past is the most effective way to create some remove from the contemporary market, which favors the known, the digestible, and the salable, privileging a limited variety of art forms and creating an intractable artistic elite—and an incomplete historical picture. Given the unprecedented power of today's global art market, a concerted attempt at the rigorous scholarly examination of recent art is more crucial than ever, providing an essential check on the ever-voracious market and its attendant systems of distribution and circulation. While *Come as You Are* includes many artists who met with great success within the globalized art market, it also examines work by artists who were either not embraced by it or who chose to work outside of its boundaries. This is particularly true of the exhibition's emphasis on digital art, the history of which has, until now, been largely separate from that of other artistic media.

There can be no doubt that additional distance on the 1990s will change our perceptions of it, but in preparing this exhibition I have sought to be as thorough as possible in my research, approaching it with the same scholarly rigor that one would a more distant historical period. My strategies for doing so included interviewing artists, curators, and critics active during the period, including as many of those in the exhibition as possible; researching the key exhibitions of the decade and their reception; scrutinizing the critical texts influencing the artistic, theoretical, and historical discourses of the day; and commissioning the catalogue essays from art historians who, like myself, were shaped by the 1990s, when most of us were in school, yet who were not actively "on the scene" during this time, and so have some inherent distance on the period.

As is the case with any era, there were many 1990s: more than could possibly be addressed in a single exhibition and requiring certain choices in how I represented its history. In exploring my principle interest in how this period's radical societal changes affected its art, I have also chosen to focus primarily on artists who were born in the 1960s and came of age as artists during the 1990s. As the first generation to grow up grappling with both the digital revolution and accelerated globalization, their art poignantly reflects these monumental societal shifts. However, the choice to focus on these artists necessarily meant that some major figures who helped shape the decade but were already established at its

28. Pamela M. Lee, in "Questionnaire on 'The Contemporary'" 25.

inception—such as Robert Gober, Mike Kelley, Charles Ray, Cindy Sherman, Lorna Simpson, and Carrie Mae Weems, to name just a few—were not included. Finally, one of the major themes of *Come as You Are* is the breakdown in received definitions of "fine art"— particularly as it related to the increase in multimedia and multidisciplinary work during the nineties—but the exhibition could not attempt to cover design, fashion, music, film, or television, all of which thrived during this time, and had a profound effect on the visual arts.

Because one of the main points that *Come as You Are* seeks to make is that its three themes overlap—or, in other words, that complex works of art can and should not be identified with a single set of issues—I do not wish to categorize the works in the exhibition by theme. Indeed, as I will discuss throughout this volume, a given artwork often engages with several of the exhibition's themes simultaneously. Nevertheless, it is instructive to trace the evolution and intersections of these themes as they emerged, which is why the works are organized into the three main periods of the early, mid-, and late 1990s. Each of these periods is represented by a section of both the exhibition and the catalogue; each catalogue section provides an introduction to that period, followed by close examinations of works from those years, within their historical context.

In my attempt to chart a survey of this complex decade, it was essential to engage numerous voices and points of view (or, to hearken back to our previous debate, to include as many perspectives as possible within the narrative that a history inherently requires). I am deeply grateful to the scholars who have contributed to this catalogue. In "Unfinished Business as Usual: African American Artists, New York Museums, and the 1990s," Huey Copeland discusses the relationship of African American artists to the "identity politics" debates of the era. Jennifer A. González examines artists' use of fashion in constructing identities in "Costume: Come as You Aren't." Suzanne Hudson chronicles the near death and subsequent resurrection of American painting in "After Endgame: American Painting in the 1990s." In "As the World Turns in 1990s' America," Joan Kee explores Asian émigré artists in the United States, within the context of discourses on multiculturalism, globalization, and postcolonialism. Kris Paulsen traces the evolution of digital art in "Ill Communication: Anxiety and Identity in 1990s' Net Art." In "Event Horizons: Gabriel Orozco and the 1990s," Paulina Pobocha focuses on that artist's innovative early work, offering a case study for the effects of globalization on artistic practice. John Tain's essay "A Place to Call Home: Artists In and Out of Los Angeles, 1989–2001"

spotlights L.A. art at a time when that city gained new prominence in the international art world. In her comprehensive chronology Frances Jacobus-Parker charts the key artistic, political, and cultural events of the 1990s. These retrospective examinations are complemented by the exhibition's website, which includes additional interviews with artists, scholars, and critics. Together, these elements offer a multiplicity of perspectives on this transformational and chaotic decade.

I am an invisible man. No, I
am not a spook like those
who haunted Edgar Allan
Poe; nor am I one of your
Hollywood-movie ectoplasms.
I am a man of substance, of
flesh and bone, fiber and liq-
uids—and I might even be
said to possess a mind. I
am invisible, understand, sim-
ply because people refuse to
see me. Like the bodiless
heads you sometimes see in
circus sideshows, it is as
though I have been surround-
ed by mirrors of hard, dis-
torting glass. When they ap-
proach me they see only my
surroundings, themselves, or
figments of their imagination
—indeed, everything and any-
thing except me. Nor is my
invisibility exactly a matter
of a bio-chemical accident to
my epidermis. That invisibi-
lity to which I refer occurs
because of a peculiar dispo-

UNFINISHED BUSINESS AS USUAL

AFRICAN AMERICAN ARTISTS, NEW YORK MUSEUMS, AND THE 1990s *

HUEY COPELAND

* Thanks to Max Allison for his research assistance in the preparation of this essay and to Alexandra Schwartz for her generous insights on previous iterations of it.

1. Huey Copeland, "*Mal d'Anthologie*: Clifford Owens and the Crises of African American Performance Art," in *Clifford Owens: Anthology*, ed. Christopher Y. Lew (New York: MoMA PS1, 2012), 24.

2. Ibid., 26.

3. Kobena Mercer, "Dark & Lovely: Black Gay Image-Making" in *Welcome to the Jungle: New Positions in Black Cultural Studies* (New York: Routledge, 1994), 230.

4. For just one example of the almost globally damning response to the exhibition, see David Rimanelli, "Pruitt and Early: Leo Castelli Gallery," *Artforum* 30 (March 1992): 102–3.

5. I refer here, of course, to Judith Butler, *Gender Trouble: Feminism and the Subversion of Identity* (New York: Routledge, 1990); and less obviously to Amei Wallach's proclamation—in the context of a profile on Lorna Simpson—that "'The Outsider Is In," *New York Newsday*, September 19, 1990, which is entirely emblematic in its rhetorical framing of the rise of artists of color.

On December 17, 2011, at New York's MoMA PS1, Clifford Owens staged one of the twenty-six performances whose documentary traces comprise *Anthology*, an ongoing project that at once aims to highlight and repair the historical record's elision of black performance art. On the day in question, his brief was to "restat[e] a photograph by Lyle Ashton Harris, *Constructs #10* of 1989, and then to recite a "memorized scholarly text on the image by Kobena Mercer" [figure 1].[1] Such a restaging would seem straightforward enough, especially for a performer as fearless as Owens, simply requiring him to mimic the *contrapposto* stance, confrontational stare, dragged-out attire, and partial nudity of Harris's original photograph. During the performance, however, Owens found himself both resistant to assuming the pose and nostalgic for the era with which his predecessor's work has become synonymous. "What," he asked, "happened to the critical moment of the 1990s of identity politics? What's changed other than there being an asshole black President?"[2] More than one artist's frustrated aside, Owens's comments begin to suggest the ambitions of African American art in the 1990s, the promise of art world transformation it represented, and the many ways in which that "critical moment" has been forgotten, travestied, or indefinitely deferred.

The acclaim that greeted Ashton Harris's adamantly queer performative deconstructions of black masculinity, which coincided with the rise of multiculturalist and identarian discourses, provides a telling snapshot of the concerns of the day and the terms in which they were articulated. In his images, Mercer argues, "Harris not only parodies the existential anguish of inauthenticity that remains unsaid, and unspeakable, in the discourse of black cultural nationalism . . . but camps up the categories of race and gender identity by positing a version of black masculine identity that mimics Judy Garland and a hundred other (white) feminine icons of metropolitan gay sensibility."[3] At the same time, practitioners without such a fine ear for the visual exigencies of difference quickly found themselves called to account for their ostensible transgressions. The white male duo of Rob Pruitt and Jack Early, for example, were critically excoriated for their 1992 exhibition *Red Black Green Red White Blue Project*, an eclectic mash-up of black artistic, vernacular, and historical posters formatted in interlocking geometric frames that lined a gallery space done up in shiny reflective metallics [figure 2].[4] In the 1990s, such punning plays were deadly serious: gender was to be "troubled," patriarchy was to be unveiled, and subjects at the "margins" were poised not merely to contest but to occupy the "center" of the art world.[5] Indeed, in the year that Ashton Harris made his *Constructs, New York Times*

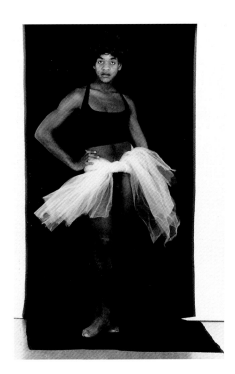

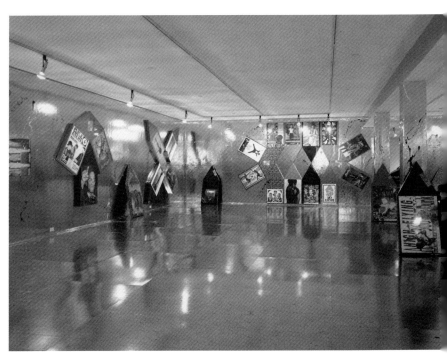

critic Michael Brenson proclaimed that black artists were now finally taking their "place in the sun."[6]

Brenson's forecast accurately predicted one representational drift of the long decade from 1989 to 2001, when black artists and curators enjoyed unprecedented access to and visibility within mainstream U.S. exhibition venues and discourses.[7] Consider the benchmarks that have come to define the critical fates and fortunes of black artists in New York during the period. In 1990, three "alternative" institutions—the Museum of Contemporary Hispanic Art, the New Museum of Contemporary Art, and the Studio Museum in Harlem—launched *The Decade Show: Frameworks of Identity in the 1980s*, which both aimed to right the wrongs of the past ten years and to set the standard of inclusion for omnibus exhibitions in the decade to come. Few institutions embraced this agenda more fiercely than the Whitney Museum of American Art as evidenced by changes in the racial composition of the artists featured in the museum's influential biennials. In contrast to the 1989 exhibition, which featured a sole black participant, abstract sculptor Martin Puryear, the 1991 iteration included contributions by Nayland Blake, Glenn Ligon, Lorna Simpson, and Carrie Mae Weems, all artists, like Ashton Harris, associated with a semiotic approach to the black image.[8]

Even this gathering would pale in comparison to the hotly debated 1993 Whitney Biennial, which featured more than a dozen

Figure 1
LYLE ASHTON HARRIS
Constructs #10 1989
Black-and-white mural print
77½ × 48 in. (196.9 × 121.9 cm)

Figure 2
ROB PRUITT AND JACK EARLY
Red Black Green Red White Blue Project 1992
Installation view, *Pruitt-Early*, Leo Castelli Gallery, New York, Jan. 4–25, 1992

6. Michael Brenson, "Black Artists: A Place in the Sun," *New York Times*, March 12, 1989, http://www.nytimes.com/1989/03/12/arts/art-view-black-artists-a-place-in-the-sun.html.

7. For a thoroughgoing account of the first half of this period, on which the present essay implicitly depends, see Huey Copeland *Bound to Appear: Art, Slavery, and the Site of Blackness in Multicultural America* (Chicago: University of Chicago Press, 2013).

8. *1989 Biennial Exhibition* (New York: Whitney Museum of American Art, 1989); *1991 Biennial Exhibition* (New York: Whitney Museum of American Art, 1991).

9. *1993 Biennial Exhibition* (New York: Whitney Museum of American Art, 1993).

10. See, respectively, *Black Male: Representations of Masculinity in Contemporary American Art*, ed. Thelma Golden (New York: Whitney Museum of American Art, 1994); Jack E. White, "The Beauty of Black Art," *Time* 144 (October 10, 1994), 66–73.

11. *1995 Biennial Exhibition* (New York: Whitney Museum of American Art, 1995); *1997 Biennial Exhibition* (New York: Whitney Museum of American Art, 1997); *2000 Biennial Exhibition* (New York: Whitney Museum of American Art, 2000).

12. For Golden, "post-black" was "a clarifying term that had ideological and chronological dimensions and repercussions. It was characterized by [a new generation of] artists who were adamant about not being labeled as 'black' artists, though their work was steeped, in fact deeply interested, in redefining complex notions of blackness. Thelma Golden, "Post-," in *Freestyle* (New York: Studio Museum in Harlem, 2001), 14.

13. Copeland, "Lorna Simpson's Figurative Transitions," in *Bound to Appear*, 72–73.

14. See Kobena Mercer, "Tropes of the Grotesque in the Black Avant-Garde," in Kobena Mercer, ed. *Pop Art and Vernacular Cultures* (Cambridge, Mass: The MIT Press, 2007), 139.

artists of African descent—about 15 percent of the total practitioners tapped for the exhibition—who worked in an even more expansive array of modes, from the wooden figurative sculptures of Alison Saar to the site-sensitive installations of Renée Green.[9] One of that biennial's co-curators, Thelma Golden, would go on to mount *Black Male: Representations of Masculinity in American Art* at the Whitney in 1994, the same year that *Time* magazine triumphantly announced the emergence of a "Black Renaissance" across the cultural field.[10] From one vantage, *Time*'s coverage represented a high watermark in the general awareness of African American visual practice, one that was only matched sporadically during the rest of the decade. To be sure, black artists of various aesthetic proclivities were featured in subsequent Whitney biennials: Ellen Gallagher in 1995; MacArthur Genius Fellows Kerry James Marshall and Kara Walker in 1997; and Dawoud Bey, Thornton Dial, and Arthur Jafa in 2000, to name only those figures who come foremost to mind.[11] Arguably, however, it would not be until Golden's 2001 exhibition *Freestyle* at the Studio Museum in Harlem, which notoriously introduced the notion of "post-blackness," that a New York exhibition highlighting artists of color would again seize the mainstream imagination.[12]

A few things can be gleaned from this admittedly partial and partisan narrative that are of both sociological and artistic import. Many of the artists who garnered attention at the outset of the decade were championed because their work rhymed with and seemed to extend the concerns of white feminists such as Eleanor Antin, Mary Kelly, and Martha Rosler, whose poststructuralist approaches to the image had placed them at the forefront of advanced critical practice.[13] Of course, practitioners in the 1990s could also look back to the examples provided by at least two strands of influential African American art that had emerged in the 1970s: on the one hand, to the black conceptualism of Adrian Piper, David Hammons, and Charles Gaines; and on the other, to the irreverent formalism of Robert Colescott, Barkley Hendricks, and Howardena Pindell, whose work in painting and sculpture worked with and against the racialized biases of the most traditional of aesthetic media. Taken together, these tendencies opened up an "expanded field" of blackness that would enable subsequent artists to fully exploit the dialectical constitution of the racial sign.[14]

To mobilize the notion of the expanded field in a discussion of black artistic practices is to turn to an unlikely source: art historian Rosalind Krauss's highly influential essay on a generation of European American sculptors whose three-dimensional work of the 1970s led her to generate a new grammar for the examination

of aesthetic transformation.[15] By her lights, accounting for, say, Robert Smithson's *Spiral Jetty*, required an analysis of the ways that the "historically bounded" term "sculpture" and the antimonies on which it depends—architecture, landscape, and most salient, the structural negation of both—might be logically expanded, thereby generating a new set of relations between forms and establishing a gridded order over the site of what modernist sculpture had become, a "black hole in the space of consciousness"[16] [figure 3]. The phrase is worth remembering: it speaks to the ways in which Krauss's essay casts the unintelligible, the ontologically absent, and the products of radical negativity in shadow so that they may be better brought to light. Now, in all likelihood, Krauss did not have the metaphorics of race in mind when she penned those words; she is, after all, the critic who, as theorist Fred Moten reminds us, "once said something to the effect that there must not be any important black artists because, if there were, they would have brought themselves to her attention."[17]

Even more to the point is Krauss's actual engagement with the work of an African American artist, which was featured in a round-table discussion on the 1993 Whitney Biennial published in the journal *October*. In that conversation, Krauss takes issue with the exhibition catalogue's tendency—emblematized, for her, by Golden's essay, "What's White"—to rush to the signified of denotative social meaning rather than to pay heed to each artist's work on the material constitution of the signifier. Krauss's prime example is Lorna Simpson's installation *Hypothetical?*, in which a black-and-white photograph of a woman's lips faces off against an orderly array of brass instrument mouthpieces [figure 4]. As the art historian notes, "on the wall bridging between the two 'grids,' there was a newspaper clipping about Tom Bradley being asked whether, were he not mayor of Los Angeles, would he, as a black man, be afraid after the Rodney King verdict. And he said, 'No, I wouldn't be afraid; I'd be angry.' I thought that was irrelevant to the piece, and not particularly interesting."[18] In these lines, as in "Sculpture in the Expanded Field," Krauss consigns everything outside of a recognizable order—meaning, affect, race—to a space of unintelligibility, the very site that African American artists have often been summarily consigned to or purposefully sought to occupy within visual representation.[19]

Krauss's dismissal, however, is more than merely indicative of the racialized lapses of the structuralist imaginary that has everywhere shaped art-historical and critical discourse since the 1970s. Through its very blindness, her generative rhetoric brings into focus the historical production of blackness as a kind of negative space,

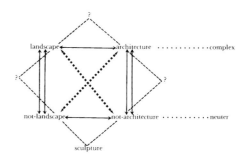

Figure 3
Originally published in: Rosalind Krauss, "Sculpture in the Expanded Field," *October* 8 (Spring 1979): 30–44.

15. Rosalind Krauss, "Sculpture in the Expanded Field," in *The Originality of the Avant-Garde and Other Modernist Myths* (Cambridge, Mass.: The MIT Press, 1985), 276–90.

16. Ibid., 279–80.

17. Fred Moten, *In the Break: The Aesthetics of the Black Radical Tradition* (Minneapolis: University of Minnesota Press, 2003), 233.

18. See Krauss's comments in Hal Foster et al., "The Politics of the Signifier: A Conversation on the Whitney Biennial" *October* 66 (Fall 1993): 6.

19. For two thoroughgoing critiques of Krauss's essay that have directed my own, see Anne M. Wagner, "Splitting and Doubling: Gordon Matta-Clark and the Body of Sculpture," *Grey Room* 14 (Winter 2004): 30–32; and Eve Meltzer, "The Expanded Field and Other, More Fragile States of Mind," in *Systems We Have Loved: Conceptual Art, Affect, and the Antihumanist Turn* (Chicago: University of Chicago Press, 2013), 117–52.

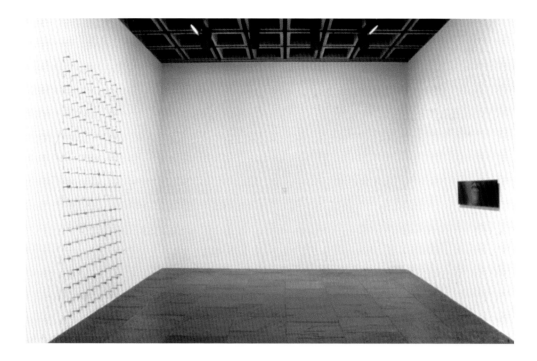

Figure 4

LORNA SIMPSON

Hypothetical? 1992

Photograph, text, instrument mouthpieces, and sound
Installation view, Whitney Biennial Exhibition, Feb. 24–
June 20, 1993
Whitney Museum of American Art, New York; promised
gift of Emily Fisher Landau P.2010.262

20. Frantz Fanon, "By Way of Conclusion," in *Black Skin,
White Masks*, trans. Charles Lam Markmann (New York:
Grove Press, 1967), 231.

21. Houston A. Baker, Jr., *Modernism and the Harlem
Renaissance* (Chicago: University of Chicago Press, 1987),
50. Baker, in turn, derives his terms from zoologist Hugh B.
Cott's work on "allaesthetic" masking in the animal king-
dom. See Hugh B. Cott, "Animal Form in Relation to
Appearance," in *Aspects of Form: A Symposium on Form in
Nature and Art*, ed. Lancelot Law Whyte (New York: Pel-
legrini & Cudahy Publishers, 1951), 121–42.

22. Darby English, *How to See a Work of Art in Total Dark-
ness* (Cambridge, Mass.: The MIT Press, 2007), 27–70.

which, as philosopher Frantz Fanon teaches us, has no ontological
resistance and so figures the ground over which the symbolic econ-
omies of white institutionality stretch their meaning.[20] In negoti-
ating these discursive and structural conditions, African American
artists have undertaken their own expansions of the visual field,
but with other sets of antimonies in mind: abstraction and figu-
ration, stereotype and portraiture. Such pairings tack between a
cryptic figuration of blackness—"a mastery of form [that] conceals,
disguises, floats like a trickster butterfly in order to sting like a
bee"—and its obverse strategy, the phaneric—defined as clearly
visible to the naked eye—which entails "the deformation of mas-
tery . . . a go(ue)rilla action in the face of acknowledged adversar-
ies."[21] I borrow these terms from the literary theorist Houston Baker
because they provide a set of coordinates—predicated on the play
between concealment and advertisement, masking and revela-
tion—that would come to shape possibilities for engagement with
the matter of blackness in the 1990s. By working the intermediary
spaces opened up between the cryptic and phaneric poles, artists
found a way out of what art historian Darby English has called the
trap of "black representational space," that cul-de-sac of "positive
imagery," defined as not-cryptic and not-phaneric.[22]

The signal works of the 1990s, many gathered in this exhibition,
make the case. In the art of Vik Muniz [plates 41–43] and Kerry
James Marshall [figure 5], the black figure is given a revivified

opacity and raised to the level of history painting, while in the
works of Michael Ray Charles [plate 48] and Nikki S. Lee [plates
50–52] the residues of racist stereotype are given fresh legs that are
immediately undercut. Charles and Marshall, for instance, share
an emphasis on dark painterly tonalities in
the depiction of black skin, but the former
artist unabashedly accedes to the logic of cli-
ché in order to bring out the particularity of
the stereotype's visual construction, whereas
the latter produces individuated presences
that nevertheless conform to a generic type
[figure 5]. Other artists, such as Glenn Ligon,
Julie Mehretu, Jason Rhoades, Ellen Galla-
gher, and Mendi + Keith Obadike would seek
to downplay the figure, searching for alterna-
tive means—words, signs, and symbols—to
invoke less the body of blackness than the
material histories that continue to produce it
as a site for the extraction of value. Emblem-
atic in this regard is the Obadikes' 2001 sale
of Keith's own "blackness" through the online
retailer eBay, an absurd gesture that simulta-
neously underlines the intransigence of racial
identity and the fungibility of those products
emerging from it [plate 66]. These modes of

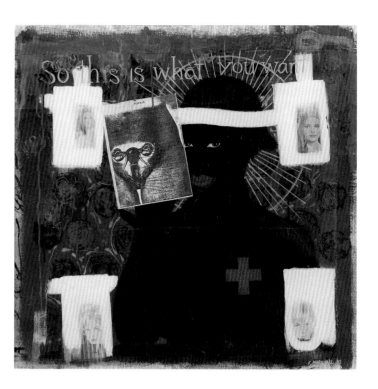

Figure 5
KERRY JAMES MARSHALL
So This is What You Want 1992
Acrylic and collage on canvas
28 × 28½ in. (71.1 × 72.4 cm)

working, positioned between the phaneric, the cryptic, and their
constitutive negations, effectively disarticulate the logics that have
long defined the black image. In the *Greenhead* paintings of Laylah
Ali [plates 59–61] and the cuts of Kara Walker [plate 24], these anti-
monies are uncannily wed to occupy the complex axis, pointing us
in the direction of African American art now: thoroughly decon-
structed, cloaked yet aggressive, and still on the hunt for a promise
of life in which difference might thrive.

Of course, the very success of these practitioners underlines
how opportunities for black artists often depend upon tastemak-
ers positioned within powerful mainstream institutions and who
can therefore create momentary openings for alternative voices
that make freshly visible African American art's capacious range
of procedures and positions. Such opportunities, however, are all
too contingent and always under threat of reverting to business as
usual. To wit, Harris, despite his initial acclaim, has yet to receive
a mid-career retrospective at a major New York museum, while
Pruitt has been critically resuscitated, thanks in part, to his own
clever re-branding and to the support of curators at Tate Modern

who have insisted on restaging the very exhibition that once promised to consign him to the dustbin of history.[23] We might say, then, in response to Clifford Owens's second, searching question, that what has changed between the "critical moment" of the early 1990s and our post-everything present, is not merely the discrediting of identity politics, but the recession of race as a vital organizing front or even a sociopolitical reality worth naming now that an illusion of black representation has been installed in art and politics.

Ironically, this all-too-familiar narrative was foretold before the 1990s even properly began. In her essay for *The Decade Show* catalogue, curator Eunice Lipton succinctly diagnosed the modes of forgetting that continue to structure marginalized histories:

> Endlessly we—women, Asians, Latins, gays, blacks, Native Americans—search the public record for our histories and for the wholeness we felt—wasn't it just a minute ago? That wholeness that comes from satisfying work, good friends, a fortifying home. Or to put it another way, from seeing and being seen, speaking to and being responded to, feeling hungry and being fed. Just as the satisfaction accompanying that visibility begins to warm us, it vanishes. The timing of denial is always exquisite.[24]

We needn't look far to find confirmation not only of the erasure of black artists from official narratives but also of the continuing ghettoization of the aesthetic, discursive, and political implications of their work. For while the explosion of African American artistic practices in the 1990s can no longer be ignored, in the reigning surveys of modern and contemporary art, they are still couched as late arrivals relative to the defining artistic achievements of the last two hundred years, despite the fact that black practitioners' work over this *longue durée* demands a radical recasting of what constitutes the aesthetic itself.[25] Indeed, the entire history of modern and contemporary art can be narrated as a story of engagement with and retreat from the vicissitudes of race and gender as manifested in the visual field, from Marie-Guillemine Benoist's *Portrait d'une négresse* (1800) up through Kara Walker's psychosexually charged silhouettes.[26]

There have been numerous terms to describe this yawning critical failure: Golden has called it "exclusion by self-imposed amnesia"; cultural critic Michele Wallace has gone as far as to deem the visual itself a "negative scene of instruction" within black culture; and Howardena Pindell, ever forthright, has documented the evidence of "art world racism" in meticulous and damning detail.[27] Placed alongside Lipton's account, each of these ascriptions suggests the economies of denial and forgetting that are part and

23. On Harris's critical fortunes and the restaging of *Red Black Green*, see respectively, Copeland, "*Mal d'Anthologie*," 26; and "Tate Modern to stage 'racist' exhibition," *The Independent*, September 26, 2009, http://www.independent.co.uk/arts-entertainment/art/news/tate-modern-to-stage-racist-exhibition-1793497.html.

24. Eunice Lipton, "Here Today. Gone Tomorrow? Some Plots for a Dismantling," in *The Decade Show: Frameworks of Identity in the 1980s* (New York: Museum of Contemporary Hispanic Art, New Museum of Contemporary Art, and the Studio Museum in Harlem, 1990), 19–20.

25. For just a few examples of this phenomenon, see Irving Sandler, *Art of the Postmodern Era* (Boulder, Colo.: Westview Press, 1996); Hal Foster, Rosalind Krauss, Yve-Alain Bois, and Benjamin H. D. Buchloh, *Art Since 1900: Modernism, Antimodernism, Postmodernism, 1945 to the Present*, Vol. 2 (London and New York: Thames and Hudson, 2005); and Frances K. Pohl, *Framing America: A Social History of American Art* (London and New York: Thames and Hudson, 2008).

26. See Huey Copeland, "In the Wake of the Negress," in *Modern Women: Women Artists at the Museum of Modern Art*, ed. Cornelia Butler and Alexandra Schwartz (New York: The Museum of Modern Art, 2010), 480–97.

27. I refer, respectively, to Golden's comments in Huey Copeland, "Post/Black/Atlantic: A Conversation with Thelma Golden and Glenn Ligon," in *Afro Modern: Journeys in the Black Atlantic*, ed. Tanya Barson and Peter Gorschlüter (Liverpool: Tate, 2010), 81; Michele Wallace, "Modernism, Postmodernism, and the Problem of the Visual in Afro-American Culture," in *Out There: Marginalization and Contemporary Cultures*, ed. Russell Ferguson et al. (Cambridge, Mass.: The MIT Press, 1990), 41; and Howardena Pindell, "Art World Racism: A Documentation," *New Art Examiner* 16 (March 1989): 32–36.

parcel of artistic discourse's fantasy of itself as a liberal space of gamesmanship. I would contend, however, that the structural underpinnings of the art world and its institutions must be seen as coterminous with the modern era's varied techniques for the "social reproduction" of "white supremacy." A few words on each of these phrases is in order. According to Barbara Laslett and Johanna Brenner, social reproduction "refers to the activities and attitudes, behaviors and emotions, responsibilities and relationships directly involved in the maintenance of life on a daily basis"; for Eduardo Bonilla-Silva, white supremacy encompasses "the racially based political regimes that emerged post-fifteenth-century" and that are now maintained "through institutional, subtle, and apparently nonracial means."[28]

The work of these adamantly feminist and antiracist sociologists provides a powerful explanatory framework. On the one hand, they allow us to understand how, despite substantive gains over the last five decades, black incomes in the 1990s remained well below those of any other ethnic group. Black populations continue to be produced as abject classes, both visually and materially, phenomena that continue to be confirmed, whether by the beating of Rodney King in '91 or the murder of yet another unarmed black male, Trayvon Martin, more than twenty years later. These episodes and accounts ask us to consider the insidious day-to-day personal and institutional biases that black subjects within the "racialized social system" of the art world aim to negotiate and make visible.[29] For if, as the artist and critic Lorraine O'Grady has argued, the rise of poststructuralist and feminist artistic discourses in the 1980s represented the consolidation of white supremacy, then our task now, as ever, must be to question all cultural formations that make use of blackness as a mode or a material.[30] It is with these imperatives in mind that we might revisit the art of the 1990s—asshole presidents aside—so that the endless task of imagining its future can properly, even joyfully, begin.

28. Barbara Laslett and Johanna Brenner, "Gender and Social Reproduction: Historical Perspectives," *Annual Review of Sociology* 15 (1989): 382–404; Eduardo Bonilla-Silva, *White Supremacy and Racism in the Post–Civil Rights Era* (Boulder: Lynne Rienner Publishers, 2001), 11; 12.

29. Bonilla-Silva, 12.

30. Lorraine O'Grady, "This Will Have Been: My 1980s," Public Lecture, Museum of Contemporary Art Chicago, March 15, 2012.

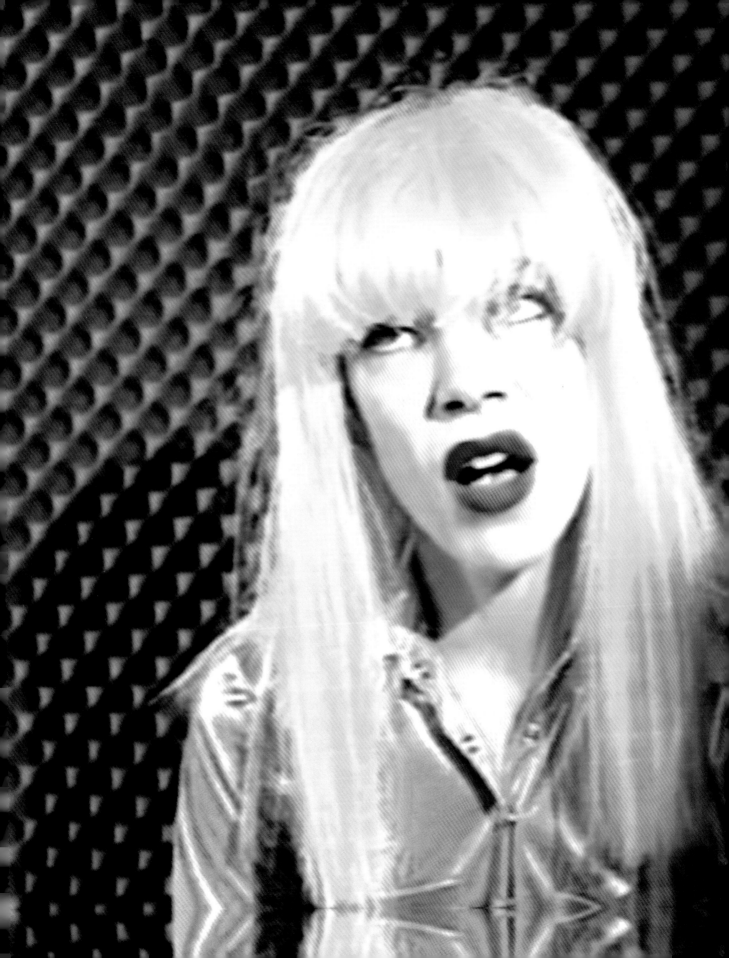

COSTUME
COME AS YOU AREN'T

JENNIFER A. GONZÁLEZ

If I am not what you say I am, then you are not who you think you are.

—James Baldwin

With museum galleries or video frames as the proscenium of choice, a cast of costumed characters stepped deftly onto the scene of the visual arts in the 1990s with self-conscious, Brechtian irony. These artists leveraged the artifice of disguise to push against the remarkably resistant fourth wall of "disinterested" contemplation established by art audiences to sustain their viewing pleasure. As a surface for legible signs, the body became a tool to reveal its own semiotic making and unmaking, its relation to visibility and invisibility, and its containment within a field of power relations. Inspired by both feminist and body-art traditions, and openly rejecting long-standing modernist critiques of theatricality, artists began actively orchestrating staged events where "dressing up" became the primary means of exploring the boundaries of subjectivity as well as the sometimes-repressive forces of subject formation. Their chosen disguises formed pointed critiques of the politics of representation through which humans are made to operate in a broader field of visual display.

An important example of this impulse can be found in James Luna's *The Artifact Piece* (1987) in which the Native American artist presented his own body as a semi-inert artifact in a glass vitrine at the San Diego Museum of Man.[1] This generative performance brought the politics of the institutional gaze—especially that of natural history museums in the United States that frequently represent Native American populations as already extinct—to the attention of the public. In another staged performance at the Whitney Museum of American Art in New York, Luna invited viewers to *Take a Picture with a Real Indian* (1991) offering them the choice of posing with him as he donned one of three costumes: a simple leather loincloth, an elaborate Plains Indian feathered headdress or regular street clothes [figure 1]. Audience choices revealed their romantic attachments to nineteenth-century images of Native Americans, as well as their comfort or discomfort with the classic relations of cultural tourism implied by the resulting photograph.[2]

Luna's work appeared at a time when scholar James Clifford's book *Predicament of Culture: Twentieth-Century Ethnography, Literature and Art* (1988) invited consideration of the ways museums play a critical role in shaping historical consciousness, cultural hierarchy, and notions of "cultural authenticity," and Judith Butler's influential *Gender Trouble: Feminism and the Subversion of Identity* (1990) argued that human subjectivities (and genders) are always

1. See Jennifer A. González, *Subject to Display: Reframing Race in Contemporary Installation Art*, (Cambridge, Mass.: The MIT Press, 2008), 37.

2. James Luna and David Merritt, *Take a Picture with a Real Indian*, video (Toronto: V Tape, 2001).

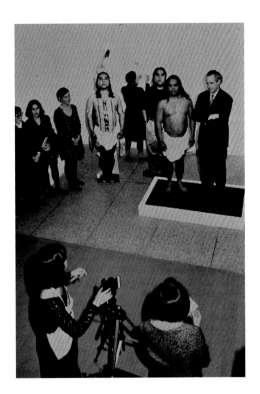 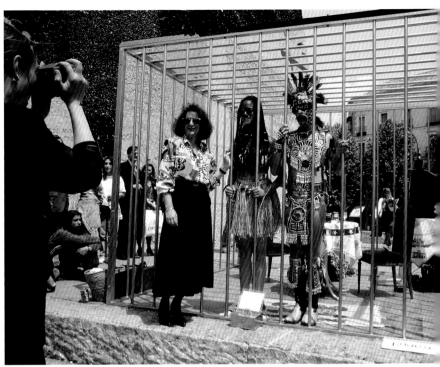

performed. Shaped by social institutions that invite (or demand) our participation, we are all to some degree performing, and therefore "in drag." Yet, performance is never entirely *free*; not all performing subjects have the capacity to perform equally or take up critical positions easily whether inside or outside of art institutions. Parodying involuntary histories of racial performance, Coco Fusco and Guillermo Gómez-Peña's *Two Undiscovered Amerindians visit the West* (1992–94) served as a highly visible, anti-colonial gesture on the quincentenary of Columbus's arrival in the Americas [figure 2]. The two artists appeared in a large golden cage, dressed in pseudo "primitive" garb such as faux leopard skins, or adorned with plastic bananas, offering a high-camp reenactment of the ways some indigenous peoples of the Americas were put on display in Europe in the nineteenth century.[3] Both *The Artifact Piece* and *Two Undiscovered Amerindians...* employed humor and sarcasm to treat painful and serious concerns of the colonial past that are still felt in unequal race relations of the present. The mistake made by some critics at the time was to read them straight, as forms of self-expression, or worse, as forms of identity politics. Instead, the artists' explicit use of costume should have tipped viewers off that the primary goal of the work was to reflect upon and to rearticulate relations of seeing and being seen.

Figure 1
JAMES LUNA
Take a Picture with a Real Indian 1991
Photographic "cutouts": Richard Lou
Performance, Whitney Museum of American Art, New York, 1991

Figure 2
COCO FUSCO AND GUILLERMO GÓMEZ-PEÑA
The Year of the White Bear and Two Undiscovered Amerindians visit the West 1992–94
Performance, various locations

3. For a short history of this practice, see Coco Fusco's essay, "The Other History of Intercultural Performance," in her book *English Is Broken Here: Notes on Cultural Fusion in the Americas* (New York: The New Press, 1995).

Such relations of visibility (and invisibility) recur in *My Life as a Dog* (1992) a rare performance by the installation artist Fred Wilson at the Whitney Museum. After greeting a group of docents and arranging to meet them in an upstairs gallery, the artist quickly changed into a uniform worn by the museum security guards, took up a post in the appointed gallery, and remained silent when his audience arrived. The docents wandered the galleries looking for the artist they had met only moments earlier, but he was no longer visible to them. He had become an anonymous man, an invisible man, like many of the other guards working the museum floor.[4] The year before, Wilson had produced a similar critique with his installation of four dark-skinned mannequins wearing New York City museum security-guard uniforms. *Guarded View* (1991) enacted a visual pun that implied the degree to which a complex play of gazes participates in the production of subjectivity for employees who are most often rendered invisible in the context of the museum [figure 3]. Headless, the row of figures echoed the lifeless life of the men and women who stand silently and unobtrusively in the whitewashed galleries of MoMA, or corridors of the Metropolitan Museum of Art, ensuring the safety of objects while, in the eyes of others, appearing as little more than immobile objects themselves.[5]

Wilson's guards do not merely signify the absence of "black" subjectivity in the context of the museum, they also reveal the normalizing procedures of the museum in shaping a "racialized" visibility and cultural hierarchy. The visual discourse of race relies upon the act of beholding and perceiving, and among the most telling artifacts of this activity are portraits produced cross-culturally. Inevitably, such images reveal more about the cultural lens of the producer than it does about the one depicted. In the Seattle Art Museum's archives Wilson unearthed a number of porcelain figurines and small portrait drawings of Europeans, Africans, Asians, and Native Americans, as depicted by other cultures. The striking fact of their eclecticism registered not merely the ideological valence of some (the British depicted Africans with devil's horns) but also the radical variation in the representation of human facial features (such as the culturally specific representations of eyes, nose, or mouth) as each demonstrated an effort to use traditional means of representation to depict "unfamiliar" subjects. The collection was displayed together as a series of photographs titled *Portrait of S.A.M.* (1993) [plate 23]. The exhibition catalogue claims that through this juxtaposition Wilson demonstrates the failure of each culture to accurately depict the "other," but this interpretation misses the point that each portrait reveals precisely the culturally

4. Lisa Corrin, "Mining the Museum: Artists Look at Museums, Museums Look at Themselves," in *Mining the Museum*, ed. Lisa Corrin (New York: The Contemporary, Baltimore in cooperation with The New Press, 1994), 9–10.

5. A significant majority of museum guards in New York museums were African American when Wilson made this piece, leading to claims by those institutions that they have a racially diverse staff. But, as Maurice Berger writes, "The boards of art museums, publishers of art magazines and books and owners of galleries rarely hire people of color in policy-making positions." Maurice Berger, *How Art Becomes History* (New York: Harper Collins, 1992), 150.

specific modes of vision that underlie its production. As with all portraits, rather than revealing the "truth" of their subject, they make evident the representational techniques and social imaginary of the artists who produce them. The portraits are accurate, in fact, within the aesthetic paradigms of those who produced them. They also signal the degree to which the museum, as a collecting institution, has the power to display some cultural perspectives and not others.

A parallel critique, from the perspective of class, appeared several years earlier in Andrea Fraser's live performance *Museum Highlights: A Gallery Talk* (1989) staged at the Philadelphia Museum of Art [plate 1]. In the video re-creation, the artist enters the frame wearing the conservative business attire of a museum docent, in tailored gray and white. Her dark hair is pulled back against her head, her face is accented by simple pearl earrings; her appearance is professional. She is "Jane Castelton," and she will be our tour guide. Our first sense that this will be no ordinary tour comes from her statement that she will be focusing on "some of the rooms in the museum," including the reception areas, dining rooms, restrooms, etc. Displacing the habitual emphasis on the artworks in the museum's collection, Fraser directs attention to the museum's infrastructure: the architecture, the social institution. In the video version of the performance Fraser is not a terribly good

Figure 3
FRED WILSON
Guarded View 1991
Wood, paint, steel, and fabric
Dimensions variable
Whitney Museum of American Art, New York; gift of the Peter Norton Family Foundation, 97.84ad

actor—her mannerisms are slightly awkward, her speech pattern is stilted, and we can see that she is reading her notes. A successful form of an "unsuccessful" delivery is humorous and disturbing at the same time. We grasp that this is a performance for our benefit, but we also grasp that we are being pulled involuntarily into a set of unpredictable discourses.

Fraser's brilliant move is to construct the majority of her monologue from found text. Museum brochures about membership and historical documents about the museum's mission form one discourse, but these are read against texts relating to other Philadelphia social institutions such as the Hospital for Mental Diseases at Byberry, or Camp Happy "for undernourished children." One chilling citation from the museum's own literature of 1922 reads "We have come to understand that to rob . . . people of the things of the spirit and to supply them with higher wages as a substitute is not good economics, good patriotism, or good policy,"[6] arguing that it is more important to provide spiritual uplift than good salaries. Through these found texts, Fraser offers a form of what is now called "institutional critique" by unraveling the history of the Philadelphia Museum of Art, its patrons, its audience, its physical construction, and its ideological origins.[7]

Initially Fraser, as Castelton, speaks in the voice of the institution, identifying with its patron class and board of trustees. But eventually the variety of texts she cites (including catalogue entries about artworks, histories of the welfare class, documents from the Department of Public Health) devolves into dissociative ramblings, as the artist walks through the galleries pointing to a wooden cabinet, for example, and describing it as "a charming group of dancing maidens."[8] Particularly effective is the moment when she addresses the "period" rooms, each representing the tastes of the upper classes of different historical eras. Fraser stands in the doorways to these rooms, but she does not let the camera (and therefore us) enter, reminding us of the many working- and middle-class subjects who have long been denied access to such opulence.

Near the end of her tour, Fraser draws our attention to the spaces of the museum that are named by donors, and comments that she, as Jane Castelton, would like to name the bookshop "Andrea." Here the slippage between artist-as-performer and character-as-performed foregrounds the tensions in the masking operation at play. At first the docent reveals her own desire to be a part of the beauty and the culture she experiences in the museum. But her desire is effectively undermined by the artist's desire to tell us a different story about economic class and privilege through the same body. The artist's layered subject position works as a kind

6. Andrea Fraser, "Museum Highlights: A Gallery Talk," *October* 57 (Summer 1991): 108.

7. See Frazer Ward, "The Haunted Museum: Institutional Critique and Publicity," *October* 73 (Summer 1995): 71–89.

8. Fraser, 113.

partially inspired by genres of American cinema to explore particular "types."[13] But unlike previous photographic portraiture based on typologies from August Sander to Richard Avedon, Lee inserts herself into the frame, breaking both the categorical purity of the "type" and the "objective" position of the photographer. Besides, it was rarely Lee who shot the pictures in which she figured, but rather friends or community members. The *Projects* series gives us a way to consider the layered function of costume within a much deeper visual-culture tradition and social environment. But if the artifice is removed and the player is merely a member of the group, can they be said to be in "costume"?

While art critics in the 1990s were sometimes at pains to grasp the "real" or the "authentic" subject of "identity politics," the artists producing these works knew perfectly well what was at stake: the broader economic, social, and historical frames of subjection—the making and the forming of the human subject through institutions, rituals, acculturation, and coercion. The conceit of my subtitle "come as you aren't" suggests the importance of non-identity embedded in the production of any identity. One might have read any of the artworks I have just discussed as a form of portraiture—even self-portraiture—but in every case this would be incorrect. Each of the costumed bodies on display enacts precisely what the artists themselves *are not*, but what they imagine (for better or worse) social institutions might make of them. When we attend to this double difference as a productive form of critical art practice, we can, perhaps in the spirit of James Baldwin, arrive at the hopeful insight that we may not be, or may not *simply* be, who others think we are.

13. Todd Richardson, "Serialization, Ethnographic Drag, and the Ineffable Authenticity of Nikki S. Lee," *New Directions in Folklore* 11 (2013): 70.

AFTER ENDGAME,

AMERICAN PAINTING IN THE 1990s

SUZANNE HUDSON

Writing in 1984, at the height of the postmodern polemics that would condemn painting as a regressive cipher, Fredric Jameson looked back to the 1960s.[1] Keen to attend to the exigencies of the era without lapsing into a mode of veneration "commemorating its triumphs or a dirge bemoaning its "many failures and missed opportunities," he nonetheless retained a belief in the utility of both narrative and periodization.[2] In his opening salvo, Jameson notes the theoretical pressures against him: accounts aiming for comprehensiveness or synthesis, whether diachronic or synchronic (that is, whether tracing the development of a subject over time or multiple subjects at a specific point in history), were distinctly out of favor. Despite this, Jameson renders a model of "a determinate historical situation"[3] by naming "a common objective situation, to which a whole range of varied responses and creative innovations is then possible, but always within that situation's structural limits."[4] Underscoring the selectiveness of his examples and his handling of them, he eschews the possibility of achieving an accurate descriptive account of history as it happened. On the contrary, he aims to theorize history as such.[5]

If I am beginning my essay for a book on American art in the 1990s with Jameson's text, it is because his admissions throw into sharp relief period prohibitions that bear directly upon how painting came to be understood alongside them in the years leading up to, and directly affecting, those that will be my explicit subject in what follows. For together with those bans that Jameson acknowledges, the visual arts experienced others: omniscience and universality, authorship and authenticity, to name just a few. Which is to suggest that Jameson's critique of the limits of historiography in the early 1980s is helpful in thinking about forms of partiality that so influenced the making, viewing, and writing of contemporary art.

Likewise meaningful is Jameson's production of a concept of history *through* the 1960s, then some twenty years on. (He was far from alone in this attention, as the 1960s came to the fore prominently in the 1980s—for thinkers on the Left and the Right, alike.) The making of a 1960s then was a project comparable in so many ways to our own turn to the 1990s, and with much the same interval of delay. But it is also important to assert that when talking about "the 1960s," Jameson did not intend a literal decade. He argued that it comprised a longer expanse (instigated by decolonization and curtailed in the mid-1970s with the end of American "Third Worldism" in the context of the Vietnam War). Thus does Jameson point to the fundamental arbitrariness at the core of delimiting a timeframe that becomes meaningful on its own terms—an

1. I am here referring to a text that lambasted German and Italian Neo-Expressionism, and figurative painting overall, for exploiting a contaminated past while upholding the value of authorship. See Benjamin H. D. Buchloh, "Figures of Authority, Ciphers of Regression: Notes on the Return of Representation in European Painting," *October* 16 (Spring 1981): 39–68.

2. Fredric Jameson, "Periodizing the '60s," *Social Text* 9/10 (Spring–Summer 1984): 178.

3. Ibid.

4. Ibid.

5. Ibid., 179.

arbitrariness that remains no less real for being addressed so self-consciously.

A discussion of American painting in the 1990s might begin in a more punctual fashion: On March 18, 1990, a security breach at the Isabella Stewart Gardner Museum in Boston resulted in the theft of thirteen artworks, among them one by Johannes Vermeer and another by Édouard Manet, as well as five drawings by Edgar Degas and three works by Rembrandt. The two perpetrators dressed up like policemen, and gained access to the closed galleries by declaring that they were responding to a call. An improbable scenario with significant consequences, the Gardner Museum heist produced a discourse around painting as an object very literally lost. Mass media stories were ubiquitous and bylines about possible leads for the unsolved case still appear. The public outcry underscores the widely regarded import of Old Master and also earlier modernist painting, even as it confirms the nature of such concern for this stolen art as properly belonging to objects remote in place and time.

Indeed, by 1990 painting was, to many critics and practitioners, a thing of the past. It became so slowly, from the late 1960s on (the period that might for our purposes indicate a long 1990s, or at least the chronological basis requisite for understanding it in a more circumscribed way). In short, with the advent of conceptual practices and the turning away from the production of objects in a studio to ephemeral, often post-studio projects, painting was supplanted in vanguard circles by a range of systems that often dispersed the art into multiple contexts or physical locations, shuttled it across bodies and time, or reconceived it as and into text. It was only with the emergence of a group of expressionistic painters—Julian Schnabel, Eric Fischl, and Francesco Clemente, among so many others—who were active internationally in the early 1980s that painting assumed widespread visibility again.

The problem was that this so-called Neo-Expressionistic work assumed a distinctly prelapsarian attitude, showing little concern for the potent interventions of feminist artists in the 1970s. Contra anti-aesthetic strains of critical practice, they indulged in large-scale panels given over to adolescent sexual fantasies and hyperbolic re-imaginings of olden myths, sometimes festooned with broken crockery and kitschy dried flowers. These acts achieved the look of spontaneity and were meant to signify emotional catharsis. Writers in favor of this work described a trans-historical humanism that connected the whole of creativity in paint, from the primordial caves to the white cube, and regarded the topical avoidance of painting as an insignificant blip in the longer course.[6]

6. One significant discussion and critique of this position can be found in Douglas Crimp, "The End of Painting," *October* 16 (Spring 1981): 69–86.

Figure 1
SHERRIE LEVINE
After Walker Evans: 4 1981
Gelatin silver print
5 ¹⁄₁₆ × 3 ⁷⁄₈ in. (12.8 × 9.8 cm)
The Metropolitan Museum of Art, New York; gift of the
artist, 1995 (1995.266.4)

Apart from grounds of misogyny if not downright bowdlerization—for example, the 1981 exhibition *New Spirit in Painting*, held at the Royal Academy of Arts in London, was the first group show of contemporary painting in Europe for a decade and a half and its thirty-eight contributing artists were to a person male—the work was challenged, by those who rallied against it, for being *painting*. The medium seemed to have become complicit with the market.

At the same time, many artists were forgoing making anew, turning to finding objects and images in the world as sources there for the taking. As Sherrie Levine wrote in a 1982 statement apropos belatedness: "The world is filled to suffocating. Man has placed his token on every stone. Every word, every image, is leased and mortgaged. We know that a picture is but a space in which a variety of images, none of them original, blend and clash. . . . We can only imitate a gesture that is always anterior, never original."[7] For her first solo show at the newly opened Metro Pictures Gallery,

7. Sherrie Levine, "Statement," *Style* (Vancouver: Vancouver Art Gallery, 1982): 48.

New York, in 1981, Levine explicitly mined the field of photography, taking existing artworks as but another cultural readymade [figure 1]. Visitors to this show saw photographs that Levine had re-photographed from bookplates. Crudely put, painting was conservative and bad as an agent of the economy and other forms (e.g., photo-based appropriation, politically inflected agit-prop, and works composed with nascent technologies) were radical and good.

To be sure, to pose that painting became a thing of the past is not to say that people finished painting, whether in the 1970s, 1980s, or 1990s, but rather that the medium was reappraised in light of pressures from within and without. This predicament formed the basis for the event that gives this piece its title: *Endgame: Reference and Simulation in Recent Painting and Sculpture*, curated by Elisabeth Sussman and David Joselit at the Institute of Contemporary Art, Boston, in 1986. The show and its catalogue posed in relation to modernist painting a cultural revaluation, not a literal stoppage. Even so, the notion of the death of painting as such became ubiquitous in debates about the meaning of representation—debates that are in so many ways analogical to the concerns that Jameson flags relative to the writing of history. Unable to achieve the quality or importance that had distinguished past exemplars, "serious" painting was over.

While *Endgame* reflected a changing status of the image at the time and rendered moves within the visual arts relative to it acute, the ideas it expresses are not unique; there have been many formulations since antiquity whereby genres of art, or art as such, were thought to end. Still, all of this stemmed from and contributed to a mounting sense that painting—while still very much alive in some camps—was far from central to the concerns that were to animate art in the 1990s. The ascent of certain forms of theory, conspicuously multiculturalism and post-colonialism, revived strains of pluralism, decentering any one medium or position registered within. A recovery of the discrete, studio-made object smacked of nostalgia if not outright anachronism in the context of an emergent globalized exhibition culture, rapidly assimilated post-1989, which increasingly turned on festivals and biennials spread across the continents, and encouraged the peripateticism of artists and the production of multimedia work created on location. Traveling among such venues became customary, giving rise to an experience economy of participatory, "relational" art, which facilitates the instantiation of social interactions within the exhibition space. In the United States, the predominance of photography and photo-based appropriation, along with video and installation art, continued apace.

If my sketch insists upon painting's marginality in the 1990s, so much the better, for it is only through recognition that painting's being wielded critically was an improbable achievement that such work becomes all the more meaningful: take Glenn Ligon's walls of dark, glittering words (culled from influential texts on blackness) effacing themselves in the process of their articulation [plate 5], or Ellen Gallagher's gorgeous and ultimately coy pink pages of penmanship paper, as though blushing at the obscenities marring their rosy surfaces [plate 26]. For identity politics, as staged in the polemical 1993 Whitney Biennial and furthered with the November 1994 opening of Thelma Golden's *Black Male: Representations of Masculinity in Contemporary American Art*, also at the Whitney Museum of American Art, New York, did not preclude the possibility of painting being apposite to concerns of race, gender, sexuality, or class, but neither did they solicit its use. Painting was feared to be a dumb, decorative artifact, the use of which might contravene, dilute, or negate oppositional content. Despite this, some vital critiques came from within painting—to be sure, were made possible by painting as a medium rendered newly operational precisely through its abandonment elsewhere.

One case in point is Byron Kim. He gained notice in the 1993 Biennial for *Synecdoche* (1991–), a project comprising a grid of hundreds of monochromes, which appear as the direct descendants of any number of Modernist exemplars [plate 10]. Their morphology immediately recalls Mark Rothko or Ad Reinhardt, and he shares those artists' tendency toward repetition, which paradoxically shows that individual manifestations of a single design are not equivalent or self-same; similarities in scale, composition, and foundational conceit invite viewers to track subtle distinctions among the works. In sharp counterpoint, however, Kim assumes this formal legacy as a container for meaning. Kim ties each painting to a specific sitter; each individual panel is an abstract portrait, which faithfully corresponds to the sitter's skin tone. Instead of shunning abstract painting, Kim instead has insisted on the possibility of employing it as a vehicle for individual signification and social content.

Identity as such became further radicalized later in the decade as these distinctly local concerns (that is, local to American artists grappling with politics on a national scale) were, so to speak, interrupted by or made differently pressing in the context of a wider world. Beyond the obvious physical movement of individuals noted above through dislocation, willed or otherwise (travel to biennials or movement athwart borders, respectively), trends included the intersection of traditional forms of artistic practice

with a kind of contemporary international style suited to the passage of objects across cultural lines. Shahzia Sikander came to represent the mobility and adaptability of technique as indexes of other kinds of translations beget by forces of globalization. The stylized, highly technical Indian and Persian miniature painting that informed her studies at the National College of Art in Lahore, Pakistan, are foundational to her subsequent work, which additionally juxtaposes Hindu and Muslim iconography, and has included performances predicated upon cultural dislocation and stereotypes [plates 44–46].

As Sikander's work evidences in its jewel-tone palettes and densely patterned, exquisite surfaces, visual pleasure need not be—is not inherently—anathema to seriousness. So, too, do Julie Mehretu's formally astute, decoratively layered paintings of mass witnessing and exploding cities bear witness to the tension that this coupling can produce [plates 62–63]. It must be noted in counterpoint though that Dave Hickey's publication of *The Invisible Dragon: Four Essays on Beauty* in 1993 announced a mode of permissiveness that attended the reclamation of beautiful painting in the United States.[8] In the wake of funding cuts from the National Endowment for the Arts, Hickey was writing to champion the work of Robert Mapplethorpe, whose photographs of men engaged in explicit sexual acts had triggered national congressional debate about censorship, the public uses of art, and its state funding. He argued that for Senator Jesse Helms and the others who flogged Mapplethorpe (and rendered him metonymic of a sick social body), the problem was not *what* the pictures showed but that Mapplethorpe had made them beautiful. Elsewhere in the text, Hickey recuperates beauty and pleasure more broadly, and in this and his curatorial work he sought to redeem beauty as a functional category. Despite the impassioned rhetoric, his belletristic writing and populist positions regarding the nature of art led many to condemn his appeal to aesthetics as conciliatory and his attempt to replace abjection with something more palatable as market-driven affirmation.[9]

Hickey's writing nonetheless presaged, or made possible, a range of other examples, in sympathy if not kind, regarding the salutary nature of aesthetics, and beauty more specifically: philosophers (Arthur Danto and Elaine Scarry); critics (Peter Schjeldahl and Jeremy Gilbert-Rolfe); and artists (Ann Hamilton and Jim Hodges). The list goes on. And it grew by decade's end. To take one case: Karen Kilimnik moved from the deconstructed, floor-bound scatter pieces for which she first became known to full mise-en-scènes in which she builds out room-sized fantasies to situate her loosely rendered, lushly insouciant paintings [plates 37–39]. They

8. Dave Hickey, *The Invisible Dragon: Four Essays on Beauty* (Los Angeles: Art Issues Press, 1993).

9. See my "Beauty and the Status of Contemporary Criticism," *October* 104 (Spring 2003): 115–30.

trade on clichés of refinement and visual consumption of some-
thing pleasurable, even as they cloy. Yet it was Elizabeth Peyton
who created images so appealing in their self-reflexive affection
for their subjects that she was credited with nearly single-handedly
reviving portraiture in the 1990s. Peyton's thinly washed, color sat-
urated, small-scaled paintings, drawings, watercolors, and prints

Figure 2
JOHN CURRIN
The Cripple 1997
Oil on canvas
44 × 36 in. (111.8 × 91.4 cm)

of friends, artists, musicians, and other cul-
tural figures, both historical and contem-
porary, are often sourced from the mass
media. They tend to chronicle moments
of vulnerability in their subjects, includ-
ing cultural icons such as Kurt Cobain
[plate 36], paying attention to minute
details of desire and imbuing the portraits
with a sense of passionate immediacy.

Where Peyton signaled a more top-
ical repossession of portraiture, others
like Nicole Eisenman and Sue Williams
retained a more seditious edge—a feminist
agenda whose necessity was impelled by
the boys' club ethos of Neo-Expressionism
and confirmed by the ascendancy of John
Currin. Currin rose to prominence with
anodyne yearbook-style mugs that double
as veiled self-portraits, sick girls languish-
ing in bed, women with water-balloon
breasts barely contained by tight sweaters
posing with or without significantly older
male companions [figure 2]. From the out-
set—a 1992 show elicited a *Village Voice*
review to boycott it on account of its sex-
ism—his paintings raised objections that
were partly quelled by Currin's technical facility, his expertise in
rendering compositions, modeling forms, building up glazes, or
varnishing a surface (which is to say, recourse to aesthetics). He
put this painterly mastery to use for outré subjects, flaunting the
juxtaposition of images taken from pin-ups, mid-century films,
stock-photo catalogs, and Internet porn, with rather more august
art-historical bedfellows: Old Master and mannerist works were
of particular import, but so were Gustave Courbet and Norman
Rockwell, among countless others.[10] Adding to the growing myth
of the artist, in 1997 Currin married sculptor Rachel Feinstein, a
dead ringer for the women he had been painting before he met her.

10. See Kim Levin's reassessment of her initial cry for boy-
cotting the show: Kim Levin, "Agent Provocateur," *Village
Voice*, November 25, 2003, http://www.villagevoice.com/
2003-11-25/art/agent-provocateur/.

It is easy to bracket Currin—he is not in this show, for one—
as an outlier, irrespective of his incredible power on the market.
(That said, he is often lumped together with his former classmate
and peer, Lisa Yuskavage, who was similarly invested in upholding
painting as a site of performed expertise, where doe-eyed nudes
with swollen breasts and abdomens populate chintzy interiors
or quixotically theatrical landscapes to queasily canny effect.)
Nevertheless, Currin's adaptation of media sources carries forth
appropriation activities from the 1980s, if here under a very dif-
ferent political sign. Perhaps following David Salle, who posited
this in the 1980s, and Peyton, his own contemporary, Currin sug-
gests that appropriation had by the late 1990s become an activity
proper to painting, while heralding the mobility of images of art
and their history that have hastened since the turn of the century.
Indeed, if in the 1990s painting and works using images from the
Internet—much less digital art—were still totally separate realms,
by the early 2000s this was no longer the case.

The Internet, far from ensuring painting's proverbial demise,
has instead provided the medium with a seemingly limitless array
of source material. It has also served to re-motivate painting and
claim for it priority as a theoretical object again, a conceptual
format through which ideas might be generated and moved. The
latter transformation is exemplified by Seth Price, who visualizes
the circulation of art in networks of things, pictures, and ideas
through institutional and commercial spaces by redistributing
pirated materials such as music and published texts and the cir-
culation of archival footage and data culled from the Internet. This
path furthermore involves conversion by and through other media,
notably the compression of electronic files—the digital products
that spread through media-sharing and social-networking sites. In
Dispersion, a seminal manifesto drafted in 2001–2 for the catalogue
of the Ljubljana Biennial of Graphic Art, and later published as
an artist's book illustrated with clip art as well as posted online,
where it may be freely downloaded, Price discusses the circulation
of art by technologies and channels of information dissemination.[11]
It is exactly these processes that have influenced painting since,
for painting is not immune to such conditions, nor does it seem
to wish to be.

11. Seth Price's text is available online at http://www
.distributedhistory.com/Dispersion2008.pdf.

AS THE WORLD TURNS IN 1990s' AMER- ICA

JOAN KEE

1. The phrase "global turn" was increasingly used from the 1970s to denote the expansion of multinational corporations as well as growing anti-American sentiment worldwide. Its use exploded in the 1990s as a large number of social scientists—political scientists and theorists in particular—used it to describe major shifts in world politics (such as the end of the Cold War) as well as in economic policy. See, for example, Hans Belting, "Contemporary Art as Global Art: A Critical Estimate," *The Global Art World, Audiences, Markets and Museums* (Ostfildern, Germany: Hatje Cantz, 2009), 38–73. Others imply that the "global turn" in contemporary art should be seen as part of a larger intellectual project based on the systematic refusal of universalist and cultural relativist attitudes. Among the first to track this was Bram Gieben and Stuart Hall, eds., *Formations of Modernity* (Cambridge, UK: Polity Press, 1992).

Perhaps the greatest achievement of the so-called global turn[1] is the frequency with which we now think it important, even mandatory, to consider art from the viewpoints of those living and working in the international art world's supposed peripheries. The symptoms are everywhere: the proliferation of large-scale biennials, greater representation of artists in Western institutions, and the critical mass of artists moving across national boundaries at an accelerated rate. Among the most significant if underestimated of these, however, was the dramatically increased visibility of artists of Asian ethnic and national origin in the United States during the 1990s, including Byron Kim, Xu Bing, Nikki S. Lee, Paul Pfeiffer, and Shahzia Sikander. The frequency of their movements between continents, nations, and categories exemplified the heightened sense of scale that helped flush into circulation the very idea of being "global."

In many cases, such movement was rooted in larger social, economic, and political concerns including the Tiananmen Square protests of 1989—which indirectly led to the expatriation of numerous Chinese artists, particularly to New York and Paris—as well as the economic liberalization of South Korea and Taiwan. Not only did the latter make it possible for an unprecedented number of artists to move overseas, it also helped define new artistic infrastructures such as the establishment of the Gwangju Biennale in southwestern Korea in 1995. The magnitude of migration compelled United States institutions into broadening their own scopes, as demonstrated, for example, by the decision of New York's Queens Museum of Art to host *Across the Pacific*, an exhibition of Korean and Korean American artists in 1993. The main thread linking the selected artists was their connection with their nation of ethnic origin, however abstract or tenuous that connection might actually be. The commercial and critical success of Asian-born artists in the United States, together with the growing economic clout of certain Asian countries, enabled the emergence of a distinct contemporary Asian art field and the rescaling of American art's boundaries. The Whitney Museum exemplified the latter with its decision to send its controversial 1993 biennial to the National Museum of Contemporary Art in Korea and its organization of *The American Effect*, the 2002 exhibition that marked the first time the museum featured works done mostly outside the United States by non-U.S. artists.[2]

Globalism's symptoms were also those of a deeper contest. The presumptive rise of contemporary Asian art in the United States in the 1990s reflected and supplanted shifting attitudes regarding

globalism and multiculturalism are concepts that make sense only when this distinction between what the image represents and how it is relayed is collapsed so that form is subjected to the demands of representation. In his digital manipulations lurks a call for viewers to admit the futility of trying to fix our position to any one standard, whether it is a specific center or the more general idea of movement across places. And the challenge remains as to whether it is possible to embrace the status of being a misfit, to recognize positions as defined by the system of overlapping scales to which we assign the name "world" as a matter of convenience.

THE COMMUNICATION

ANXIETY AND IDENTITY IN 1990s' NET ART

KRIS PAULSEN

1. Jon Ippolito, "Ten Myths of Internet Art" *Leonardo* 35, (2002): 485–86.

2. The WWW is a "public" space on the Internet. It is public in the sense that anyone with a connection can gain access. The Internet was "publically" owned by the United States government until 1994–95, when it was privatized. It was not, and is not, entirely publically accessible. It consists of numerous private networks controlled by the military, research centers, and corporations. Wendy Hui Kyong Chun, *Control and Freedom* (Cambridge: The MIT Press, 2006), 38.

3. Tim Berners-Lee and Robert Cailliau, "World Wide Web: Proposal for a HyperText Project," November 12, 1990. Archived e-mail document, http://www.w3.org /Proposal.html.

4. Ibid.

In the mid-1990s, Internet art was just emerging on the fringes of contemporary art practice, and it was still rare to encounter it in the museum or gallery. One was quite likely, however, to encounter it when online. In 1995, net art constituted a significant portion of the World Wide Web (WWW). It occupied 8 percent of the web, and artists were actively using other online channels, such as e-mail, instant messaging, video conferencing, MP3s, and software to make and circulate art.[1] The World Wide Web had come into existence just a few years earlier in 1991, when Tim Berners-Lee used his newly developed application protocol, Hypertext Transfer Protocol (HTTP), and computer language, Hypertext Markup Language (HTML), to carve out a publically accessible section of the rapidly expanding "network of networks," the Internet.[2] When he developed the web, he envisioned it as a means of delivering information, "such as reports, notes, data-bases, computer documentation and on-line systems help," to Internet users through a series of linked documents that would be easy to navigate, eliminating "waste of time, frustration, and obsolete answers in simple data lookup."[3] It would "provide a common (simple) protocol for requesting human readable information stored at a remote system using networks" so that a user could "follow links pointing from one piece of information to another one."[4] But net-art websites did not merely present art or information about art via the Internet; they used the new medium to create works of art that critiqued and complicated the user's relationship to the technology and the easy flow of information. Online artists exploited the public's lack of experience with the web to make intentionally confusing sites that were not readily distinguished from typical, informational web pages, and that played upon general fears about false identities, the circulation of ill-founded information, and AIDS-era concerns about illness and viral contamination. Net artists short-circuited Berners-Lee's system by purposefully introducing frustration, disinformation, unreadability, and anxiety into the web.

By the mid-1990s, the web was rapidly becoming the primary way that individuals connected with institutions, corporations, and one another. These connections, however, were marked by ambiguity and risk. The distance and disembodiment of online interaction meant that users weren't always certain who the others out there actually were or what the consequences of their online actions would be. Sites were potentially dangerous, putting the user's machine in contact with malicious software and viruses, and one's online "friends" may have borne little resemblance to who they were "IRL" (In Real Life). As media theorist Wendy Chun describes it, the Internet was a "virtual nonplace" where "users

actions separated from their bodies, and in which local standards became impossible to determine. It thus freed users from their bodies and locations."[5]

Net art emerged in the midst of these anxious new encounters with digital technologies and mediated others. Online artists created sites aimed at disorienting and destabilizing the viewer by the adoption and *détournement* of familiar web genres and forms, appropriating corporate websites for the circulation of their work, or by reworking computer code. Like their counterparts in mainstream artistic practice, net artists took up the key themes of the 1990s evidenced elsewhere in *Come as You Are*: the fluidity of racial and sexual identity, the politics and erotics of globalized exchange, and the vulnerability of the individual to lurking threats of contamination and disease. Net artists, however, explored the specific ways in which networked telecommunications and digital technologies enabled and exacerbated these conditions.

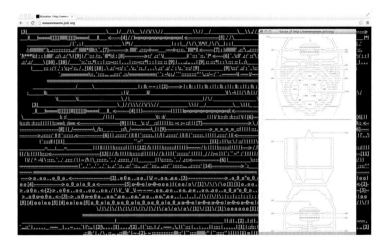

Figure 1
JODI
%Location 1995–98
wwwwwwwww.jodi.org
Website, display, and dimensions variable

TERMINAL CONDITIONS

First-generation net artists, such as JODI and Mark Napier, used the web to undermine the expectations of communication and functionality that Berners-Lee and others saw as its primary reason for being. In doing so, they not only exposed the essential, formal modernist conditions of the web as an artistic medium, but also highlighted the new users' fears of contagion, malfunction, and surveillance. JODI, a web collective composed of Joan Heemskerk and Dirk Paesmans, first appeared online in 1993. Their original site, later archived at wwwwwwwww.jodi.org in 1995, presents the user with a confounding vision [figure 1]. Neither image nor text, the homepage is filled with a jumbled sequence of punctuation and numerals that comprise a single neon green hyperlink on a black screen. The site seems to be in a state of disrepair, the

5. Chun, 38.

effect cryptic and sinister, calling up associations with the Internet's early identity as a military tool. If the user clicks on the link, she comes to a series of ominous images—a roughly drawn aerial map of New York and New England marked with text links such as "target=," "SURGERY," and "BETALAB." The links lead the user on a frustrating *dérive* through looped video-game screens, inscrutable diagrams, glitchy and discombobulated interfaces, and colorful frozen static. Each click of the mouse instills in the user the worry that the website is not broken, but rather that the machine may have been corrupted by contact with the suspicious site. Or, worse, she imagines that she may be unintentionally war gaming with her random clicking, having real effects somewhere far away. Rather than being in control of the online experience, JODI reveals the user as a novice consumer, unaware of the workings of the web and lost in the system that she believes she is "navigating."

The unsettling effects of wwwwwwwww.jodi.org are intentional. Anyone who knows how code generates web pages can peek at the source files for the confusing site and see what is actually happening. JODI purposefully misused HTML scripts to generate the inscrutable website. Rather than writing actionable lines of code, they arranged ASCII characters into a diagram of a nuclear bomb. Just as the user cannot read the abstract glyph on the home page, the computer cannot read the image hiding in the code. The artists transpose the human-readable and machine-readable domains, and the informational structure of Berners-Lee's web is hijacked for abstraction.

Garbage In, Garbage Out

Wwwwwwwww.jodi.org works on the basic computer science principle of "garbage in, garbage out." That is, computers will execute all instructions given to them, regardless of whether the code is full of errors, or in JODI's case, illogical. For *Untitled-Game (A-X, Q-L, Arena, Ctrl-Space)* (1998–2002), JODI reworked the code of the popular online game *Quake* [plate 56]. The artwork is available as a series of downloadable game "mods," software packages that modify the structure of the original game. JODI exploited glitches in the code of the hyperrealistic "first-person shooter" to transform it into an abstract, and often psychedelic, but still "playable" game. *Quake*'s medieval mazes and lush landscapes become stark, modernist environments, disorienting psychedelic spaces, or impassive, flashing Technicolor screens. The user's commands—shooting, navigating, and so on—still work, but now produce different effects. She might find herself trapped in a rapidly swirling universe of vector-graphic checkerboards, or spraying pixels rather than

artillery across the screen. In *Untitled-Game*, JODI "breaks" *Quake*'s code, but they do not produce "garbage." By manipulating the algorithms that generate the game, they unveil the abstract, Op-Art underpinnings of the hyperreal virtual world: the naturalism and "human readable" information of the virtual world is a fiction; all that exists are flashing bits of information and light.

Mark Napier, too, began using the web to make abstract, software-based net art in the mid-1990s. Rather than authoring specific net-art websites or modifying the code of online games as JODI did, Napier created a series of browsers that altered the appearance of the sites the user would normally visit, including *Shredder* (1998) and *Riot* (2000) [figure 2 and plate 64]. A web surfer can use these browsers just as she would any other: type in a URL or select a bookmark, and the browser will take her to the desired page. What she encounters there, however, is quite different. *Shredder* uses a Perl script to separate the constitutive elements of the web page into graphic, vertical strips. Like the analog office tool used to ensure informational obfuscation, Napier's virtual version shreds coherent messages into jumbled ribbons of data. *Riot* also disrupts the easy transmission of information over the web. Rather than muddling the content of a single page, *Riot* combines the graphic and textual elements of the sites that different users are simultaneously surfing into a single window. One user's pornography may be interlaced with another's news or e-mail; not-for-profit .orgs are muddied by the corporate concerns of .coms. The riot of information across the screen destabilizes not only the user's assumption that browsers should transparently display the informational content of the sites they access but also assumptions about property and privacy. *Riot* causes the discrete, individually held "domains" of the web to infiltrate one another and makes the private searches of individual users visible to the anonymous community of surfers. In doing so, Napier illustrates an untapped site of power and individual agency. His browsers allow him to wield artistic control over the entire web. Any website, no matter how carefully designed, falls into the service of Napier's modernist aesthetic of intersecting planes and collaged sources.

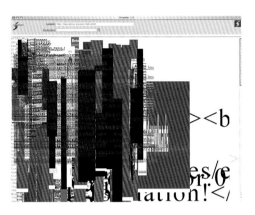

Figure 2
MARK NAPIER
Shredder 1998
http://www.potatoland.org/shredder
Website, display and dimensions variable

ETHEREAL IDENTITIES

Like JODI and Napier, Prema Murthy and Mendi + Keith Obadike experiment with the malleable nature of codes, exploiting the inherent gaps between input and output, identity and appearance. But rather than playing with the algorithmic underpinnings of computational systems, they deal with how the slippery signifiers of racial, ethnic, and sexual identity are mobilized in the immaterial,

online space of the Internet by appropriating common web forms, such as online pornography in Murthy's *Bindi Girl* (1999) [plate 57], or using corporate websites as the hosts for a parasitic project, as the Obadikes do with their eBay.com work, *Blackness for Sale* (2001) [plate 66]. Cultural theorists of the 1990s imagined cyberspace as an arena of interaction in which users could free themselves from the specificity of their physical bodies and create new online identities, generating a post-racial, post-gendered environment.[6] Disembodiment did not, however, produce an egalitarian system where race and gender no longer mattered. Rather, it pointed to how identity is performed online and off through the circulation of signs of race, ethnicity, gender, and class.

Murthy's multimedia online porn parody, *Bindi Girl*, uses the traditional Hindu bindi as a sign of desire and otherness that points to how race and ethnicity become commercial products in online pornography. *Bindi Girl* appeared on Thing.net early in June 1999. By clicking on a red bindi floating in the center of the home page's warning about explicit content, the user launches a multi-window site. One window presents a rapidly flashing series of appropriated pornographic photographs of South Asian women interspersed with broken lines of text from the *Kama Sutra*. In each image a bindi dot, or series of dots, obscures the nudity of the model. The viewer is left with only brief impressions of explicit imagery and spiritual texts, but her eyes are dazzled by the dots. The bindi comes to stand in for the Asian body, despite its total graphic abstraction and Murthy's careful use of it to frustrate erotic consumption. Bindi dots form the buttons on a remote that navigate the user to other areas of the site, including a "harem" of similarly bindi-obscured photographs, a comical online chat of failed "cybersex," a souvenir shop that peddles used socks and panties, and videos of live web performances Murthy put on during the original one-month run of the site, which are now available on a pay-per-view basis.

At each moment, Murthy presents her avatar, Bindi, and the other South Asian models on her website as simultaneously available and unattainable, real and virtual, idealized and tragically average. "Avatar," Murthy points out, has a specific meaning in Hindi: "[the] incarnation of a Hindu deity, [the] embodiment of an archetype." Murthy uses both Bindi and the bindi dot as avatars for the "goddess/whore archetype that has historically been used to simplify the identity of women and their roles of power in society."[7] Murthy's parodic pornography treats the bindi as a free-floating sign available for feminist reappropriation. The flashing bindi dots hover as afterimages in the user's vision, disrupting and censoring

6. For critical engagements with the disembodying effects of networked technology, see Scott Butkatman, *Terminal Identity: The Virtual Subject in Postmodern Science Fiction* (Durham, North Carolina: Duke University Press, 1993); Sadie Plant, "On the Matrix: Cyberfeminist Simulations (1996)" in *The Cybercultures Reader*, David Bell & Barbara M. Kennedy eds. (New York: Routledge, 2000); and N. Katherine Hayles, *How We Became Posthuman: Virtual Bodies in Cybernetics, Literature, and Informatics* (Chicago: University of Chicago Press, 1999).

7. Eric Baudelaire, "Bindi Girl—Interview with Prema Murthy," Rhizome.org, June 3, 1999. http://rhizome.org /discuss/28607/.

"live" for four days; since then, it has existed as an archived screen capture on the Obadikes' personal website. Finally, Tribe's *Traces of a Constructed City* has become as unnavigable as the city it documented. A description of the project resides on Tribe's web page and the photos are archived in a Flickr slideshow, but the original site and experience is lost.

These works may no longer exist in their original forms, and contemporary viewers may not be able to access or experience them in exactly the same way, but the critiques they offered of networked life are more pressing and prescient than ever. The fears and anxieties that the net artists explored have been actualized and have become commonplace: governments surreptitiously install software on the devices of unsuspecting users to monitor their information and connections; corporations track web searches and "crawl" e-mail to glean data about the user's identity so that it can target advertisements to each individual's specific identity-demographic; and users willingly make their private lives completely public, freely uploading intimate details about their lives to corporate websites, that then, in turn, sell that information to interested parties. The automated violation of users' privacy, clandestine operations of malicious software, and the unthinking construction of online avatars and identities that transform the facts of embodied existence into market research are accepted facts of contemporary life. The anxiety and disorientation the early net artworks created—and can still create—remind the user that while she may now be comfortable and confident navigating in cyberspace, the web is still full of traps; the net is still a snare.

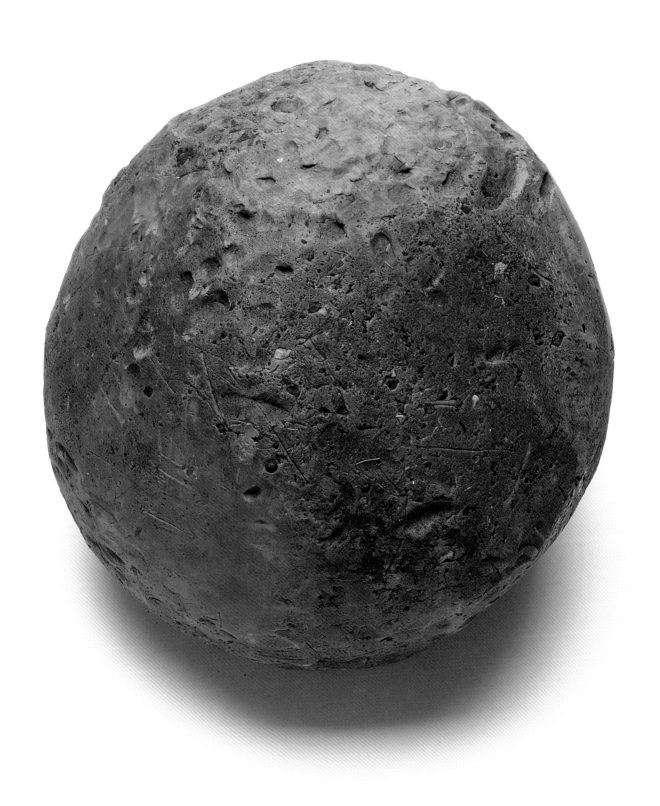

EVENT HORI-ZONS

GABRIEL OROZCO AND THE 1990s

PAULINA POBOCHA

In 1997, Gabriel Orozco exhibited *Black Kites* at Documenta X [figure 1]. The work is a human skull covered with a finely rendered checkerboard pattern hand-drawn in graphite. It took Orozco several months to complete, time provided by the artist's collapsed lung, which required a long and sedentary period of rehabilitation. This was an unusual situation for Orozco, whose career up to this point had been predicated on movement. Throughout the majority of the 1990s, he traveled frequently, making and exhibiting work in Mexico, the United States, and across Europe, complemented by intermittent trips to Asia and South America. Typically, Orozco brought very little with him—maybe a compass, a few pencils, and a notebook. He made sculptures primarily from materials found on-site. Often, the resulting work was emblematic of the location where it was conceived, constructed, and shown.

As an example, for his first solo exhibition in Paris in 1993, Orozco cut a classic Citroën DS into thirds, removed the center slice, and sutured the vehicle back together [figure 2]. While he has described this in physical terms as a process of "extraction and reconfiguration,"[1] it was also a highly deliberate and nuanced gesture that revealed a depth of inquiry into the local cultural context. The Citroën first entered the market in the 1950s, a time when France was still recovering from World War II, and its sleek aerodynamic design promised the future. The car invaded the popular imagination, as Roland Barthes described in a 1957 essay: "It is obvious that the new Citroën has fallen from the sky inasmuch as it appears at first sight as a superlative *object*. We must not forget that an object is the best messenger of a world above that of nature: one can easily see in an object at once a perfection and an absence of origin, a closure and a brilliance, a transformation of life into matter (matter is much more magical than life), and in a word a *silence* which belongs to the realm of fairy-tales."[2] Orozco titled his sculpture *La DS,* borrowing from the French the car's colloquial nickname, which phonetically doubles as *deése*, the word for goddess.

La DS could be called a site-specific sculpture, though that would require a slight adjustment to the term as it was defined in the 1970s. In that rubric, site-specific art was physically tied to the location in which it was made. Robert Smithson's *Spiral Jetty* (1970) on the Great Salt Lake and Michael Asher's *Installation* (1970) at Pomona College offer emblematic examples of works permanently wedded to their physical sites. Yet Orozco's *La DS*, though fully transportable, nonetheless engages the particular historical, cultural, and material context of where it was made, forging continuity between the work and this environment. In Orozco's practice, *La DS* offers one example of site-specificity, but there are many

1. Paulina Pobocha and Anne Byrd, "1993: First Was the Spitting," in *Gabriel Orozco*, ed. Ann Temkin (New York: The Museum of Modern Art, 2009), 86.

2. Roland Barthes, "The New Citroën," in *Mythologies*, trans. Annette Lavers (New York: Hill and Wang, 1972), 88.

Sculptures made in Rotterdam (*Four Bicycles [There is Always One Direction]*, 1994); Chicago (*Elevator*, 1994); Berlin (*Until You Find Another Yellow Schwalbe*, 1995); or Gwangju (*Light Signs [Korea]*, 1995) relate to their respective contexts, symbolically as well as materially.

During the 1990s many artists of Orozco's generation were on the move more often than not, a lifestyle enabled if not required by the concomitant growth of art fairs, emergent biennials, and the exhibition spaces cropping up in their vicinities. By the decade's end the art world, previously oriented around city centers—whether New York, Paris, London, or Cologne—had been greatly transformed, a condition satirized in 1999 by Maurizio Cattelan's Sixth Caribbean Biennial. For the project, Cattelan invited ten other artists to enjoy a one-week vacation on the island of St. Kitts. In addition to Orozco and Cattelan, the list of participants included Olafur Eliasson, Douglas Gordon, Mariko Mori, Chris Ofili, Elizabeth Peyton, Tobias Rehberger, Pipilotti Rist, Wolfgang Tilmans, and Rirkrit Tiravanija—artists whose rise to prominence coincided with this shifting cultural landscape. During the biennial, no art objects were exhibited. The artists instead did things anyone on a Caribbean vacation would—they swam, ate, danced, relaxed, and took some snapshots.

According to the biennial's catalogue, published more than one year later, the project reflected on the "tendency of today's art galleries to mutate into hangouts or headquarters. In the end all that this *Caribbean Biennial* is doing is presenting an intensified, encapsulated version of everyday life."[3] Tacitly, this statement acknowledges what Nicolas Bourriaud theorized in 1998 as "relational aesthetics." In the years since its initial publication, the critic's eponymously titled book has become a foundational text on the art of the 1990s, and the term has been adopted as shorthand to characterize a range of diverse artistic practices. Attempting to identify the transformations witnessed in art production, Bourriaud describes the emergence of a largely discursive practice engaged in proposing *or* representing models of sociability. "Art," he says, "is a state of encounter."[4] Sometimes that encounter was literalized in the form of a game, meeting, or meal in which the audience could also take part. This was the case with Tiravanija's landmark *untitled (free)* (1992), in which the artist reconfigured a

Figure 1

GABRIEL OROZCO

Black Kites 1997

Graphite on skull

8½ × 5 × 6¼ in. (21.6 × 12.7 × 15.9 cm)

Philadelphia Museum of Art; gift (by exchange) of Mr. and Mrs. James P. Magill, 1997

Figure 2

GABRIEL OROZCO

La DS 1993

Modified Citroën DS

55³⁄₁₆ × 189¹⁵⁄₁₆ × 45⁵⁄₁₆ in. (140.1 × 482.5 × 115.1 cm)

Fonds national d'art contemporain (Cnap), Ministère de la Culture et de la Communication, Paris

3. Jens Hoffman, Jenny Liu, Ann Magnuson et al., *6th Caribbean Biennial*, ed. Bettina Funcke (Paris: Les presses du réel/Janvier, 2001).

4. Nicolas Bourriaud, *Relational Aesthetics*, trans. Simon Pleasance, Fronza Woods, and Mathieu Copeland (Dijon, France: Les presses du réel, 2002), 18.

SoHo gallery—a commercial space typically reserved for the display and purchase of art—for the free distribution and consumption of food, specifically the artist's Thai curry. The work proposed to create a convivial atmosphere that encouraged lingering and conversation, thus acutely changing the social dynamics within the space.

Other times, the encounter was more oblique. An artwork, for instance, could point to or subtly reveal the social constructions shaping our everyday landscape. Orozco, Bourriaud writes, "is operating at the hub of 'social infra-thinness' (*l'inframince social*), that minute space of daily gestures determined by the superstructure made up of 'big' exchanges, and defined by it."[5] Among the works he cites is *Hammock Hanging Between Two Skyscrapers* created for the artist's 1993 *Project* exhibition at the Museum of Modern Art in New York. For the work, Orozco hung a cotton hammock from Mexico between two trees in the museum's sculpture garden. An object commonly found on a beach or in a backyard, the hammock was out of place in its new surroundings. It was antithetical to the context of the museum and to midtown Manhattan's fast-paced business economy. By inserting this object into an environment where it did not belong, Orozco heightened the viewers' awareness of physical spaces and social structures that are normally taken for granted despite their fundamental role in shaping day-to-day experience.

In Orozco's work, a dialectical relationship forms between the art object and its external environment. He has explored this contingency throughout his career and his works reflect on the condition both symbolically, within the realm of culture—as evidenced by *Hammock*—and physically, in material terms. For the 1993 exhibition *In Transit* at the New Museum of Contemporary Art in New York, Orozco exhibited *Yielding Stone (Piedra que cede)* (1992), a ball of plasticine equivalent in weight to the artist's body [plate 8]. After hammering the material together, he rolled the ball down Broadway where it became encrusted with debris. Because plasticine is an oil-based modeling clay that does not harden when exposed to air, the work continues to change its shape and composition, slouching under the weight of gravity and incorporating the dust and dirt that settle on its surface. "Every time you see it, it's going to be damaged, it's going to be fingerprinted, it's going to be different. It is a non-definitive proposition, the opposite of a static monument but sculpture as a body in motion," Orozco has said.[6]

Sculpture, for Orozco, is a site of exchange. This is evident across the range of his production since the 1990s. In this regard, photography deserves consideration. Orozco began taking photographs in

5. Ibid., 17.

6. Pobocha and Byrd, "1993: First Was the Spitting," 74.

1985, in the aftermath of the devastating earthquake that destroyed sections of Mexico City. The practice developed concurrent to his sculptural production and can be understood as an extension of it.

Orozco's photographs are modest in size, typically sixteen inches tall and twenty inches wide, and printed in color. With a few exceptions, human figures are absent from the frame. His are images of sculptural events. Often, they are preexisting situations encountered by the artist. *Pinched Ball (Pelota ponchada)* (1993), for instance, pictures a deflated soccer ball, located in the center of the composition, sitting atop a surface of asphalt [plate 9]. The ball's concave, collapsing body serves as a vessel for a puddle of water, which in turn reflects the light of the sky. Within the photograph, these components are stacked like nesting dolls, heightening their implied tactility—the immaterial effects of light are contained by the liquid surface of the puddle whose amoebic shape amplifies the pliancy of the rubber thus strengthening the contrast between the ball and the rigid ground on which it sits. Other times, Orozco's photographs capture the artist's interventions into his environment. *Island Within an Island* (1993) is among the best-known works of this kind. It pictures a swath of land on Manhattan's west side conspicuously free of people. The World Trade Center towers dominate the skyline visible in the background of this south-facing view. In the foreground, a miniature approximation of the skyline built from scavenged wood and various debris leans against a concrete barrier. Orozco's fugitive sculptural tableau persists only through the photographic image, and it is only the photographic image that stages a foreground and a background to create the central drama of the composition—and, in effect, the sculptural event. "I wanted to construct a self-sustaining image that generates meaning by itself and is not a mere anecdote of the action," Orozco has said.[7]

The interdependence of sculpture and photography in Orozco's practice is most evident in works that slide from one medium to the other. Take, for instance, *My Hands Are My Heart* (1991), a small, lumpy mass of fired clay the artist formed by squeezing the material in the palms of his hands until it loosely resembled a human heart [plate 7]. It is an imprint, *par excellence. My Hands Are My Heart* also exists as a pair of photographs. Each image shows the artist holding the sculpture in front of his bare torso. In one, his fingers fold tightly around the object and in the other, he gently cradles it with open palms in a gesture of offering. Taken together, the images illustrate the basic procedure with which the object was made. In both photos, the figure is spotlit from above. Raking light accentuates Orozco's thin frame, creating deep shadows beneath

7. Paulina Pobocha and Anne Byrd, "1981–1991: Early Years," in *Gabriel Orozco*, ed. Ann Temkin (New York: The Museum of Modern Art, 2009), 58.

his collarbone, emphasizing the sinewy muscles of his arms, and bringing the bones of his rib cage into low relief. Positioned against the center of his chest, the sculpture of the heart now doubles as a sternum, a resemblance heightened by the chromatic similarity of the terra-cotta and Orozco's dimly lit body. The photographs, unlike the sculpture, evoke the art-historical tradition of Christian devotional imagery, particularly that of the sacred heart of Christ, which also proliferates in Mexican folk art.

Writing broadly about Orozco's work, James Meyer states that it "thematizes a peripatetic existence in staged poetical figurations of transience."[8] *Yielding Stone*, perhaps more than any other sculpture by Orozco, can be read following this principle, especially if it is read as a self-portrait. Meyer's assessment, however, neglects the critical dimensions of Orozco's project. This is an argument put forward in the art historian's 1997 essay titled "Nomads," which addressed the rise of the "artist-traveler" in the 1990s. Elaborating on the phenomenon, Meyer situates it as the by-product of a newly globalized world. "It is hardly surprising," he writes, "that this culture of itinerancy has influenced the terms of production itself."[9] Leaving aside the primitive and mystical associations the word "nomad" connotes, it relegates the artist to the permanent condition of outsider. Meyer's essay appeared in *Parkett* one month before *Black Kites* debuted at Documenta X. The issues it raises are central to a consideration of *Black Kites,* specifically, and Orozco's practice, at large.

Orozco made *Black Kites* in his apartment near Washington Square Park in New York, where he had lived intermittently since 1992. Work began in the winter of 1996. For a few hundred dollars, he purchased a human skull a few blocks away at the Evolution Store in SoHo and spent the next several months studying the object and mapping its contours with a densely rendered graphite grid. In order to accommodate the complex topography of the skull, the grid, which appears on the crown as a remarkably precise black-and-white checkerboard pattern, had to bend and stretch out of shape. Under these circumstances, geometric regularity became impossible to maintain and the grid disintegrated under the weight of its own logic.

Since the Renaissance, grids have been used to impose order on nature, allowing an artist to create illusionistic representations of three-dimensional space on a two-dimensional plane, free from the contingencies of embodied sight. Albrecht Dürer's famous woodblock print from the early sixteenth century—of a man drawing a reclining woman with the help of a grid—illustrates the process. Looking through the grid aids the artist's translation of the

8. James Meyer, "Nomads," *Parkett* 49 (May 1997): 207.

9. Ibid., 205.

volumes of the female body into lines on a page. In this scenario, the body conforms to the grid. As Rosalind Krauss has pointed out, the dominance of the grid reaches its apotheosis in the twentieth century when modern artists boldly foreground the grid and celebrate its synthetic properties. "The grid," Krauss writes, "is a way of abrogating the claims of natural objects to have an order particular to themselves; the relationships in the aesthetic field are shown by the grid to be a world apart and, with respect to natural objects, to be both prior and final. The grid declares the space of art to be at once autonomous and autotelic."[10] *Black Kites* emphatically denies the grid its primacy. In this work, the "natural object" that the grid was designed to contain, deforms it instead. For a moment, one symbol of human intelligence (skull) triumphs over another (grid), though the inverse is also true—the grid after all envelops the skull.

Orozco made *Black Kites* specifically for Documenta X, the international contemporary-art exhibition that takes place every five years in Kassel, Germany. Organized by Catherine David, the 1997 iteration placed an emphasis on the political potential of art. Orozco, familiar with the format, anticipated the show to feature many multi-part installations and large-scale environments. In this context, he wanted *Black Kites* to function as a "black hole."[11] Approximately eight and a half inches tall, the work is intimate in scale. The skull's broken teeth, jagged cranial plates, and weathered surfaces are a visceral reminder that the work's significance stems as much from its physical reality as from its symbolic implications. This blunt presentation of human remains simultaneously calls to mind the artistic tradition of the *memento mori* and more broadly, a centuries-old cult of the dead manifest in both medieval Christian reliquaries as well as contemporary Tomb of the Unknown Soldier monuments, found in dozens of countries around the world.[12] The realness of the skull was critically important to Orozco who, throughout the drawing process, engaged in what he has described as "dialogue with a dead body."[13] The intensity of the drawing had to equal that of its support. In *Black Kites*, labor, skill, and time are inscribed in graphite onto the work's surface.

It is worth noting—as Benjamin Buchloh, one of the artist's most astute critics has—that Orozco uses the bone as a ready-made and alters it through the addition of drawing, which in this case is a graphic, visually seductive abstraction.[14] The Belgian artist Marcel Broodthaers relied on a similar technique to make *Fémur d'homme belge* (1964–65) and *Fémur de la femme française* (1965). Both works feature a human femur bone. *Fémur d'homme belge* is painted the colors of the Belgian flag—black, yellow, and red—and *Fémur de la femme française* the blue, white, and red of the French

10. Rosalind Krauss, "Grids," *October* 9 (Summer 1979): 50–52.

11. Gabriel Orozco, interview with Paulina Pobocha, unpublished manuscript, New York, November 2013.

12. For an in-depth study see Laura Wittman, *The Tomb of the Unknown Soldier, Modern Mourning, and the Reinvention of the Mystical Body* (Toronto: University of Toronto Press, 2011).

13. Ibid.

14. Benjamin H. D. Buchloh, "Benjamin Buchloh Interviews Gabriel Orozco in New York," in *Gabriel Orozco: Clinton Is Innocent* (Paris: Musée d'Art Moderne de la Ville de Paris, 1998), 99, 103.

flag. Broodthaers, who throughout his career interrogated expressions of national identity, cannily satirizes the essentializing drive to stabilize individual identity within the parameters of the nation-state, signified here by the Belgian and French tricolors.[15] By contrast, Orozco's skull can be understood as an object without origin. Lacking known provenance, it could have come from anywhere, an ambiguity heightened by the artist's recourse to abstraction. Nevertheless, this object cannot exist apart from broader cultural and historical considerations; of this Orozco is well aware. After all, the skull is the ultimate stereotype of Mexican identity, its iconography descendant from Mesoamerican cultures and persistent in the popular arts today—a visual tradition rich enough to absorb elaborately decorated Aztec skulls, José Guadalupe Posada's barbed political cartoons, and cheap souvenirs sold street-side in tourist destinations across the country.[16]

Discussing Orozco's selection of a clichéd emblem of Mexicanness, Buchloh persuasively argues that "Orozco's return to one of the 'foundational' icons of his national identity establishes the full scope of the contradictions that the formation of any identity innately demands, including the confrontation with the systems of unconscious determination and control, and schemes of political, ideological, and economic interest disguised as the 'natural' foundations of subjectivity."[17] *Black Kites* exploits external cultural symbols in an effort to expose and destabilize them. "The skull must not be interpreted as an identification or a refus[al] of Mexican culture," Orozco said. "Probably it's both, and that's what makes it so strange."[18] *Black Kites* brings antithetical concepts into close and uncomfortable contact: the black graphite against white bone, two-dimensional pattern and three-dimensional volume, rigid geometry and abject materiality, rational thought and spiritual mysticism, particular national identities and humanness in the broadest sense. Orozco makes no attempt to reconcile these terms; doing so would dislodge the work from a matrix of contingency where meaning is continuously formed and from which the work draws its power. As provocative as it is profound, *Black Kites* brings into focus a strategy central to Orozco's practice. Drawn from the world and situated within it, Orozco's sculptures, tied at once to historical and material circumstance, demonstrate the slippery and precarious means by which meaning is produced in a culture increasingly characterized as "global." Articulating this premise most fully, *Black Kites* is a defining work of the 1990s.

15. Rachel Haidu, *The Absence of Work: Marcel Broodthaers, 1964–1976* (Cambridge, Mass.: The MIT Press, 2010), 1–45.

16. Edward Sullivan, *The Language of Objects in the Art of the Americas* (New Haven: Yale University Press, 2007), 265–70.

17. Benjamin H. D. Buchloh, "Sculpture between Nation-State and Global Commodity Production," in *Gabriel Orozco*, ed. Ann Temkin (New York: The Museum of Modern Art, 2009), 42.

18. Gabriel Orozco, "Benjamin Buchloh Interviews Gabriel Orozco in New York," 95.

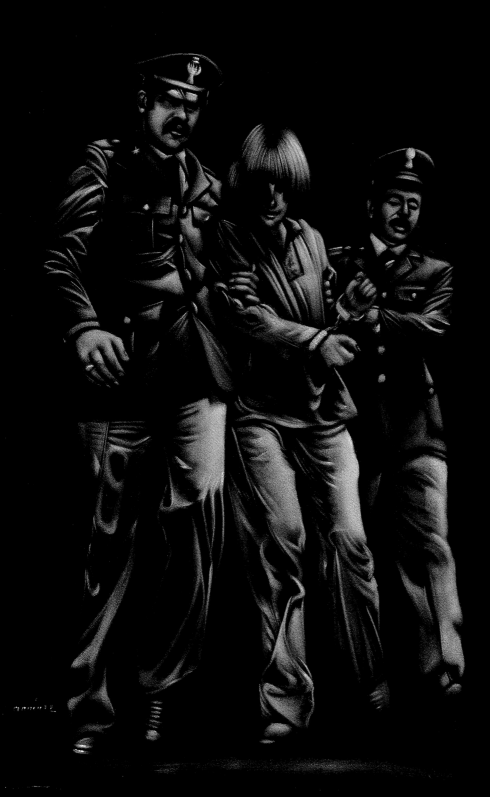

A PLACE TO CALL HOME

ARTISTS IN AND OUT OF LOS ANGELES, 1989–2001

JOHN TAIN

Let's get one thing out of the way right away: despite its title, the exhibition *Helter Skelter: L.A. Art in the 1990s* was not about art of that decade.[1] While most of the work in the show—on view at the Museum of Contemporary Art, Los Angeles (MOCA), from January through April 1992—does date to the early nineties, almost all of the featured artists had made their reputations in the eighties (e.g., Charles Ray, Mike Kelley, Raymond Pettibon, Lari Pittman), if not before (Chris Burden, Richard Jackson, Llyn Foulkes). In other words, given its occurrence early in the decade and its roster of mostly mid-career artists, *Helter Skelter* might be more accurately considered a summation of art of the 1980s.[2] If it continues to serve as a reference in discussions of art from the 1990s, however, it is partly because the exhibition, curated by Paul Schimmel, fundamentally shifted perceptions of art in Los Angeles by dislodging long-held clichés of "Finish Fetish" and "Light and Space," which had been lingering since the 1960s to describe, and sometimes to dismiss, art made in Southern California.[3] In their place, *Helter Skelter* presented a history that emphasized a dystopian and edgy undercurrent.[4] Perhaps most importantly, Schimmel's counter narrative definitively put the city on the art world map, making good on its promise that "'regional' art need not bear the burden of provincialism" by catapulting its sixteen artists to newfound visibility.[5] None, with the possible exception of Burden, had been anywhere as well known on a national or international level before the exhibition as after it.[6] At the same time, the discrepancy between their local prominence and their stature outside the region helps explain their belated reception in the nineties as "new artists": for all intents and purposes they *were* new, at least to this wider audience.

But while *Helter Skelter* did much to alter the perception of L.A. artists and to close the reception gap, its bad-boy vision of art did not prove particularly pertinent to what *would* eventually emerge as "L.A. art in the 1990s." Its references to noir and Charles Manson certainly bear little relation to Laura Owens's work, which helped define painting in Southern California in this period, and in which seeming whimsy often belies a tour-de-force demonstration of technical virtuosity, as is the case with *Untitled* (1995) [plate 35].[7] Indeed, what is notable is how little *Helter Skelter's* framework applies to the artists of this generation, whose diversity of approaches and attitudes resist easy pigeonholing. This is not to say their work entirely escapes categorization. Overall, there is a notable disregard for the trappings of traditional fine art in favor of everyday materials and subject matters. Thus, Glenn Kaino's *The Siege Perilous* (2002) makes its point by placing an Aeron chair, one

1. Paul Schimmel, *Helter Skelter: L.A. Art in the 1990s* (Los Angeles: Museum of Contemporary Art, 1992).

2. Thus, only one of the artists included in *Helter Skelter*, Manuel Ocampo, is also included in *Come as You Are*.

3. During the late 1960s, the terms "Finish-Fetish" and "Light-and-Space" were used to describe work created in Southern California that dealt with the region's culture and environment, and which utilized high-tech materials, such as plastic, resin, and glass. Among Finish-Fetish artists, Billy Al Bengston, John McCracken, and Craig Kauffman were best known for creating painting and sculpture inspired by car and surf culture, in both materials and subject matter. Among Light-and-Space artists, James Turrell and Robert Irwin were best known for their large-scale installations using light as a medium.

4. The influence of *Helter Skelter* can be seen in *Sunshine and Noir: Art in L.A., 1960–1997* (1997), the traveling survey of Los Angeles artists mounted by the Louisiana Museum of Modern Art in Denmark, whose very title blends the two images of Southern California. See also *Red Eye: L.A. Artists from the Rubell Family Collection* (Miami: Rubell Family Collection, 2007), 12, 17.

5. Schimmel, 20.

of the most ubiquitous icons of the dot-com era, on a revolving platform so that its spinning silhouette evokes the apocryphal Holy Grail of Arthurian legend [plate 67]. Indeed common furniture becomes commonplace in the work of several artists of this period. Jennifer Pastor's *Untitled* (1992) takes the form of a retro-looking tray-table floor lamp [plate 12], while Jorge Pardo's *Vince Robbins* (1997) delivers color, not as painting, but through the glass shade of a hanging lamp [plate 49]. But this turn away from the traditions of high art was limited to neither artists of Los Angeles nor this period. Rather than grasp at generalizations or interpret L.A. art as expressions of some West Coast *Kunstwollen*,[8] it may be more productive to identify the concrete ways in which artists engaged with the shifts related to the international success that came after *Helter Skelter*. Indeed, as the city continued its entry into the global marketplace, their practices became increasingly concerned with place and community.

Historically, foremost among the region's artistic communities were the local educational institutions. For while there may not have been a "Los Angeles school" of art—no identifiable style or look—there were several schools that employed and taught artists, and that served as spaces for aesthetic experimentation and the formation of social circles. As with previous generations, a large number of the artists who came to prominence in this moment graduated from one of the area's art schools and university art departments.[9] (Continuing the tradition, many in turn became teachers themselves.) The California Institute of Arts (CalArts), the Art Center College of Design, and the art department at the University of California, Los Angeles (UCLA), in particular played central roles during this period, and it is no accident that they can claim almost all of the L.A. artists in *Come as You Are* as graduates.

All three faculties more or less formed their identities in the two decades leading up to the nineties. Opened in 1970, CalArts rapidly became the best known of the region's schools, thanks to its teachers—Michael Asher, Douglas Huebler, and John Baldessari chief among them—and its impressive alumni, which included Jack Goldstein, David Salle, Barbara Bloom, others of the so-called CalArts Mafia.[10] Meanwhile, the art department at UCLA began to shed its mid-century origins with the hiring of Chris Burden in 1978, followed by other notable arrivals, such as Charles Ray, Nancy Rubins, and Paul McCarthy. By 1997, the school had generated enough buzz that one critic observed that if "UCLA were a rock scene, it would be Seattle, right after [Nirvana's] *Nevermind* went platinum."[11] The MFA program at Art Center was the youngest of the three, formally beginning only in 1986. However, with Mike

6. The exhibition's immediate impact on Paul McCarthy is striking: from 1980 to 1992, he had had seven one-person exhibitions, only one of them outside Los Angeles (in Liège, Belgium, 1983). Following *Helter Skelter*, in 1993 alone, he had four: three in Europe and one in New York.

7. For a thorough account of Owens's methodical painting practice, see Russell Ferguson, "Laura Owens Paints a Picture," *Parkett* 65 (September 2002): 58–62.

8. Originated by the Viennese art historian Alois Riegl (1858–1905) and further developed by the German-American art historian Erwin Panofksy (1892–1968), the term *Kunstwollen*, roughly translated as "artistic will," could be defined as the force driving the evolution of style, determined by the sociohistorical context of a given artist or period.

9. On this point, see Terry Myers, "Art School Rules," *Sunshine and Noir: Art in L.A. 1960–1997* (Humlebaek, Denmark: Louisiana Museum of Modern Art, 1997), 200–207.

10. Richard Hertz, *Jack Goldstein and the CalArts Mafia* (Ojai, Calif.: Minneola Press, 2003). See also Douglas Eklund, *The Pictures Generation* (New York: Metropolitan Museum of Art, 2009); Ralph Rugoff, "Liberal Arts," *Vogue* (August 1989): 328–33, 373.

11. Dennis Cooper, "Too Cool for School," *Spin* (July 1997): 88.

Kelley, Stephen Prina, and Patti Podesta among its core faculty members, and Diana Thater, Sharon Lockhart, and Frances Stark its early graduates, it quickly rose to prominence. The three institutions' renown was such that articles on them began appearing in the pages of *Artforum*, the *New York Times*, and even popular magazines such as *Vogue* and *Spin*, which likened their diplomas to an MBA in their power to guarantee worldly success.[12]

Depictions in the popular media of the L.A. MFA as a red-hot commodity may have been exaggerated, but they did underscore the rise of a new market for local artists. Historically, art schools in Los Angeles had served as the centers of gravity for various communities of artists in the absence of a strong gallery system or collector base. That began to change in the 1980s with the spread of the growing art market to Southern California and the appearance of new dealers, including some from New York and Europe. While many of them closed shop with the 1989 recession and the subsequent collapse of the art bubble, the local economy regained enough strength by the middle of the following decade to support standouts such as Regen Projects and Blum and Poe, as well as the clusters of galleries at Bergamot Station (which opened in 1994) and Mid-Wilshire (1998). In order to feed the increased demand, gallerists took to recruiting students before they had even graduated. The schools did not lose their standing as a result, but did begin to function as gateways to the art market, rather than as alternatives to it. In this way, the rise of the gallery system threatened to render obsolete the traditional divide between the academy and the market.

In 1989, Douglas Huebler could already warn of the threat posed by dealers poaching at CalArts.[13] Within a few short years, artists graduating from MFA programs became fully immersed in the market's accelerated pace of reception. For example, a year after finishing at UCLA, Jennifer Pastor was included in the *Invitational '93* group show at Regen Projects. Visitors may or may not have understood the presentation in *Untitled* (1992) of two nests—one found and rather deflated-looking, the other an impressive man-made artifact of steel and resin—as a subtle meditation on nature versus culture, but they surely would have been struck by the consummate professionalism of the sculptural *trompe l'oeil*; perhaps too much so to suspect that it was the work of an artist fresh out of school. They probably would have been equally unaware that two of the other artists included in the exhibition, Toba Khedoori and Frances Stark, were still students (at UCLA and Art Center, respectively), and that the fourth, Catherine Opie, had received her MFA only a few years prior.

12. Ibid., 86–94; Andrew Hultkrans, "Surf and Turf," *Artforum* (Summer 1998): 134–46; Deborah Solomon, "How to Succeed in Art," *New York Times Sunday Magazine* (June 27, 1999): 38–41.

13. Rugoff, 373.

Nor were local dealers the only ones eager to attract newly minted L.A. artists to their stables. The fall after his graduation, Jason Rhoades held his first solo exhibition at the recently opened David Zwirner Gallery in New York. (Already, through his advisor Richard Jackson, Rhoades had been included in a group exhibition at the Rosamund Felsen Gallery in Los Angeles while still at UCLA.) *CHERRY Makita – Honest Engine Work*, the sprawling manic installation, of which *Red* (1993) formed a part, cemented his reputation and set him on the path to success [plate 14].[14] While Rhoades may be an extreme example of the success that younger artists achieved, he was far from alone. As one commentator noted, "Where once it took a promising artist a decade to make a dent in the gallery scene, students and recent grads now receive splashy introductions on both coasts, and even beyond."[15] Certainly, this was the experience of many of the L.A. artists included in *Come as You Are*.

Indeed, Los Angeles artists' expanding sphere of influence meant that, as often as not, they showed their work on the East Coast and beyond. Like Rhoades, Sharon Lockhart developed her career mostly elsewhere. One of her best-known works, the precisely staged *Untitled*, of 1996, debuted not at Blum and Poe, her L.A. dealers, but at the Petzel Gallery in New York, where it was shown in a one-person exhibition that same year [plate 40]. The piece was acquired by the Walker Art Center in Minneapolis for its permanent collection the very next year, and later, by the Metropolitan Museum of Art. Fellow Art Center alum Diana Thater similarly was not bound to California, producing several of her signature site-specific video installations in Europe, including *Ginger Kittens* (1994), for which she transformed Friesenwall 116a's storefront vitrine in Cologne into a kind of video lightbox for the sunflower-saturated imagery [plate 27]. Even L.A. artists who did not have the benefit of connections through school gained from the city's newfound popularity. Just a few years after his arrival in the city, and coming hot on the heels of his participation in *Helter Skelter*, Manuel Ocampo was selected for inclusion in *Documenta IX* in 1992, though his swastika-bearing canvases, such as *La Liberté*, ran afoul of German authorities.[16] And Daniel Joseph Martinez had four major projects outside Los Angeles in the year 1993 alone. For the Aperto section of the Venice Biennale, he produced *I couldn't remember if death or love was the solution to defeating the empire; One thought he was invincible, the other thought he could fly—superheroes, assassins and astrology, they all pray to the wrong god* (1993), a large-scale installation featuring video and grisaille paintings on black velvet that paired images of the arrest of Italian

14. Photographs and a short text on the installation can be found in Eva Meyer-Hermann, *Jason Rhoades: Volume, a Rhoades Referenz* (Cologne: Oktagon, 1998), 32–33, 39. See also Eva Meyer-Hermann, *Jason Rhoades* (Cologne: DuMont, 2009), 187–98.

15. Hultkrans, 146.

16. Ocampo's work was subsequently removed and hidden from view. See Michelle Quinn, "Works Pulled from German Exhibit," *Los Angeles Times* (June 15, 1998).

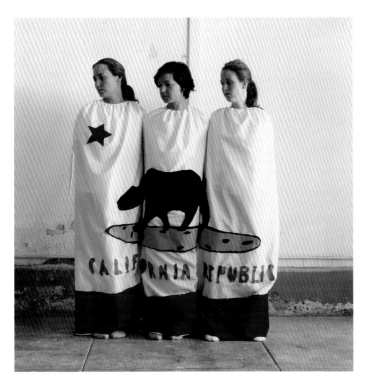

Figure 1

SHARON LOCKHART

Untitled 1997

Framed chromogenic print, edition of 6
48 × 48 in. (121.9 × 121.9 cm)
From the exhibition *Sharon Lockhart, Laura Owens,
and Frances Stark*, Blum & Poe, Los Angeles, June 7–
July 12, 1997

Red Brigade members with Situationist key-words [plates 15–18].[17] In short, L.A. artists became just as migratory as their peers from other rising art centers of the nineties, such as London and Berlin.

The impact of the globalized art market in the 1990s itself was the subject of another exhibition that took place at MOCA, also curated by Paul Schimmel. Coming almost a decade after *Helter Skelter*, *Public Offerings* (2001) presented twenty-four artists, six of them from Los Angeles, who were able to almost instantaneously establish enviably international careers right after graduation, and sometimes even before.[18] In his catalogue essay, Lane Relyea offered a skeptical assessment of the phenomenon, noting that the integration of schools and galleries took place as part of an overall "routinizing of the art system," which ends up subsuming all values to those of the market.[19] Within this system, Los Angeles existed less as a place in which artists lived and worked, and in which artworks bore specific meaning, than "a designation used in tandem with other place names by jet-setting collectors and curators trying to organize their expanding Rolodexes."[20]

According to Relyea, even as artists continued to produce work for exhibition in the white-cube network, they registered their own reservations and resistances to the "increasingly unified international art circuit," as when Sharon Lockhart, Laura Owens, and Frances Stark organized an exhibition at Blum and Poe in 1997 investigating "the nature of discourse and dialogue amongst friends, amongst artists," as a way of emphasizing the importance of the community they form for one another [figure 1].[21] The sense of community and place was strong indeed among artists in the city. The *Portraits* that Catherine Opie produced throughout the 1990s offer one vivid example of the way artistic work could and did emerge from very close ties to a community [plates 19–20]. Like Opie herself, many of her sitters belonged to the queer and fetish club scene in California, and it was often in venues like Club Fuck! and Sin-a-matic, and not in the art world, that Ron Athey, Vaginal Davis, and other queer performance artists produced their work.[22] Jorge Pardo's *4166 Sea View Lane* (1998), a house constructed in lieu of a show at MOCA, literally grounds itself in its neighborhood, serving simultaneously as exhibit and exhibition,

17. Daniel Joseph Martinez, telephone interview, October 14, 2013. My gratitude to Martinez for generously taking time to discuss his work and his practice.

18. Paul Schimmel, *Public Offerings* (Los Angeles: Museum of Contemporary Art, Los Angeles, 2001).

19. Lane Relyea, "L.A.-Based and Superstructure," *Public Offerings*, 248n20.

20. Ibid, 250.

21. Blum and Poe press release for the exhibition, quoted in Relyea, "L.A.-Based and Superstructure," 252. See also Lisa Anne Auerbach, "Sharon Lockhart, Laura Owens, and Frances Stark at Blum and Poe," *LA Weekly*, June 27, 1997. The exhibition, simply titled *Sharon Lockhart, Laura Owens, and Frances Stark*, ran from June 7 to July 12, 1997.

sculpture and architecture, but also as home and place for family and friends [figure 2].[23]

MOCA's support of Pardo's decidedly non-portable work of art underscores the divided role museums played in the globalization of the art world. In one sense, the inauguration of a museum offered civic leaders an easy way to signal a city's joining of the new world order. Los Angeles experienced its own boom, as evidenced by the Santa Monica Museum of Art (opened 1988), the Hammer Museum (1990), and the Getty Center (1997). If anything, the Museum of Contemporary Art (1983) set an early precedent for the phenomenon. As former MOCA curator Connie Butler points out, the transformation by Frank Gehry of a former vehicle depot into the Temporary Contemporary, as its original building in Little Tokyo was first called, provided a "generative example of adaptive reuse" for museums including DIA Beacon, Tate Modern, and Gehry's own Guggenheim Bilbao.[24] These new institutions in turn participated in the process of cultural homogenization—think only of how Bilbao led other cities to clamor for their own Richard Serras. But MOCA took a decidedly different approach in programming the Temporary Contemporary's forty-thousand square feet of exhibition space. It was there that the museum "built an international reputation" by staging a series of ambitious historical surveys examining the history of postwar art, "part of [whose] self-proclaimed mandate ha[d] been to ask the question about how and if California or Los Angeles figures into a given history."[25] Such a strategy acknowledged the global discourse on art, while at the same time providing historical context and memory through

Figure 2
JORGE PARDO
4166 Sea View Lane 1998

22. In an interview with Maura Reilly, Opie emphasized the centrality of community to all of her work. See Maura Reilly, "The Drive to Describe: An Interview with Catherine Opie," *Art Journal* 60 (Summer 2001): 82–95. For a discussion of performance in non-art settings, see for example Jennifer Doyle, "White Sex: Vaginal Davis Does Vanessa Beecroft," *Sex Objects: Art and the Dialectics of Desire* (Minneapolis: University of Minnesota Press, 2006), 121–40. As Renée Petropoulos pointed out in conversation, the concern with community also drove artistic activism over AIDS and feminist issues of the late eighties and early nineties.

23. Chris Kraus, "4166 Sea View Lane," *Jorge Pardo* (London: Phaidon, 2008), 104–15.

24. Connie Butler, "L.A., Now and Then," *Recent Pasts: Art in Southern California from the 90s to Now*, ed. John Welchman (Zurich: JRP Ringier, 2005), 34.

25. Ibid, 36.

26. Herbert Muschamp, "When Getting to It Is Part of a Museum's Aesthetic," *New York Times*, November 26, 2000.

27. On Lannan, see Eric Latzky, "Liberating Funds," *L.A. Style* (June 1990): 210–13.

28. Mel Gussow, "A White Knight from the Computer Kingdom Makes His Mark in Theater," *New York Times*, Aug. 19, 1999. Thanks also go to Kris Kuramitsu, curator and director of art programs for the Peter Norton Family Foundation from 2001 to 2006 for taking time to speak with me about the Foundation. Kris Kuramitsu, telephone interview, December 13, 2013.

29. Tom Rhoads, telephone interview, Nov. 16, 2013. Thanks to Tom Rhoads for sharing his expertise on the status of nonprofits in the period. For the Norton Family Foundation, as well as Peter and Eileen Norton, see Kris Kuramitsu, "Different ways to see the world," *Art On Paper* 8 (July/August 2004): 20–21; and BettiJane Levine "The 'Model-Millionaires,'" *Los Angeles Times*, June 12, 1994.

30. Bliss was founded in 1987 by the artists Kenneth Riddle, Gayle Barklie, and Jorge Pardo in Riddle's home in Pasadena, and worked primarily with artists connected to Art Center. Guest Room, opened by artists Russell Crotty and Laura Gruenther in 1991, was located in a spare bedroom. Robert Gunderman with Stephen Herzog and Leonard Bravo, opened Food House in 1992. Gunderman now runs ACME gallery with Randy Sommer. See Jan Tumlir, "Lessons of the Class of 90: Siting Recent Art in Los Angeles," *LA Artland* (London: Black Dog, 2005): 24–39. See also David Pagel, "Call to Arms, Arts," *Los Angeles Times*, January 22, 2006, in which Gunderman also notes the crucial support offered by the Nortons to small local galleries.

31. See Doug Harvey, "POST-Mortem, Popping Corn," *L.A. Weekly*, September 1, 2005; Paul Young, "Top Ten Galleries on the Edge," *Los Angeles Magazine* 42 (November 1997): 92–97, where POST is the only artist-run space mentioned.

which local differences could be understood. Such was the impact that one critic, writing in 2002, remarked that "[m]ore than any event in recent decades, the Temporary . . . changed the cultural face of Los Angeles."[26]

The city's philanthropic organizations also helped to bolster the art scene on a regional and national level. At a moment when artists and institutions were hard hit by cuts in government funding due to the Culture Wars of the late 1980s and early 1990s and by the recession of 1990–91, private foundations like the Lannan stepped in to fill the funding void, but also drew attention to the city as a cultural force.[27] The Peter Norton Family Foundation in particular played a key role in supporting and promoting art in Los Angeles. Established in 1989, it distributed over $15 million in its first ten years of operation to artists, as well as to museum curators for acquisitions and related projects.[28] It was less the amount that mattered, though, than the strategic deployment of those funds. Peter and Eileen Norton decided early on to focus on emerging artists and artists of color, reasoning that giving in this area could have the greatest impact. Combined with their other art-patronage activities—especially their annual commissioning of original art editions for the Peter Norton Family Christmas Art Project, which was distributed to a national mailing list of hundreds of influential figures—the Foundation's actions helped sustain the local community of artists by not simply providing reliable financial support, but also offering high-profile exposure at a national and international level.[29]

This concern with the social worlds in which artworks exist can also be seen among the plethora of artist-run spaces that were opened in the 1990s. Unlike their 1970s predecessors, nineties' spaces such as Bliss, Guest Room, and Food House were not nonprofit institutions, opting instead for more informal and casual structures that also allowed artists greater leeway in how to exhibit the work of their peers.[30] For instance, POST, founded by HK Zamani in 1995 in his studio, gave emerging younger artists the opportunity to exhibit work as they wished, with a freight elevator reserved for site-specific installations.[31] And at CalArts, Dave Muller turned the notion of post-studio practice on its head, organizing one-day shows of fellow MFA students in his own work space. This evolved in 1994 into the Three-Day Weekend series of exhibitions/parties organized by Muller, with a rotating cast that included artists Lisa Anne Auerbach, Andrea Bowers, and Sam Durant, critic Diedrich Diederichsen, and post-punk band the Red Crayola [figure 3]. They were mostly held in Muller's home, though there were also mobile editions staged on buses, and in cities such

music μουσική

as Houston and London.[32] Through these spaces, Muller, Zamani, and their peers created a network spreading out from Los Angeles to other parts of the world that facilitated artistic exchange within the context of sociability.

This movement, deemed by one critic "the commitment of artists themselves to the creation of an interesting and worthwhile scene" came to a head at the turn of the century with the blossoming of Chinatown as an artists' neighborhood brought on by the arrival of Black Dragon Society and China Art Objects.[33] The latter, founded by Steve Hanson and Giovanni Intra with Amy Yao, Peter Kim, and Mark Heffernan in early 1999, rapidly developed a reputation as an artists' operation.[34] Given that Hanson and Intra had met while at Art Center, it is perhaps not surprising that they involved their fellow graduates. Pae White designed the space (and also had the first show), and Jorge Pardo and Sharon Lockhart participated in collaborative shows. But so did others, such as Laura Owens (CalArts) and UCLA graduates Eric Wesley and Jon Pylypchuk. Even if ostensibly a for-profit gallery, the space cultivated a decidedly noncommercial ambiance, functioning more as a hangout for artists and their friends: the space even featured a basement mini-nightclub designed by artists Andy Alexander and Andy Ouchi. Hitting a different musical note, Frances Stark paid homage to Black Flag in a lithograph for her 1999 exhibition at the gallery by highlighting the punk band's logo graffitied on a nearby building [plate 58].[35] The print in fact reproduced an image of Chinatown from a found postcard, and deftly evoked the neighborhood's history of hosting different scenes, including punk groups that flocked to concerts at the Hong Kong Cafe in the late seventies and early eighties.

Figure 3
DAVE MULLER
The Yellow Wheels of Steel 2001
Acrylic on paper in two parts
32 × 40 in. (81.3 × 101.6 cm) each, installed dimensions variable

32. Dave Muller, "Three Day to Today: Dave Muller in Conversation with Hans Ulrich Obrist (1998) and John C. Welchman (2005)," in *Recent Pasts*, 56–69. See also David A. Muller and Leanne Alexis Davidson, "Three Day Weekend," *Real Life* 23 (Autumn 1994): 32–39.

33. Will Bradley, "Giovanni Intra 1968–2002," *Frieze* 73 (March 2003): 54–55. Black Dragon Society was founded by artists Roger Herman and Hubert Schmalix, photographer Eika Aoshima, and film producer Chris Sievernich. For a survey of different spaces, see David Pagel, "Storefront Galleries," *Los Angeles Times*, Nov. 1, 2001.

34. Doug Harvey, "It's Chinatown," *L.A. Weekly*, May 3, 2000. For details on China Art Objects, see Frances Stark, "A Little Untoward History: On Chinatown's Recent Influx of Art and Its Potential," *Recent Pasts*, 41–56.

Figure 4
Poster announcing the arrival of Deep River
Gallery 1997

Designed by Glenn Kaino and Daniel Joseph Martinez
Printed by Rolo Castillo with illustration by Joe Benitez

A different community coalesced around Deep River, founded in 1997 by artists Rolo Castillo, Glenn Kaino, Daniel Joseph Martinez, and Tracy Schiffman, with support from the Peter Norton Family Foundation. The entire space, located in an industrial area on the borders of Little Tokyo, was dedicated to exhibitions, with the "office," consisting of a folding table and chairs, set out on the sidewalk [figure 4]. And despite the "No art critics allowed" sign on the entrance, the space welcomed fifty-three artists over thirty-four exhibitions during its five-year run. Artists given early or first exhibitions included Rheim Alkadhi, Mark Bradford, Ken Gonzales-Day, Kori Newkirk, and Liat Yossifor.[36] Among the spaces of the 1990s, Deep River distinguished itself through its commitment to diversity, extending into physical space the work of Favela.com, an early web-based project by Kaino, working with Martinez and five additional collaborators, that sought to give artists who "didn't have any access to the Web" a presence on the Internet.[37]

Perhaps just as important as the desire for inclusivity was the explicit conception of the space itself a form of artistic practice, and not merely a context for artistic work. In this, Deep River relates to Martinez's earlier interventions in social space, as with the projects undertaken in the aftermath of the L.A. Riots (which erupted on April 29, 1992—just a few days after *Helter*

35. The original image is reproduced in Stark, "A Little Untoward History," *Recent Pasts*, 45.

36. Brian Keith Jackson, "How I Made It: Mark Bradford," *New York Magazine* (October 1, 2007): 76.

Skelter closed).[38] For his best-known piece, *Museum Tags: Second Movement (Overture) or Overture con Claque (Overture with Hired Audience Members)* (1993), Martinez redesigned the entrance tags for the Whitney Biennial so that each visitor wore some part of the sentence, "I can't imagine ever wanting to be white," thereby transforming the seemingly neutral space of the gallery into charged room for debate. Infamously, the piece caused a furor, as did *The Burning of the Castle* (1993), created for the exhibition *Revelaciones/Revelations: Hispanic Art of Evanescence*. The site-specific installation, located on Cornell University's main quad, resulted in racist vandalism, and subsequently demonstrations by Latino student organizations. In Martinez's communiqué to the main student group Tupac Amaru, he explicitly places their struggle within a lineage of historical protests, invoking the '92 Riots (as well as the 1965 Watts Riots and May '68). In both cases, the discussions, debates, and activities that took place in social space were as much a part of the work as any object. While it may not have relied on the confrontation and provocation of these earlier pieces, Deep River nevertheless also proceeded from the premise that art should lead to change in the body social. It was explicitly conceived as a form of "social sculpture," and exemplifies the coincidence of artistic practice with a concern for community.[39]

From *4166 Sea View Lane*, a "sculpture-that-is-also-a-home," to Deep River, a social sculpture project to provide a home for artists excluded by the market, artists working in Los Angeles increasingly made room for the social within their artistic practice.[40] This is clear in the case of artists such as Jorge Pardo, whose work, frequently architectural in form, inspired what has become known as relational aesthetics, and Daniel Joseph Martinez and Glenn Kaino, who presage more recent iterations of public or social practice. But this concern also inspired the countless artist-run sites, from Three Day Weekend to China Art Objects to Andrea Zittel's High Desert Test Sites, that appeared across Southern California. It manifests even among artists whose practices seem to be firmly object-based, as is the case with Catherine Opie. Indeed, it could be argued that the looming proximity of the market only sharpened artists' desire for art to function as something other than commodity. Whatever the case, the most salient image of L.A. art in the 1990s can be found, not in any particular work or artistic style, but in the collective ethos and practices of the individuals and institutions who worked together to build the various communities that shared the spaces, physical and social, of the city. During the nineties, L.A. artists may have been stars on the global stage, but at home, in their communities, they could be down-to-earth too.

37. Glenn Kaino, telephone interview, January 19, 2014. Many thanks to Kaino for offering insight on Deep River. See also Kaino, *Communicating Rooks: The Work of Glenn Kaino* (Ostfildern, Germany: Hatje Cantz, 2009), 100–101, and Dennis Nishi, "How I Got Here: Glenn Kaino," *Wall Street Journal*, July 17, 2008.

38. See Daniel Joseph Martinez, "Clowns, Terrorists, and the Town Crier: Manifesto for Art Practice," *The Things You See When You Don't Have a Grenade!* (Santa Monica, Calif.: Smart Art Press, 1996), 40.

39. Daniel Joseph Martinez, "A Little Flesh, a Little Breath, a Reason to Live, a Future to Build: Field Notes from the Corner of Traction and Hewitt Streets, Downtown Los Angeles," *Daniel Joseph Martinez: A Life of Disobedience* (Ostfildern, Germany: Hatje Cantz, 2009), 186. See also in the same volume, Lauri Firstenberg, "A Model of Radical Temporality, Deep River: Los Angeles (1997–2002)," 178–79. The term "social sculpture" was originally coined by the German artist Joseph Beuys.

40. Tumlir, "Lessons of the Class of 90," 38.

PLATES

Plates are arranged chronologically, except when works by the same artist are grouped together.

1989–1993

ALEXANDRA SCHWARTZ

The term ethnicity acknowledges the place of history, language, and culture in the construction of subjectivity and identity, as well as the fact that all discourse is placed, positioned, situated, and all knowledge is contextual.... The displacement of the "centered" discourses of the West entails putting in question its universalist character and its transcendental claims to speak for everyone, while being itself everywhere and nowhere.[1]

—Stuart Hall, "New Ethnicities"

Published in 1989, Stuart Hall's "New Ethnicities," a foundational text of postcolonialist theory, was both inspired by, and set the tone for, the debates about identities and difference that would characterize the 1990s. While Hall was writing in the British context—and his thinking about postcolonialism would prove especially prescient as globalization took hold over the course of the decade—his words speak eloquently to the situation in the United States at the beginning of the 1990s.

As is detailed in this volume's introductory essay and chronology, the early nineties was the era of "identity politics," a problematic moniker that nevertheless became a catchphrase. It was used, both in the mass media and in the academy, to characterize the era's debates around identities and difference: that is to say race, ethnicity, class, gender, and sexuality. Within the art world the term was often associated with the National Endowment for the Arts censorship controversies of the late 1980s and early 1990s prompted by the withdrawal of federal funding to exhibitions by artists including Robert Mapplethorpe, Andreas Serrano, and the self-proclaimed "NEA 4" (Karen Finley, John Fleck, Holly Hughes and Tim Miller). Much of the art in question dealt with sexuality—especially LGBT issues and the AIDS crisis—drawing the ire of conservative members of Congress and an equally passionate defense from the Left, triggering an intense debate about artistic freedom and censorship. Combined with the dip in the art market in the late 1980s, these debates helped set the stage for the early 1990s when much of the most-discussed contemporary art spotlighted social and political issues.

EXHIBITING IDENTITIES

Beginning in the late 1980s, a number of major exhibitions focused on issues of identities and difference, helping to bring these debates and the artists who engaged in them, to prominence. Among the earliest of these was *The Decade Show: Frameworks of Identity in the 1980s* (1990), a joint project of the Museum of Contemporary Hispanic Art, the New Museum of Contemporary Art, and the Studio

1. Stuart Hall, "New Ethnicities," in *Black Film, British Cinema*, ICA Documents 7 (London: Institute of Contemporary Art, 1989), repr. in *The Post-Colonial Studies Reader*, ed. Bill Ashcroft, Gareth Griffiths, Helen Tiffin, 2nd ed. (London and New York: Routledge, 2006), 201.

Museum in Harlem, and spearheaded by their respective directors Nilda Peraza, Marcia Tucker, and Kinshasha Holman Conwill (with a young Thelma Golden compiling the catalogue's chronology). The organizers sought to create an alternative to, as Tucker put it, "the very white, very male, very mainstream view of what happened during the eighties," instead exploring what Peraza called "issues of exclusion and alternative aesthetics" by showcasing artists from "a wide variety of nationalities, who explore different aesthetic and social concerns, who are interested in developing and making a statement, who are aware of the social dimensions of art."[2] This exhibition was followed by *Parallel History: The Hybrid State* (1991–92), organized by Jeanette Ingberman and Papo Colo for Exit Art; influenced by postcolonialist discourses, the exhibition reflected the curators' belief that "there is no longer a mainstream view of American art culture, with several 'other,' lesser important cultures surrounding it. Rather, there exists a 'parallel history,' which is now changing our understanding of our transcultural society."[3]

Yet the exhibition that, arguably by virtue of its location at one of the largest New York museums, ultimately ushered the conversation around art, identities, and difference into the mainstream was the 1993 Biennial Exhibition at the Whitney Museum of American Art. The exhibition was organized by Elisabeth Sussman, John Handhardt, Thelma Golden, and Lisa Phillips.[4] In her catalogue essay, Sussman summed up their project when she observed, "I do not mean to characterize the art of the last two years by sociological analysis, but to recognize that art production springs up from a relation of cultures of identities (in the plural). It is their rich interrelations that make up the social reality which underlies the art of this Biennial."[5] At the time, the exhibition was touted by some as a watershed (including the *New York Times*'s Roberta Smith, whose review is quoted in this volume's introduction), both for its social content and for its heavy inclusion of women artists and artists of color, particularly artists of African descent, many of whom were particularly championed by Golden.[6] It also, however, had remarkably vehement detractors in the press, and among the museum-going public.[7] It would eventually go down in history with the backhanded moniker the "political Biennial," yet today is widely perceived as a landmark exhibition, both for its innovations and its controversies.

The spring following the opening of the Whitney Biennial saw that of the 1993 installment of that other perennial, the Venice Biennale, and its auxiliary *Aperto '93* exhibition. The theme of the main exhibition was "cultural nomadism," or put plainly, multiculturalism, with its organizers encouraging participating countries

2. Nilda Peraza, Marcia Tucker, and Kinshasha Holman Conwill, "Directors' Introduction: A Conversation," *The Decade Show* (New York: Museum of Contemporary Hispanic Art, The New Museum of Contemporary Art, The Studio Museum in Harlem, 1990), 9–10.

3. Exit Art Online Archive: http://users.rcn.com/exitart/exhibit/91-92/hybrid.html.

4. According to Sussman, the exhibition was shaped in part by her exchanges with two of the most influential theorists of the social history of art, Marxist art historian and critic Benjamin H. D. Buchloh, and pioneering postcolonialist literary theorist Homi K. Bhabha (Elisabeth Sussman, interview with the author, January 13, 2011). Both served as unofficial consultants on the exhibition, with Bhabha also contributing the essay "Beyond the Pale: Art in the Age of Multicultural Translation" to the catalogue.

5. Elisabeth Sussman, "Coming Together in Parts: Positive Power in the Art of the Nineties," *1993 Biennial Exhibition* (New York: Whitney Museum of American Art, 1993), 14.

6. Sussman, interview with the author.

7. Christopher Knight's review for the *Los Angeles Times* typified the most widespread criticisms of the show: "Under the enthusiastic banner of opening up the institutional art world to expansive diversity, the Whitney has in fact perversely narrowed its scope to an almost excruciating degree. The result: Artistically, it's awful" ("Art Review: Crushed by Its Good Intentions," *Los Angeles Times*, March 10, 1993, http://articles.latimes.com/1993-03-10/entertainment/ca-1335_1_art-world).

to allow artists of other nationalities in their national pavilions. Although it is not often discussed as such, this exhibition was, in small strokes, the first postcolonial biennial (although Okwui Enwezor's 1997 Johannesburg Biennial is widely considered to be the first to fully embrace postcolonialist theory in its methodology). In reviews, the '93 Venice Biennale was often compared to that year's Whitney Biennial, with many critics considering it a less incendiary take on related themes of identities and difference. It was the *Aperto* exhibition, however, that gained the lion's share of critical attention; with its focus on emerging artists, it provided early exposure for key artists of the 1990s, and featured Janine Antoni's *Lick and Lather* and Daniel Joseph Martinez's cycle of paintings on the *Brigate Rosse* (Red Brigades), both of which appear in *Come as You Are*.[8]

The next year, Thelma Golden organized *Black Male: Representations of Masculinity in Contemporary American Art*, which expanded upon many of the issues she raised in the Biennial. This exhibition, also at the Whitney Museum, examined changing perceptions of African American masculinity within the context of both United States history and contemporary discourses on critical race theory and postcolonialism. As Golden writes in the catalogue:

> Black masculinity suffers not just from overrepresentation, but over-simplification, demonization, and (at times) utter incomprehension. In developing this exhibition, I found myself faced with this thought: Since masculinity in general is about privilege as the internal force, is black masculinity a contradiction in terms? I wanted to produce a project that would examine the black male as body and political icon.[9]

In 2001, Golden organized the equally influential exhibition *Freestyle* at the Studio Museum in Harlem, which she joined in 2000; launching many of the most prominent artists of the coming decade, *Freestyle* also, more controversially, introduced the term "post-black" into the critical lexicon.[10] Works from Laylah Ali's *Greenheads* series of 1996–2005 and Julie Mehretu's *Untitled* drawings series of 2000 appeared in *Freestyle*, and are also featured in *Come as You Are*.

Along with such examinations of race and ethnicity, another key aspect of the era's explorations of identities and difference centered on gender and sexuality. During this time LGBT activism was often tied to the HIV/AIDS crisis, whose impact on the art world was profound, claiming numerous lives and figuring prominently in much of the work of the era. While artist-activist groups founded during the 1980s—including Group Material, Gran Fury,

8. For an insightful pair of reviews of the 1993 Venice Biennale and *Aperto*, see Thomas McEvilley, "Venice the Menace" and Giorgio Verzotti, "*Aperto* '93: The Better Biennial," *Artforum* 32 (October 1993): 102–5.

9. Thelma Golden, "My Brother," *Black Male: Representations of Masculinity in Contemporary American Art* (New York: Whitney Museum of American Art, 1993), 19–20.

10. The Studio Museum continued its series on emerging black artists with the exhibitions *Frequency* (2005), *Flow* (2008), and *Fore* (2012).

and other collectives related to the activist organization ACT UP—continued to be greatly influential during this time, other artists, perhaps most famously Felix Gonzalez-Torres, addressed the AIDS crisis in their work, using a more metaphorical formal vocabulary.[11] Theorists including Judith Butler and Eve Kosofsky Sedgwick published books during the early nineties that shaped a national conversation on gender, sexuality, and the body, as did journalists including Susan Faludi and Naomi Wolf, whose work was central to the "third-wave feminism" that emerged during this time.[12] The early nineties also saw a revival of feminist activism within the art world, including a spate of protests by feminist groups such as the Guerrilla Girls, founded in 1985, and the Women's Action Coalition (WAC), established in 1992, which was founded partly in response to the Anita Hill hearings. At the time, these issues were highlighted in the controversial but influential 1994 exhibition *Bad Girls*, organized by Marcia Tucker for the New Museum, and its "independent sister exhibition" *Bad Girls West*, organized by Marcia Tanner for the UCLA Wight Art Gallery. These themes likewise reverberate throughout *Come as You Are*.

The majority of the exhibitions that shaped the dominant discourse on nineties' art took place in New York institutions, and though they generally included artists working across the country, considerations of the East and West Coasts often remained distinct. The exhibition that defined the period's bourgeoning Los Angeles art scene was the 1992 *Helter Skelter: L.A. Art in the 1990s*, organized by Paul Schimmel for the Museum of Contemporary Art, Los Angeles. Though the artists included embraced diverse practices in multiple media, the exhibition became known for celebrating a "bad boy" ethos associated with such artists as Mike Kelley, Paul McCarthy, Charles Ray, and Jim Shaw. Because these artists first attained prominence in the 1980s, they are not included in *Come as You Are*, but their work had a huge effect on the L.A. artists who came of age during the decade, including Sharon Lockhart, Jennifer Pastor, Laura Owens, Jason Rhoades, Frances Stark, and Diana Thater. And while one might debate the degree to which the exhibition's "bad boy" reputation was accurate or deserved, the reactions—both negative and positive—helped form Los Angeles art in the ensuing years.

INDIVIDUAL CRITIQUES

Of these exhibitions, *Helter Skelter*, the '93 Whitney Biennial, *Aperto '93*, *Black Male*, *Bad Girls*, *Bad Girls West*, and *Freestyle* all spotlighted American artists who came of age in the 1990s, and who also appear in *Come as You Are*.[13] As crucial as these thematic

11. Helen Molesworth's 2009 exhibition *Act Up New York: Activism, Art, and the AIDS Crisis, 1987–1993* at the Harvard Art Museums and traveling to White Columns, New York, was an important survey of this work; Molesworth revisited aspects of this work in her 2012 exhibition *This Will Have Been: Art, Love and Politics in the 1980s*.

12. Judith Butler's *Gender Trouble: Feminism and the Subversion of Identity* and Eve Kosofsky Sedgwick's *Epistomology of the Closet* were both published in 1990; Susan Faludi's *Backlash: The Undeclared War Against American Women* and Naomi Wolf's *The Beauty Myth: How Images of Beauty Are Used Against Women* were both published in 1991.

13. Artists included in *Come as You Are* also appeared in the following exhibitions: *Helter Skelter*: Manuel Ocampo; the 1993 Whitney Biennial: Janine Antoni, Matthew Barney, Andrea Fraser, Karen Kilimnik, Byron Kim, Daniel Joseph Martinez, Pepón Osorio, Gary Simmons, Fred Wilson; *Aperto '93*/Venice Biennale: Janine Antoni, Daniel Joseph Martinez; *Black Male*: Byron Kim, Glenn Ligon, Gary Simmons, Fred Wilson; *Bad Girls*: Janine Antoni, Jeanne Dunning, Beverly Semmes; *Bad Girls West*: Jeanne Dunning, Beverly Semmes; *Freestyle*: Laylah Ali, Julie Mehretu.

Duchamp's readymades, particularly his *Bottle Rack* (1914), as well as to Jasper Johns's 1960 sculpture *Painted Bronze (Ballantine Ale)*, which was also influenced by Duchamp.

Finally, these years witnessed an increasing number of artists who integrated the rapidly evolving digital technologies into their practices. Based in San Francisco during the early 1990s, the artist collaborative Aziz + Cucher (Antony Aziz and Sammy Cucher) moved to New York in 1996. While in San Francisco, they were at the forefront of artists experimenting with the new digital technologies being pioneered in nearby Silicon Valley. Their 1992 photograph *Man with a Computer*, from the series *Faith, Honor and Beauty*, presents a statuesque, nude man holding an early Apple laptop. The artists collaborated with a commercial firm to use an industrial precursor to Photoshop to "erase" the central figure's masculine characteristics, a discomfiting take on the recurring theme of gender and sexuality; this early use of digital manipulation predicted the explosion of such practices later in the decade.[18] In an updated twist on classical statuary, the central figure stands as a symbol of the technological revolution: while he grasps his laptop, like a sacred text, in one arm, he gestures toward the future with the other.

18. Anthony Aziz and Sammy Cucher, interview with the author, January 17, 2013.

1 ANDREA FRASER (born 1965, USA)
Museum Highlights: A Gallery Talk 1989
Performance, Philadelphia Museum of Art, 1989

2 MANUEL OCAMPO (born 1965, Philippines)

La Liberté 1990

Oil on canvas
48¼ × 48 × 2⅛ in. (122.5 × 121.9 × 5.4 cm)
The Museum of Contemporary Art, Los Angeles; gift of
Councilman Joel Wachs

A mis adorables hijas,
Tengo que confesarles que ya no me siento tan bien como antes, la vida me ha dado duro, y el dolor se hace cada dia mas grande.

3 PEPÓN OSORIO (born 1955, Puerto Rico)
A Mis Adorables Hijas 1990
Mixed media
36 × 28 × 72 in. (91.4 × 71.1 × 182.9 cm)

4 FELIX GONZALEZ-TORRES (born 1957, Cuba–died 1996, USA)
"Untitled" (Portrait of Dad) 1991
White candies individually wrapped in cellophane,
endless supply
Overall dimensions vary with installation
Ideal weight: 175 lbs.
Carlos and Rosa de la Cruz Collection

GLENN LIGON (born 1960, USA)
Invisible Man (Two Views) 1991
Oil stick and coal dust on canvas, diptych
28⅛ × 20 in. (71.4 × 50.8 cm) each
Currier Museum of Art, Manchester, New Hampshire; museum purchase: The Henry Melville Fuller
Acquisition Fund, 2010.22.a,b

I am an invisible man. No, I am not a spook like those who haunted Edgar Allan Poe; nor am I one of your Hollywood-movie ectoplasms. I am a man of substance, of flesh and bone, fiber and liquids—and I might even be said to possess a mind. I am invisible, understand, simply because people refuse to see me. Like the bodiless heads you sometimes see in circus sideshows, it is as though I have been surrounded by mirrors of hard, distorting glass. When they approach me they see only my surroundings, themselves, or figments of their imagination—indeed, everything and anything except me.

6 RIRKRIT TIRAVANIJA (born 1961, Argentina)
untitled (Blind) 1991
20 glass bottles with wax seal in cardboard box
10½ × 8 × 16 in. (26.7 × 20.3 × 40.6 cm)
Collection of Martin and Rebecca Eisenberg

7 GABRIEL OROZCO (born 1962, Mexico)
My Hands Are My Heart 1991
Two silver dye bleach prints
9⅛ × 12½ in. (23.2 × 31.8 cm) each

GABRIEL OROZCO
Yielding Stone (Piedra que cede) 1992
Plasticine, edition 2 of 3
14½ × 15½ × 16 in. (36.8 × 39.4 × 40.6 cm)
Walker Art Center, Minneapolis; T. B. Walker
Acquisition Fund, 1996
1996.166

GABRIEL OROZCO
Pinched Ball (Pelota ponchada) 1993
Silver dye bleach print
16 × 20 in. (40.6 × 50.8 cm)

12 JENNIFER PASTOR (born 1966, USA)
Untitled 1992
Sandblasted steel and pigmented epoxy resin structure,
holding sandblasted steel and pigmented epoxy resin
nest and a found nest
70 × 42 in. (177.8 × 106.7 cm)
Eileen and Michael Cohen

Below: detail

13 JANINE ANTONI (born 1964, Bahamas)
Lick and Lather 1993
Two self-portrait busts: one chocolate and one soap
24 × 16 × 13 in. (61 × 40.6 × 33 cm)

14 JASON RHOADES (born 1965–died 2006, USA)
Red 1993

Various materials
Dimensions vary with installation
Ann and Mel Schaffer Family Collection
Installation view: *CHERRY Makita–Honest Engine Work*
David Zwirner, New York
September 11–October 16, 1993

124

15 DANIEL JOSEPH MARTINEZ (born 1957, USA)
Combined Action 1993

All on this spread from the series *I couldn't remember if death or love was the solution to defeating the empire; One thought he was invincible, the other thought he could fly — superheroes, assassins and astrology, they all pray to the wrong god*
Acrylic on velvet
24 × 36 in. (61 × 91.4 cm)

16 DANIEL JOSEPH MARTINEZ
Constructed Situation 1993

Acrylic on velvet
36 × 24 in. (91.4 × 61 cm)

17 DANIEL JOSEPH MARTINEZ
Detournement 1993
Acrylic on velvet
36 × 24 in. (91.4 × 61 cm)

18 DANIEL JOSEPH MARTINEZ
Systematic Decomposition 1993
Acrylic on velvet
24 × 36 in. (61 × 91.44 cm)

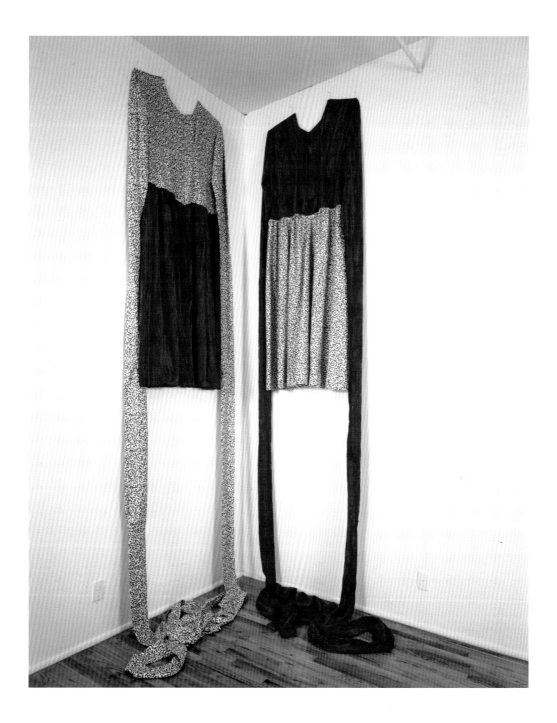

21 BEVERLY SEMMES (born 1958, USA)
Famous Twins 1993
Crushed velvet and cotton
Two parts, 140 × 48 in. (355.6 × 121.9 cm) each
The Frances Young Tang Teaching Museum and Art
Gallery, Skidmore College, Saratoga Springs, New York;
gift of Joel and Zoe Dictrow

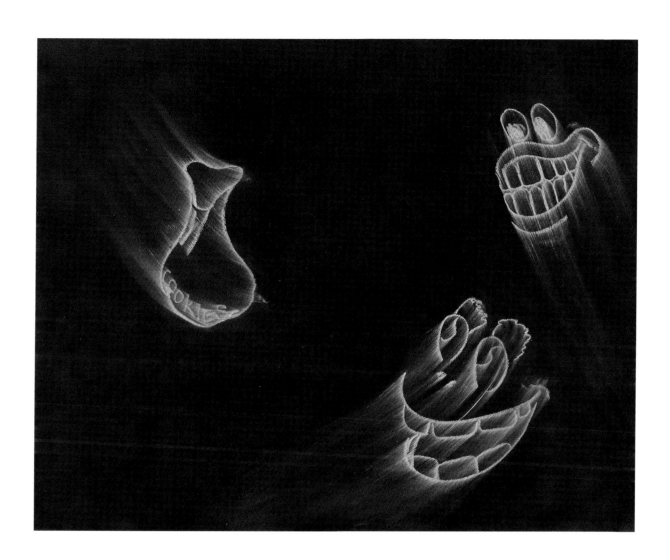

22 GARY SIMMONS (born 1964, USA)
Black Chalkboards (Two Grinning Faces with Cookie Bag) 1993
From the series *Erasure*
Chalk and slate paint on fiberboard with oak frame
48 × 60 in. (121.9 × 152.4 cm)
Hort Family Collection

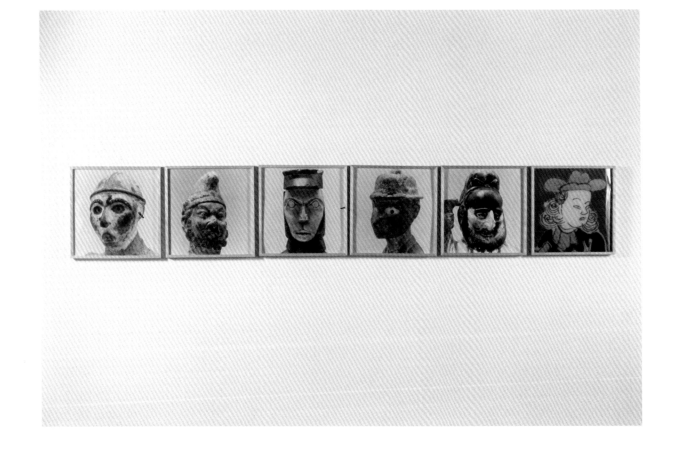

FRED WILSON (born 1961, USA)
Portrait of S.A.M. (Europeans) 1993
Six color photographs
16 × 16 in. (40.6 × 40.6 cm) each
Collection of Peter Norton

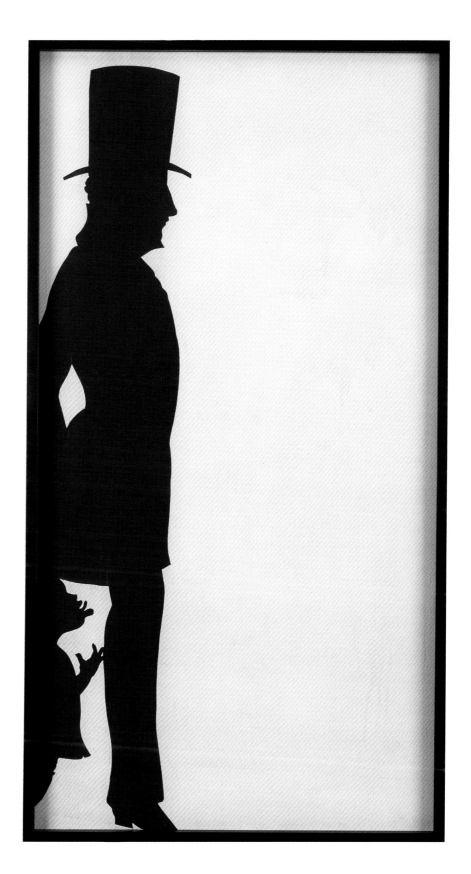

KARA WALKER (born 1969, USA)
Untitled 1993–94
Paper on prepared canvas
59½ × 31¼ in. (151.1 × 79.4 cm)
Collection of Stuart & Sherry
Christhilf

ALEXANDRA SCHWARTZ

One general effect of the digital revolution is that avant-garde aesthetic strategies came to be embedded in the commands and interface metaphors of computer software. In short, the avant-garde became materialized in a computer.

—Lev Manovich, *The Language of New Media*[1]

Although the digital revolution had its roots far earlier, the commercial debut of the World Wide Web in 1989, followed by that of the Internet in 1993, permanently altered not only the technological, but also the socioeconomic landscape worldwide. Microsoft founder and CEO Bill Gates was one of the first public figures to fully comprehend the impact of the Internet, as is evidenced by the prophetic, manifesto-like internal memo that he issued to his employees on May 26, 1995. In it he proclaims, "The Internet is a tidal wave. It changes the rules. It is an incredible opportunity as well as incredible challenge."[2] The remainder of the decade (and the beginning of the twenty-first century) was in fact dominated by this tidal wave, which changed everything from everyday communication to global commerce to how art functioned.

Artists were in the forefront not only of adapting to these new technologies but also of understanding their societal effects. The new genre of digital art (also known as new media art) reflected these changes in both form and content. In the United States, digital art largely arose from the burgeoning Internet start-up culture on the East and West Coasts; its ties to e-commerce, as well as the film and music industries, were always particularly strong. It also had important roots in Eastern Europe, where it stemmed from avant-garde performance of the 1960s through 1980s, and where its early development was fostered by the Soros Centers for Contemporary Art throughout the former Soviet Block.[3] During the nineties a number of American digital artists began their careers as expatriates in Eastern Europe:[4] a fact that reflected the era, when the rise of digital technologies and globalization led to increased international communication and exchange.

Internet art (also called net art or web art) dominated the early history of digital art; in fact, Internet art developed, thrived, and ultimately died out between the early 1990s and the mid-2000s. The Internet art world largely existed in a parallel universe to the mainstream art world: a separation that was determined by a combination of factors. First, most Internet art was both made with and designed to be viewed from personal computers, accessible by anyone with Internet access, anywhere: a fact that both determined its democratic spirit and, from a practical point of view,

1. Lev Manovich, *The Language of New Media* (Cambridge, Mass. and London: The MIT Press, 2002), 15.

2. For the full text of the memo, see: "This Day in Tech: May 26, 1995: Gates, Mircosoft Jump on 'Internet Tidal Wave,'" *Wired*, http://www.wired.com/thisdayintech/2010/05/0526 bill-gates-internet-memo/.

3. The Soros Centers for Contemporary Art were part of the Open Society Foundations, founded in 1979 by the philanthropist George Soros "to help countries make the transition from communism" (http://www.opensociety foundations.org/about).

4. Mark Tribe, interview with the author, November 25,

required major adaptations to its format in order to be screened in a gallery. Second, many Internet artists viewed themselves as outliers, and were not invested in, or chose to work apart from the art world; they also frequently came to art making from other industries (in which they usually continued to work), often web design, programming, film, or music. Indeed, initially many Internet art projects had commercial sponsors, among them the television network MTV and the advertising firm Razorfish.[5]

Gradually, a handful of institutions developed across the United States to support Internet art and artists. Among the most influential were Interport, a service provider that offered a weekly list of the one hundred top-hit sites, including artworks; Echo NYC founded in 1992 to provide free web accounts to women and fostering new Internet art projects; the e-zine Word.com, edited by Marisa Bowe, which ran from 1995 to 2000;[6] mailing lists including Nettime, Syndicate, and Old Boys Network; print publications such as *Mute* and *Intelligent Agent*; and platforms including *Telepolis* THE THING, and Rhizome.org, which was founded by Mark Tribe in 1996 as an e-mail list, and is now a major foundation supporting art and technology.[7] Far more than in the United States, European institutions were early adapters of digital art, although many of the early exhibitions took place in media centers and festivals rather than in museums. (One might argue that the receptivity of many European institutions to digital art was linked to the fact that, due to ample state funding, they tend to enjoy greater economic freedom—from driving visitor attendance and thus revenue, and from the pull of the art market—than their U.S. counterparts.) Foremost among these were media centers including ZKM (Center for Art and Media) in Karlsruhe, Germany, and the Waag Society Institute for Art, Science & Technology in Amsterdam, The Netherlands; and festivals including Ars Electronica, founded in Linz, Austria, in 1979, and the Dutch Electronic Art Festival (DEAF) founded in Rotterdam, The Netherlands, as the Manifestation for the Unstable Media in 1987 and renamed in 1994.

Toward the end of the 1990s, the mainstream American art establishment had begun to turn its attention to digital art. New York's Postmasters Gallery supported the medium early on, including with its influential exhibition *Can You Digit?*, held from March 16 to April 13, 1996. The Walker Art Center in Minneapolis ranked among the first museums to exhibit digital art online. Between 1997 and 2003, under the direction of Steve Dietz, its Gallery 9 presented the work of more than one hundred artists, and in 1998, Dietz organized *The Shock of a View*, a six-month series of online exhibitions and live panel discussions. By the early 2000s, museums also began

5. Marina Zurkow, interview with the author, January 12, 2013.

6. Ibid.

7. Rachel Greene, *Internet Art*, World of Art series (New York and London: Thames & Hudson, 2004), 14.

mounting Internet art exhibitions in their brick-and-mortar galleries. *BitStreams* and *Data Dynamics*, a pair of related exhibitions organized by Lawrence Rinder and Debra Singer at the Whitney Museum of American Art in 2000–2001, and *010101: Art in Technological Times*, organized by Aaron Betsky, Janet Bishop, Kathleen Forde, and John S. Weber at the San Francisco Museum of Modern Art in 2001, explored the various iterations of digital art; and the 2002 Whitney Biennial, also organized by Rinder and Singer, dedicated a special section to it. While *BitStreams*, *Data Dynamics*, and the 2002 Whitney Biennial mostly presented Internet art and digital video, *010101*, whose title referred to binary code, explored the relationship of digital technologies to other media, including sculpture and architecture.

Ultimately, what set Internet art apart from more traditional media was the fact that there was no object to buy or sell. While this quality created a wide-open field for artists wishing to work outside the market's constraints (an ironic twist, given Internet art's roots in e-commerce), Internet art's unsalability was also a key factor in its growing obsolescence, since aside from sponsorships, there existed almost no means to fund it. In another paradox, Internet art's demise might also be attributed to the fact that, as much as Internet artists thrived on experimenting with new technologies, the speed with which those technologies evolved also meant that their work was constantly being outmoded; because web platforms were constantly changing, early Internet works often became unviewable within a few years of their creation. As Internet artists realized that they needed a more technologically stable, permanent, and salable platform for their work, they adapted. While some developed technologies that allowed digital works to be sold on computer hardware and screened in galleries and homes, others incorporated digital technologies into larger, multidisciplinary practices, including installation, photography, printmaking, video, and computer modeling.

Behind the Screens

In his first Internet artwork, *Traces of a Constructed City* (1996/2004), the pioneering digital artist Mark Tribe mapped the proliferation of new building projects then under way in reunified Berlin. After living in San Francisco in the early nineties, when Silicon Valley was just taking off, and attending art school at the University of California, San Diego, Tribe moved to Berlin in the mid-nineties; like many artists from around the world, he was attracted to that city's wide-open creative opportunities, burgeoning arts scene, and low rents in the years immediately following the fall of the Wall. He

became active in both the city's vibrant club scene and, through it, the growing community of musicians and artists experimenting with digital media.[8] *Traces of a Constructed City* draws an indexical connection between the rampant new construction throughout Berlin and that occurring simultaneously on the Internet. At the same time, it represents Tribe's desire, shared by many early digital artists, to take advantage of the accessibility of the Internet to create a new, inherently democratic art form.

Alex Bag was not long out of art school at Cooper Union when she created *Untitled Fall '95* (1995), a video in which she plays multiple roles, primarily a student attempting to make sense of her experience at New York's School of Visual Arts, interspersed with set pieces of a London shop girl–cum–punk musician, a Ronald McDonald doll attempting to pick up a Hello Kitty doll, and the Icelandic singer-artist Bjork, explaining how television works. With the help of friends and family, Bag shot this and related videos in her own New York apartment. She has explained that this work stemmed both from her own time in art school and her interest in exploring the impact of television on both visual and popular culture.[9] The artist views video as the defining medium of her generation, but unlike the avant-garde video artists of the 1960s and 1970s (some of whom were her art-school professors), her generation's understanding of it was shaped by television.[10] She also has a particularly personal connection to television, as her mother had her own children's TV show, which featured puppets, when Bag was a child. As the artist notes, she made *Untitled Fall '95* at a moment when the tropes of reality television, with its "head and shoulders, confessional shots," were just becoming part of the pop culture lexicon (MTV's *The Real World* was then the first and only reality show on the air); and when the twenty-four-hour cable-news cycle had, with the O. J. Simpson murder case, just started to take hold of the public imagination.[11] *Untitled Fall '95* was prescient in its ironic commentary on media culture, uncannily presaging the YouTube videos so ubiquitous today.

One of the most internationally successful artists to emerge in Los Angeles during the 1990s, Doug Aitken was instrumental in developing the use of digital technologies to create complex film and video installations. His work often addresses the alienating effects of the technological advancements and increased mobility of the age of globalization. For his early single-channel video *monsoon* (1995), a film transferred onto digital video, Aitken travelled to Jonestown, Guyana, where twenty years earlier the cult leader Jim Jones led almost one thousand followers in a mass suicide. A monsoon was predicted to hit Jonestown during the time Aitken

8. Tribe, interview with the author.

9. Alex Bag, interview with the author, October 16, 2013.

10. Ibid.

11. Ibid.

recognizable as exaggerated facial features, refer to nineteenth-century minstrel shows, in which white performers in blackface impersonated African American characters. Blending an investigation of racial prejudices with one of the history of painting, Gallagher creates works of exquisite formal rigor that also engage incisively with the most complicated social and historical issues.

As the decade progressed, artists' examinations of identities and difference in United States culture became increasingly integrated with related issues around the world: an indication of the expanding globalization of American life. Laylah Ali's allegorical *Greenhead* paintings (1996–2005) cite news images of international racial and ethnic conflict to address both the growing ubiquity of the global media and issues of difference at home and abroad. With their cartoonlike forms and green skin, the figures in these works represent blank-slate "others," enacting scenes of conflict that are culled directly from the news media. At once wrenching and, with their elegant compositions and aesthetically pleasing palettes, disarmingly beautiful, these works ask us to consider our relationship to the ever-more-relentless twenty-four-hour news cycle, as well as our preconceptions about difference. Selections from the *Greenheads* series were featured in the 2000 exhibition *Freestyle* at the Studio Museum in Harlem.

The growing number of artists who were born outside the United States, yet worked in the United States and launched their careers in the American art world, also testified to mounting globalization. Many of these artists' work reflected their own experiences living between cultures, framed within the larger societal implications of an increasingly global society. The Brazilian-born artist Vik Muniz first exhibited his 1996 photographic series *Sugar Children* in the Museum of Modern Art's 1997 *New Photography* exhibition, helping launch this artist to international fame. To make them, Muniz created drawings made from sugar, which he then photographed. The subjects were all children whose parents or grandparents worked in sugar plantations on St. Kitts, where the artist had visited and was struck by the contrast between these children's happiness and the sadness of their hardworking parents.[16] In the larger sense, these images comment upon the disparity between poor countries, where products such as sugar are produced cheaply and often with exploitative labor practices, and rich countries leading the global neoliberal economy, where products such as sugar are sold, and which ultimately profit.

Differences in perceptions of gender and sexuality across cultures constituted a major theme for many artists. Born in Iran and living in the United States intermittently since 1974, Shirin Neshat

16. Mark Magill, "Vik Muniz" (interview), *Bomb* 73 (Fall 2000), http://bombsite.com/issues/73/articles/2333.

came to prominence with her "Women of Allah" series of hand-altered photographs, created between 1993–97. In works such as *Untitled* (1995), Neshat presents portraits of traditionally dressed Muslim women, many of whom hold weapons; over sections of these images, Neshat overlays passages of Arabic calligraphy quoting the Iranian woman poet Tahereh Saffarzadeh. According to the artist, "'Women of Allah' visualizes personal and public lives of women living under extreme religious commitment. A majority of the photographs deal with the concept of *shahadat* or martyrdom. One finds a strange juxtaposition between femininity and violence. Ultimately, the *shaheed* or martyr stands at the intersection of love, politics, and death."[17] Neshat subsequently expanded her practice into video and filmmaking, earning an international reputation as one of the most versatile artists of her generation.

Shahzia Sikander was trained in traditional Persian miniature painting in her native Pakistan, before immigrating to the United States to attend the Rhode Island School of Design in the early 1990s. Her works of the late 1990s—*Uprooted Order I* and *II* (1996) and *Cholee Kay Pechay Kiya? Chunree Kay Neechay Kiya? (What is Under the Blouse? What is Under the Dress?)* (1997)—employ this traditional vocabulary, but with an unmistakably contemporary twist. While the dynamic between the sexes is a standard theme for classical Persian miniature painting, Sikander depicts overtly sexual, and often fraught, scenarios in a surreal light, calling into question traditional notions of sexuality, gender, and especially femininity.

The Korean-born artist Nikki S. Lee was based in the United States during the 1990s, and created series of self-portraits in which she masquerades as women and occasionally men who typified various American cultural stereotypes. In her *Punk Project* (1997) Lee appears pierced and snarling, her hair dyed; in *Hispanic Project* (1998) she adopts Latina fashion; and in *Ohio Project* (1999) she poses outside trailers and on pickup trucks, enacting the stereotype of "white trash." By morphing through these disparate identities, Lee examines issues of gender, race, and class, while demonstrating the arbitrariness of these stereotypes. In the spirit of artistic antecedents such as Cindy Sherman, and in line with the contemporaneous theories of gender such as those developed by Judith Butler, she explores how gender is constructed through images.

MIXED MEDIA: INSTALLATION, PARTICIPATION, AND PAINTING

The mid-nineties also saw the further development of installation art, with artists expanding the range of media included within this idiom to explore connections between disciplines. To create his

17. Shadi Sheybani, "Women of Allah: A Conversation with Shirin Neshat," *Michigan Quarterly Review* 38 (Spring 1999), http://hdl.handle.net/2027/spo.act2080.0038.207.

large-scale, multimedia installations, Mark Dion leads a team of researchers in an extensive investigation of a given subject, often relating to issues such as ecology, archeology, history, and economics. For *Department of Marine Animal Identification of the City of San Francisco (Chinatown Division)* (1998), which has not been exhibited since the year it was made, he and his team researched and identified the biological and geographic origins of the fish sold in San Francisco's Chinatown. (Dion made a related work about New York City's Chinatown in 1992.) The resulting installation takes the form of a laboratory, including fish samples, research files, and even furniture, all of which viewers were encouraged to peruse. While tracing the scientific background of the fish, Dion's work examines how people and things from across the world come together within the global economy, of which the Chinatown fish market stands as a kind of microcosm.[18] Dion's active engagement with the communities in which he works represented a move toward participatory, socially engaged art during this period, one of the first American showcases for which was curator Mary Jane Jacob's 1993 exhibition *Culture in Action*, in which Dion took part.[19]

The Cuban-born, Los Angeles–based artist Jorge Pardo creates works that hover between art and design. Engaging with the history of modernism, particularly mid-century Southern Californian design and architecture, he creates both objects and room-sized installations. (In 1998 he created an entire house for an exhibition at Los Angeles's Museum of Contemporary Art, into which himself moved after the show closed.)[20] *Vince Robbins* (1997) is one of a series of hanging lamps that Pardo began creating in the mid-1990s; though often exhibited in a gallery setting, they are, like most of his work, fully functional. Pardo was also one of the co-founders, with his Art Center classmates Kenneth Riddle and Gayle Barklie, of Bliss Gallery, established in a house in South Pasadena in 1987. The inherent interactivity of Pardo's work has sometimes led him to be counted among the participatory artists of the 1990s, and he was included in the Guggenheim Museum's 2008 participatory art survey *theanyspacewhatever*.

The age-old aesthetic question of the division between art (as an inherently nonfunctional form) versus design (as a utilitarian discipline) ran throughout much of the nineties. One of the most incisive artists to parse these issues was Andrea Zittel, whose body of work is devoted to the avant-garde ideal of "art into life," or the possibility that art objects can help bring about social reform. Zittel's A-Z Administrative Services—begun in New York in the early 1990s and relocated to the California desert, as A-Z West, in 2000—encompasses everything from room-sized machines-for-

18. Mark Dion, interview with the author, February 27, 2013.

19. The works in *Culture in Action* were sited around the city of Chicago and were rooted in the artists' interaction with the community; as Jacob writes in the catalogue:

> the use of exhibition locales outside the museum has been motivated not only by a practical need for space, but also by the meaning that such places convey and contribute to the work of art, the freedom they allow for innovation, the potential they offer for public accessibility, and the psychic space they afford artists and audience (Mary Jane Jacob, "Outside the Loop," *Culture in Action: A Public Art Program of Sculpture Chicago* [Seattle: Bay Press, 1993], 50).

For a historical consideration of this exhibition, see Joshua Decter et al., *Exhibition as Social Intervention: 'Culture in Action' 1993*, Afterall Exhibition Histories series (London: Afterall Books, 2014).

20. The house is at 4166 Sea View Lane in Mount Washington, Los Angeles. The exhibition was organized by Ann Goldstein for MOCA's Focus Series.

living to clothing, all created according to the avant-garde principle of better life through better design. Among these projects is a series of uniforms, which the artist regularly wears herself. The "Personal Panels" (1994) are simple, geometric cloth panels that, when draped together in pairs and fastened across the body, become everyday clothing. Inspired by garments made by Russian constructivists, they are part conceptual art, part utilitarian object. Because of Zittel's interest in redefining how individuals live within their communities, her work has at times been considered participatory art, including by Bourriaud in *Relational Aesthetics*.

Yet at the same time that participatory art was being touted by Bourriaud and other critics as an art form that circumvented, and thus inherently critiqued, the market,[22] there also existed a resurgence of interest in the most classical objects of art, particularly painting. Much of the discourse around nineties-era painting was tied to a nostalgia for traditional standards of artistic skill and craft, which crystallized around notions of "beauty." These arguments were led by the editors and contributors to the Los Angeles–based magazine *Art Issues*, among them Dave Hickey, who articulated his influential theories in his 1993 book *The Invisible Dragon: Essays on Beauty*.

Painting during these years was multifaceted and diverse. Laura Owens played a key role in the resurgence of the medium during the 1990s; graduating from Cal Arts in 1994, she was active in the Los Angeles art scene of that period. Owens's rarely seen *Untitled* (1995) exemplifies her explorations of established painting conventions, combined in unexpected ways that offer fresh insights into their histories. As is typical of her work, the longer one examines this painting, the more one discovers about its complex web of references and subtle sleights of hand. Its foreground initially appears abstract, a vast neutral field marked with red lines, yet those lines also refer to the Renaissance technique of single-point perspective, used to create the illusion of three-dimensional space. But *Untitled*'s spatial perspective is dramatically skewed: far from a traditional illusionary painting. Moreover, its background is representational, showing a wall full of pictures, each in a different art historical style. It becomes clear that *Untitled*'s foreground may also be read as floorboards, and that the space it depicts is an old-fashioned picture gallery, hung salon-style and offering a condensed history of painting. Nodding knowingly to the art of the past, Owens creates inventive syntheses of multiple traditions.

Elizabeth Peyton met with immediate success following her debut exhibition in 1993; organized by gallerist Gavin Brown in a room in New York's Chelsea Hotel, it helped spark a "revival" of

21. For a historical overview of participatory art, see: Claire Bishop, *Artificial Hells: Participatory Art and the Politics of Spectatorship* (London and New York: Verso, 2012).

22. For a counterargument to the concept of participatory art as a critique of the market, see Janet Kraynak, "Rirkrit Tiravanija's Liability," in *The "Do-it-Yourself" Artwork: Participation from Fluxus to New Media*, ed. Anna Dezeuze, Rethinking Art's Histories series (Manchester, United Kingdom, and New York: Manchester University Press, 2010), 165–84.

painting during the 1990s. Peyton is known for her painted portraits that humanize well-known historical and contemporary cultural figures, including musicians, artists, and her own friends and acquaintances. In the early nineties she began making paintings and drawings based on photographs from mass media sources. Updating the historical genre of portraiture for the digital age, these works pay homage to their subjects while also calling attention to the often destructive culture of fame. *Princess Kurt* (1995) is one of a series of paintings Peyton made of Nirvana front man Kurt Cobain in the months following his suicide, at the age of twenty-seven, in 1994; it depicts the singer dressed in drag at a 1993 concert in Brazil. Peyton situates her work within the larger history of painting, and in her portrayal of Cobain, sought to capture the sense of timelessness conveyed by historical portraits. At the same time, this work is an elegy to Cobain and Nirvana, reflecting the sense of melancholy and loss that ran throughout much of nineties' culture.[23]

Karen Kilimnik's varied practice helped set a standard for the multimedia approach embraced by many artists emerging during the nineties. In her work she conjures a world full of the most stereotypically feminine symbols—ballet slippers, Prince Charmings, cartoon characters, celebrities—yet depicts them with an idiosyncratic sensibility that appears, paradoxically, both self-conscious and disingenuous. While her "scatter art" installations of the late 1980s and early nineties were influential in their seemingly haphazard assemblages of found objects and everyday materials, she is arguably best known for her faux-naïve paintings, which combine well-known images from ballets, fairy tales, celebrity tabloids, and the history of art. *Beppi at Schuylkill Park* (1996) plays on the aristocratic tradition of portraits of pets (epitomized by Thomas Gainsborough and other eighteenth-century British painters), while *The Toy Soldier (*1999) evokes military portraiture, yet the joke is that it depicts a doll rather than an actual officer, calling to mind the dancing toy soldiers in *The Nutcracker* (ballet looms large in Kilimnik's iconography). Kilimnik also paints images of eminent personages, both living and dead, as in *Mary Shelley in London before writing Frankenstein* (2001). It is telling that, just as the digital revolution accelerated during the mid-nineties, artists were turning to the past, in both form (the ancient medium of painting) and content (the age-old genres of still life, landscape, portraiture, and history painting): updating these traditions for a new era, while arguably expressing a yearning for continuity during a time of rapid change.

23. My thanks to Elizabeth Peyton and Corinna Durland for their insights on this work.

25 JEANNE DUNNING (born 1960, USA)
Leaking 3 1994
Laminated cibachrome prints and frames
21½ × 17½ in. (54.6 × 44.4 cm) each
Collection of Hannah Higgins and Joe Reinstein

26 ELLEN GALLAGHER (born 1965, USA)
Tally 1994
Oil, pencil, and paper on canvas
84 × 72 in. (213.4 × 182.9 cm)
Museum of Fine Arts, Boston; The Living New
England Artist Purchase Fund, created by the
Stephen and Sybil Stone Foundation
1994.278

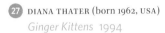 DIANA THATER (born 1962, USA)

Ginger Kittens 1994

Two flat-panel monitors, two DVD players, one
synchronizer, green gels
Dimensions variable
Installation view, *Diana Thater*, 1301PE Gallery,
September 18–October 25, 2008

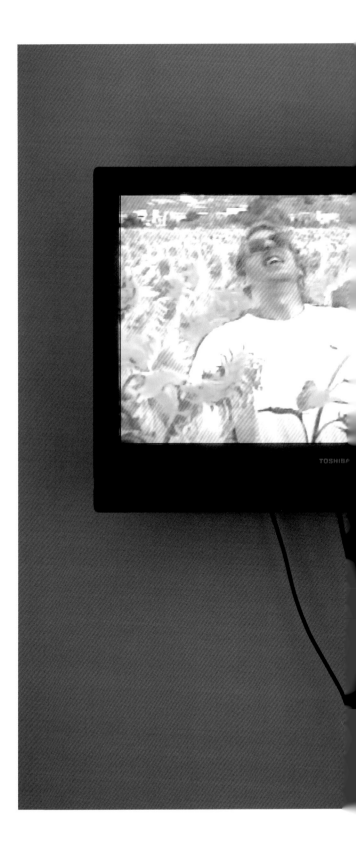

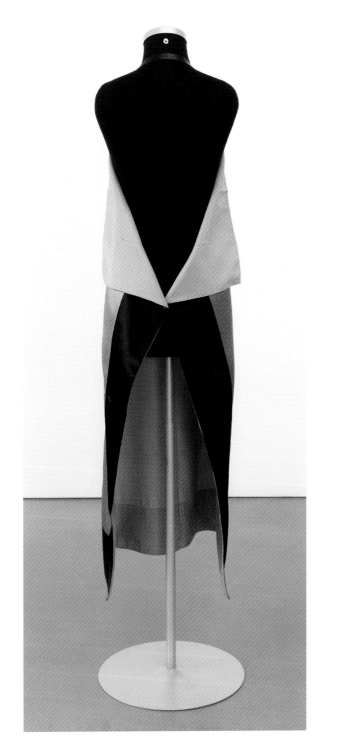

28 ANDREA ZITTEL (born 1965, USA)
Personal Panel 1994
Rayon, satin, and leather
43¾ × 40½ in. (111.1 × 102.9 cm)

29 ANDREA ZITTEL
Personal Panel 1994
Synthetic suit fabric and suspenders
44 × 50 in. (111.8 × 127 cm)

30 31 ANDREA ZITTEL
Study for Personal Panels 1994
Gouache on paper
12 × 9 in. (30.5 × 22.9 cm)

SHIRIN NESHAT (born 1957, Iran)
Untitled, from the series "Women of Allah" 1995
Gelatin silver print and ink
Photograph by Kyong Park
Image: 8⅞ × 13⁷⁄₁₆ in. (22.5 × 34.1 cm)
Sheet: 11 × 14 in. (27.9 × 35.6 cm)
Museum of Fine Arts, Houston; museum
purchase funded by Mary Lawrence Porter

33 DOUG AITKEN (born 1968, USA)
Monsoon 1995
Color film, sound, transferred to digital video
6 min. 43 sec. loop

34 ALEX BAG (born 1969, USA)
Untitled Fall '95 1995
Video, color, sound
57 min.

LAURA OWENS (born 1970, USA)
Untitled 1995
Oil, acrylic, enamel, marker, and ink on canvas
72½ × 84¼ in. (184.2 × 214 cm)

36 ELIZABETH PEYTON (born 1965, USA)
Princess Kurt 1995
Oil on linen
14 × 11 × ¾ in. (35.5 × 27.9 × 1.9 cm)
Walker Art Center, Minneapolis; T. B. Walker
Acquisition Fund, 1995
1995.117

37 KAREN KILIMNIK (born 1955, USA)
Beppi at Schuylkill Park 1996

Oil on canvas
20 × 16 in. (50.8 × 40.6 cm)
Erie Art Museum, Pennsylvania; gift of the American
Academy and Institute of Arts and Letters

38 KAREN KILIMNIK
The Toy Soldier 1999
Water-soluble oil color on canvas
16 × 12 in. (40.6 × 30.5 cm)

39 KAREN KILIMNIK
Mary Shelley in London before writing Franken-
stein 2001

Water-soluble oil on canvas
20 × 16 in. (61.9 × 50.8 cm)
Philadelphia Museum of Art; purchased with the Adele Haas
Turner and Beatrice Pastorius Turner Memorial Fund, 2002

40 SHARON LOCKHART (born 1964, USA)
Untitled 1996

Framed chromogenic print, edition 6 of 6
73 × 109 in. (185.4 × 276.9 cm)
The Metropolitan Museum of Art, New York; purchase,
Neuberger Berman Foundation Gift and Lila Acheson
Wallace Gift, 2004 (2004.62)

41 VIK MUNIZ (born 1961, Brazil)
Big James Sweats Buckets 1996
From the series *Sugar Children*
Gelatin silver print
13¼ × 10½ in. (33.7 × 26.7 cm)
The Metropolitan Museum of Art, New York;
purchase, anonymous gift, 1997 (1997.230.2)

42 VIK MUNIZ

Jacinthe Loves Orange Juice 1996

From the series *Sugar Children*
Gelatin silver print
13¼ × 10½ in. (33.7 × 26.7 cm)
The Metropolitan Museum of Art, New York; gift of
Vik Muniz and Marion A. Tande, 1997 (1997.234)

43 VIK MUNIZ

Valentine, the Fastest 1996

From the series *Sugar Children*
Gelatin silver print
13⅜ × 10½ in. (33.9 × 26.7 cm)
The Metropolitan Museum of Art, New York;
purchase, anonymous gift, 1997 (1997.230.1)

44　SHAHZIA SIKANDER (born 1969, Pakistan)
Uprooted Order I 1996
Vegetable colors, dry pigment, watercolor,
and tea on hand-prepared wasli paper
17½ × 12 in. (45 × 31 cm)
Collection of A. G. Rosen

45　SHAHZIA SIKANDER
Uprooted Order II 1996
Vegetable colors, dry pigment, watercolor,
and tea on hand-prepared wasli paper
17½ × 12 in. (45 × 31 cm)
Collection of A. G. Rosen

46 SHAHZIA SIKANDER

Cholee Kay Pechay Kiya? Chunree Kay Pechay Kiya? (What is Under the Blouse? What is Under the Dress?) 1997

Vegetable color, dry pigment, watercolor, and tea on hand-prepared wasli paper
Marieluise Hessel Collection, Hessel Museum of Art, Center for Curatorial Studies, Bard College, Annandale-on-Hudson, New York

47 MARK TRIBE (born 1966, USA)
Traces of a Constructed City 1996/2004
Net art

48 MICHAEL RAY CHARLES (born 1967, USA)
(Forever Free) Have a Nice Day! 1997
Acrylic latex, stain, and copper penny
on paper
60 × 35¾ in. (152.4 × 90.8 cm)
Collection George Horner, Brooklyn,
New York

 JORGE PARDO (born 1963, Cuba)
Vince Robbins 1997
Plastic, steel, lightbulb, and electric wire
Dimensions variable
Museum of Contemporary Art Chicago; restricted gift of
Carlos and Rosa de la Cruz, 1998.29

50 NIKKI S. LEE (born 1970, South Korea)
Punk Project (1) 1997
Fujiflex print, edition 5 of 5
21¼ × 28¼ in. (54 × 71.8 cm)
Ann and Mel Schaffer Family Collection

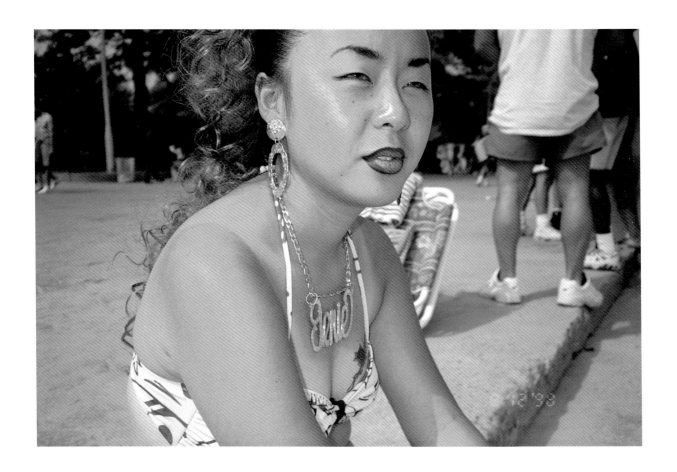

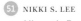 NIKKI S. LEE
Hispanic Project (25) 1998
Fujiflex print, edition 4 of 5
21¼ × 28¼ in. (54 × 71.8 cm)
Ann and Mel Schaffer Family Collection

52 NIKKI S. LEE
Ohio Project (7) 1999
Fujiflex print, edition 2 of 5
28¼ × 21¼ in. (71.8 × 54 cm)
Ann and Mel Schaffer Family Collection

1998–2001

ALEXANDRA SCHWARTZ

The decline in sovereignty of nation-states . . . does not mean that sovereignty as such has declined . . . political controls, state functions, and regulatory mechanisms have continued to rule the realm of economic and social production and exchange. Our hypothesis is that sovereignty has taken a new form, composed of a series of national and supranational organisms united under a single logic of rule. This new global form of sovereignty is what we call Empire.[1]

—Michael Hardt and Antoni Negri, *Empire*

Globalization 3.0 is shrinking the world from a size small to a size tiny and flattening the playing field at the same time. And while the dynamic force in Globalization 1.0 was countries globalizing and the dynamic force in Globalization 2.0 was companies globalizing, the dynamic force in Globalization 3.0—the force that gives it its unique character—is the newfound ability for *individuals* to collaborate and compete globally.[2]

—Thomas L. Friedman, *The World Is Flat: A Brief History of the Twenty-First Century*

An unlikely pair of best sellers during the early 2000s, both of the books quoted above examine the entrenchment of globalization during the 1990s. *Empire*, a key text of postcolonialist geopolitical theory written by the political philosophers Michael Hardt and Antonio Negri in the nineties and published in 2000, proposes that the Western colonial powers have, since 1989, been replaced with the juggernaut of global capitalism. *The World Is Flat: A Brief History of the Twenty-First Century*, published by the *New York Times* journalist Thomas L. Friedman in 2005 is, despite its ironic title, an economic history of the 1990s, tracing the spread of globalization as a by-product of the post-Communist neoliberal economy and the digital revolution. While *Empire* achieved the rare feat of "crossing over" from the academic to the mainstream book market, *The World Is Flat* was so popular that it was almost instantaneously revised and reprinted in 2006 and 2007. Both nearly five hundred pages long, these books were a far cry from the typical best seller, yet their success testified to a remarkable public thirst to understand the socioeconomic changes of the 1990s.[3]

In the art world, the most obvious results of nineties-era globalization were the swelling of the art market and the exponential proliferation of international art fairs and biennials. As the art historian Terry Smith has noted, these events had two, in many ways contradictory, effects. On the one hand, the explosion of the international art market resulted in the creation of a formidable

1. Michael Hardt and Antoni Negri, *Empire* (Cambridge, Mass., and London: Harvard University Press, 2000), xi–xii. Their emphasis.

2. Thomas L. Friedman, *The World Is Flat: A Brief History of the Twenty-First Century, Further Updated and Expanded, Release 3.0.*, 3d ed. (New York: Picador/Farrar, Straus and Giroux, 2007), 10.

3. Globalization had been debated in academic discourses for some time. Frederic Jameson was instrumental in its early theorization in relationship to culture. In 1991, he identified a "new system" that he termed "late capitalism," the "cultural logic" of which is postmodernism. He characterizes late capitalism by the "transnational division of labor," as well as "a vertiginous new dynamic in international banking and the stock exchanges"; changes in technology, particularly the "new forms of media interrelationship [caused by] computers and automation"; "the flight of production to Third World areas"; and "all the more familiar social consequences, including the crisis of traditional labor, the emergence of yuppies and gentrification on a now-global scale" (Fredric Jameson, *Postmodernism, or, the Cultural Logic of Late Capitalism* [Durham, North Carolina and London: Duke University Press, 1991], xix). In the early nineties the term "globalization" had not yet entered the common vernacular; by 1998, when Jameson returned to the subject, it had, although he draws a distinction between postmodernism and globalization. He defines the latter as "a communicational concept, which alternatively masks and transmits cultural or economic meanings," and which is tied to innovations in "communicational technologies" (Frederic Jameson, "Notes on Globalization as a Philosophical Issue," in *The Cultures of Globalization*, ed. Fredric Jameson and Masao Miyoshi [Durham, North Carolina, and London: Duke University Press, 1998], 55).

4. Terry Smith, *What Is Contemporary Art?* (Chicago and London: University of Chicago Press, 2009), 7.

5. Ibid, 7–8.

6. *La multiplication des images du globe terrestre est un des symptômes du reserrement de la communication et des liens, médiatiques et personnels, entre les hommes sur la planète* (Jean-Hubert Martin, "Préface," *Magiciens de la terre* [Paris: Editions du Centre Pompidou, 1989], 8). My translation.

7. For in-depth analyses of these exhibitions, see Rachel Weiss et al., *Making Art Global, Part 1: The Third Havana Biennial 1989*, Afterall Exhibition Histories series (London: Afterall Books, 2011); and Lucy Steeds et al. *Making Art Global, Part 2: Magiciens de la Terre 1989*, Afterall Exhibition Histories series (London: Afterall Books, 2013).

8. For a useful critical analysis of the exhibition, see Carol Becker, "The Second Johannesburg Biennale," *Art Journal* 57 (Summer 1998): 86–107.

9. Okwui Enwezor, "Introduction: Travel Notes: Living, Working, and Travelling in a Restless World," *Trade Routes: History and Geography: the 2nd Johannesburg Biennale* (Johannesburg, South Africa: The Greater Johannesburg Metropolitan Council, and The Hague, The Netherlands: The Prince Claus Fund for Culture and Development, 1997), 8.

star system of (predominantly Western, white, male) artists and "the embrace by certain artists of the rewards and downsides of neoliberal economics, globalizing capital, and neoconservative politics."[4] On the other, the waning of the old colonial geopolitical structure led to the success of many artists from former "second-" and "third-world" nations that did not previously participate in the art world; and with this shift came "a plethora of art shaped by local, national, anticolonial, independent, antiglobalization values (those of identity, diversity, and critique)." He dubs this phenomenon "the postcolonial turn."[5]

Some of the principal sites in which this dynamic—what one might call the dialectic of art-world globalization—both emerged and was scrutinized were international group exhibitions. These shows' monumental scale and, quite literally, global ambitions were born of and played into the accelerating international art market; yet they also attempted to critique the effects of economic globalization in general and on the art market in particular. One of first such exhibitions was *Magiciens de la terre* (Magicians of the Earth), a sweeping pan-cultural survey co-organized in 1989 by the Centre Pompidou and the Grande Halle de la Villette, Paris, which sought to draw connections between contemporary Western art and that of Africa, Asia, and Latin America. As its lead curator, Jean-Hubert Martin, writes in the catalogue, "The multiplication of images around the globe is one of the symptoms of the strengthening of communications and connections, in the mass media and in personal relations, between people on the planet."[6] Widely criticized for its Eurocentric perspective and exoticization of non-Western cultures, the exhibition nonetheless set a precedent (or arguably anti-model) for exhibitions seeking to examine the intensifying pull of globalization. That same year saw the Third Havana Biennial in Cuba, which in its attempt to represent cultures from every corner of the world, represented the first self-consciously "global" biennial, forging a new model for the many international biennials that followed it.[7]

The first large-scale exhibition fully to embrace a postcolonialist perspective on globalization came some eight years later, with the Second Johannesburg Biennial (one of the spate of new international biennials that emerged during the 1990s).[8] Entitled *Trade Routes: History and Geography*, it was curated by Okwui Enwezor. In the exhibition catalogue, Enwezor observes, "Today, it is evident that the world is quickly changing. The question then is whether this unprecedented flurry of active ties and events called globalization . . . leads not to transformation but to displacement."[9] Seeking to call attention to those, primarily from emerging and

traditions. *Pratibimba #3* (1998–2002) is one of a series of three self-portraits, the title of which refers to a Sanskrit word for "reflection." In them, she dresses in costume as a fantastical combination of geisha, goddess, and manga-style cyber-heroine: a meditation on images of women in both ancient and contemporary culture.

Glenn Kaino's large-scale installations often engage with issues surrounding postcolonialism, as well as the rise of digital culture. (Since the nineties, the artist has also maintained a parallel career in technology.) *The Siege Perilous* (2002) consists of an Aeron chair, spinning rapidly on its axis and encased within a Plexiglas vitrine. As the artist notes, Aeron chairs were often found in the offices of nineties-era Internet start-ups; this slyly humorous work positions the chair as an artifact and icon of that dizzying age.[13] A fixture on the Los Angeles art scene since the late 1990s, Kaino co-founded the influential Deep River Gallery in Chinatown; intended to "move the dialogue of the periphery to the center," the gallery was designed from its inception to exist for only five years (1997–2002).[14]

Kaino's Los Angeles colleague Frances Stark works in multiple media with a large range of themes, producing a prodigious body of works on paper, a medium that lends itself particularly well to her recurring explorations of shifting technologies, verbal language, music, literature, and the histories of art, especially book arts. In 1993 she received her MFA from Art Center College of Design, where her studies with Mike Kelley had a marked influence on her work, and subsequently became active in L.A.'s community of young artists. Her 1999 *Chinatown Poster* commemorates this scene; she has commented:

> The Black Flag bars spray-painted on the side of a Chinese bank managed to escape airbrushing on a Chinatown postcard. This was later highlighted in a silkscreened poster announcing an exhibition of mine at China Art Objects Galleries: WHAT PART OF NOW DON'T YOU UNDERSTAND? The graffiti indexes the punk scene in the neighborhood twenty years before its then new, and readily celebrated, resurgence in non-tourist (counter)cultural activity.[15]

As the development of digital technologies accelerated, anxieties about the implications of these changes also mounted, culminating in the widespread panic concerning the Y2K bug, which, it was rumored, would destroy multiple financial and other digital systems when the systems reset at midnight on January 1, 2000. One of the most prominent Internet artists to explore the implications of programming, code, and hacking was Mark Napier, whose work appeared in key early Internet art exhibitions including *010101: Art in Technological Times* at the San Francisco Museum of Modern Art

13. Glenn Kaino, interview with the author, March 16, 2013.

14. Ibid.

15. Frances Stark, *Frances Stark: Collected Works* (Eindhoven, The Netherlands: Van Abbemuseum, and Cologne: Verlag der Buchhandlung Walter König, 2007), 39.

and the 2002 Whitney Biennial. His web-based work *Riot* (2000) functioned on the model of an Internet browser, retaining information from sites that the user had previously viewed. The resulting artwork is a scrambled, ever-shifting collage of texts, images, and links: a surreal glimpse into the burgeoning netscape.

Increasingly, however, digital artists turned their attention to the shifts in personal identities and social interactions that the Internet created. In the most literal sense, digital role-playing was on the rise, reaching its apotheosis with "simulations"—video games, such as *The Sims* (2000) and *Second Life* (2003), which allowed players to assume avatars with which they could lead alternate online lives. Many artists used the phenomenon of mutating online identities as a springboard for critical explorations of difference. Prema Murthy's 1999 *Bindi Girl* is an Internet-based work critiquing stereotypes of South Asian women in the mass media. Sexually explicit, the work juxtaposes an avatar of a South Asian woman— the titular Bindi Girl—against Indian music; the girl enacts a series of provocative poses playing on elements of South Asian fashion and beauty traditions, with their inherent and perceived eroticism. The message of the work is summed up by Murthy's quotation of the Kama Sutra on the site's home page: "Women are hardly known in their true light, though they may love men, / or become indifferent toward them; may give them delight, / or abandon them; or extract from them all the wealth that they possess."

Marina Zurkow was a key figure in the New York Internet art community of the 1990s. After working in film, she began creating digital art at the beginning of the decade, collaborating with Razorfish and other early commercial sponsors in the city's Silicon Alley tech corridor. She was also active in the growing community of women in technology, fostered through institutions such as Echo NYC and Word.com. Zurkow created *Braingirl* (2000–2003) as a nine-episode, science fiction–inspired animated series, designed for the Internet; the artist imagined that the website would be viewed surreptitiously from a personal computer at an office cubicle or school desk. One of a series of works in which Zurkow explored issues surrounding preteen girls, *Braingirl* is, according to the artist, about, "a mutant-cute girl who wears her insides on the outside, literally, . . . exploring how cartoons manifest our secret fears and desires upon the body."[16]

Blackness for Sale (2001), by the Igbo Nigerian–American artist team of Mendi + Keith Obadike, was an intervention into the online auction site eBay. The "sale," held in late August through early September 2001, invited viewers to bid on the hue of Keith Obadike's skin, provoking a dialogue on and critique of the meaning of skin

16. Marina Zurkow, "Braingirl: Overview," http://www.o-matic.com/play/braingirl/.

color in contemporary racial politics. This work was one of the first Internet art projects to engage with web "institutions" such as e-commerce sites (eBay itself was only six years old at the time), and was also one of the first web phenomena of any kind to "go viral," receiving a record number of hits. It was removed by eBay as "inappropriate" material after only four days (the sale was originally intended to run for eight). Although the controversy surrounding it died down suddenly after the terrorist attacks of September 11, 2001, it remains one of the most influential works in the history of Internet art.[17]

The turn of the millennium was arguably defined by 9/11, which, in the most extreme and tragic terms, brought to a crisis the issues of identities and difference, new technologies, and globalization that had been simmering throughout the 1990s. Like all aspects of cultural production, the visual arts reflected the geopolitical situation that arose in its aftermath, and while artists struggled to process these events in their work, the art market, like all sectors of the economy, suffered in the years that followed. As the 2000s progressed and the attacks' immediate impact receded, it became evident that globalization constituted the single most important factor shaping contemporary art: from the increased prominence of "itinerant" art stars working all over the world; to the proliferation of international art fairs and biennials; to the swelling of the global art market, which, even following the 2008 financial crisis, rebounded to unprecedented heights. The view from 2014 is hazy, for while it seems impossible (and, for many, undesirable) that the art market should continue to grow at such a pace, there is no end in sight; yet simultaneously, the situation for many artists seems increasingly untenable, with cities such as New York and London—the traditional cultural hubs—becoming unaffordable to all but the most successful creative people. What appears clear, however, is that the seeds of the current art world were sown during the 1990s, and that many of the sociopolitical and artistic issues that first crystallized during that decade remain very much in question today.

17. Mendi and Keith Obadike, interview with the author, June 12, 2013.

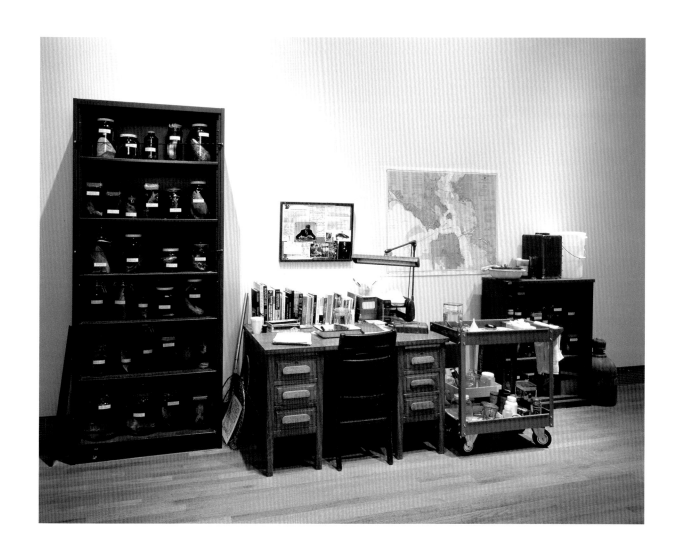

53 MARK DION (born 1961, USA)
*Department of Marine Animal Identification of the
City of San Francisco (Chinatown Division)* 1998

Mixed media
Dimensions variable

55 MARIKO MORI (born 1967, Japan)
Pratibimba #3 1998–2002
Acrylic Lucite with Cibachrome print
48 in. (121.9 cm) diameter
Ann and Mel Schaffer Family Collection

56 JODI (Joan Heemskerk, born 1968, Netherlands and Dirk Paesmans, born 1965, Belgium)
Untitled-Game (A-X, Q-L, Arena, Ctrl-Space) 1998–2002
untitled-game.org
Quake Game-Mod

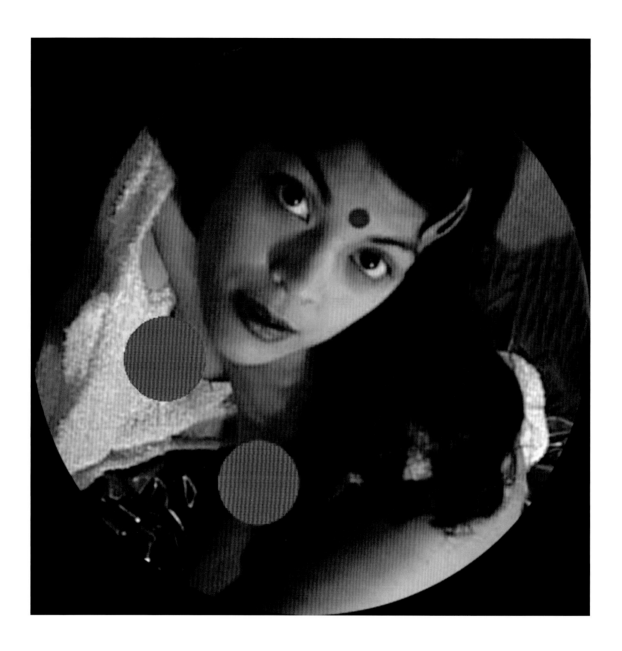

 PREMA MURTHY (born 1969, USA)
Bindi Girl 1999
http://www.thing.net/~bindigrl/
Website, display and dimensions variable

FRANCES STARK (born 1967, USA)
Chinatown Poster 1999
Print on paper
18⁵⁄₁₆ × 22¹⁵⁄₁₆ in. (46.4 × 58.1 cm)

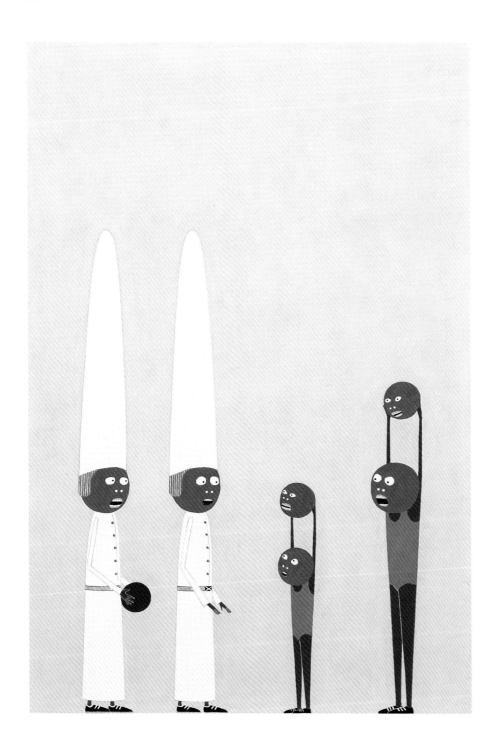

 LAYLAH ALI (born 1968, USA)
Untitled 2000
Gouache and pencil on paper
19 × 13 in. (48.3 × 33 cm)
Collection of A. G. Rosen

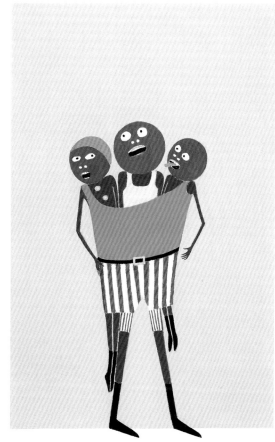

 LAYLAH ALI
Untitled 2000
Gouache and pencil on paper
6 × 4½ in. (15.2 × 11.4 cm)
Collection of A. G. Rosen

61 LAYLAH ALI
Untitled 2000
Gouache and pencil on paper
8 × 5 in. (20.3 × 12.7 cm)
Collection of A. G. Rosen

62 JULIE MEHRETU (born 1970, Ethiopia)
Untitled 2000
Ink, colored pencil, and cut paper on Mylar
18 × 24 in. (45.7 × 61 cm)
Collection of Nicholas Rohatyn and Jeanne
Greenberg Rohatyn

63 JULIE MEHRETU
Untitled 2000
Ink, colored pencil, and cut paper on Mylar
18 × 24 in. (45.7 × 61 cm)
Collection of Alvin Hall

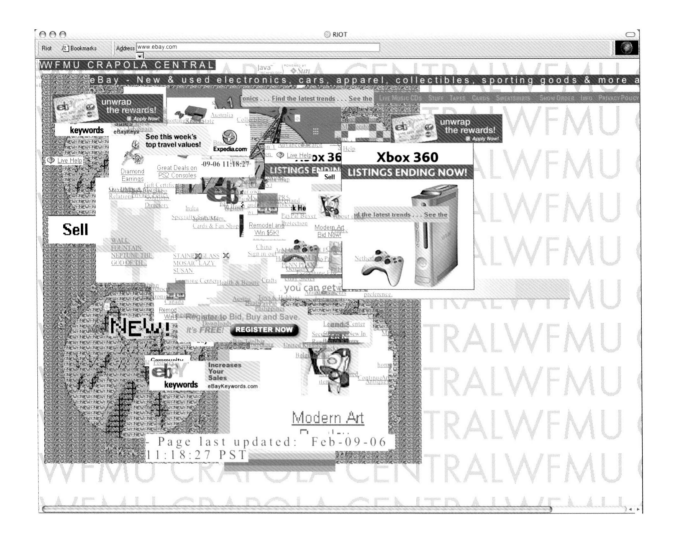

MARK NAPIER (born 1961, USA)

Riot 2000

http://potatoland.org/riot
Website, display and dimensions variable

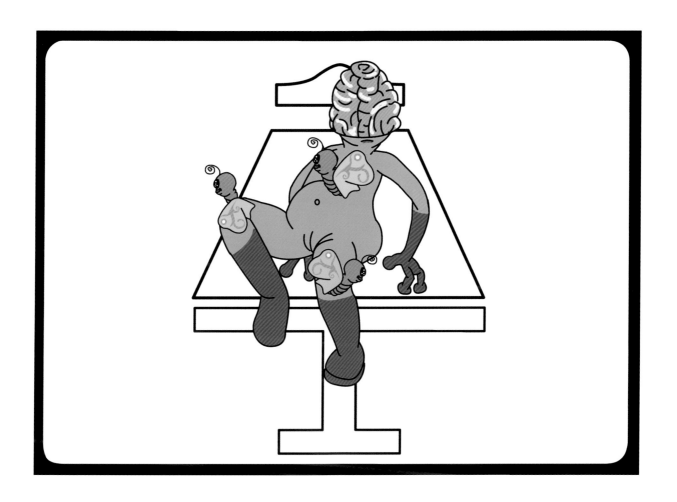

65 MARINA ZURKOW (born 1962, USA)
Braingirl, episode 5: Eyetest 2002

Nine-episode animated series
Created with Macromedia Flash and
distributed on DVD

	Keith Obadike's Blackness	
	Item #1176601036	

<u>Black Americana</u>

Fine Art

Description

Currently	$152.50		First bid	$10.00
Quantity	1		# of bids	12 <u>(bid history)</u> <u>(with emails)</u>
Time left	**6 days, 0 hours +**		Location	**Conceptual Landscape**
			Country	**USA/Hartford**
Started	Aug-8-01 16:08:53 PDT		✉ <u>(mail this auction to a friend)</u>	
Ends	Aug-18-01 16:08:53 PDT		🎁 <u>(request a gift alert)</u>	
Seller (Rating)	**Obadike**			

<u>(view comments in seller's Feedback Profile)</u> <u>(view seller's other auctions)</u> <u>(ask seller a question)</u>

<u>Watch this item</u>

High bid	**itsfuntobid**
Payment	Money Order/Cashiers Checks, COD (collect on delivery), Personal Checks
Shipping	Buyer pays actual shipping charges, Will ship to United States and the following regions: Canada
Update item	**Seller:** If this item has received no bids, you may <u>revise</u> it. <u>Seller revised</u> this item before first bid.

Seller assumes all responsibility for listing this item. You should contact the seller to resolve any questions before bidding. Auction currency is U.S. dollars ($) unless otherwise noted.

Description

This heirloom has been in the possession of the seller for twenty-eight years. Mr. Obadike's Blackness has been used primarily in the United States and its functionality outside of the US cannot be guaranteed. Buyer will receive a certificate of authenticity. Benefits and Warnings Benefits: 1. This Blackness may be used for creating black art. 2. This Blackness may be used for writing critical essays or scholarship about other blacks. 3. This Blackness may be used for making jokes about black people and/or laughing at black humor comfortably. (Option#3 may overlap with option#2) 4. This Blackness may be used for accessing some affirmative action benefits. (Limited time offer. May already be prohibited in some areas.) 5. This Blackness may be used for dating a black person without fear of public scrutiny. 6. This Blackness may be used for gaining access to exclusive, "high risk" neighborhoods. 7. This Blackness may be used for securing the right to use the terms 'sista', 'brotha', or 'nigga' in reference to black people. (Be sure to have certificate of authenticity on hand when using option 7). 8. This Blackness may be used for instilling fear. 9. This Blackness may be used to augment the blackness of those already black, especially for purposes of playing 'blacker-than-thou'. 10. This Blackness may be used by blacks as a spare (in case your original Blackness is whupped off you.) Warnings: 1. The Seller does not recommend that this Blackness be used during legal proceedings of any sort. 2. The Seller does not recommend that this Blackness be used while seeking employment. 3. The Seller does not recommend that this Blackness be used in the process of making or selling 'serious' art. 4. The Seller does not recommend that this Blackness be used while shopping or writing a personal check. 5. The Seller does not recommend that this Blackness be used while making intellectual claims. 6. The Seller does not recommend that this Blackness be used while voting in the United States or Florida. 7. The Seller does not recommend that this Blackness be used while demanding fairness. 8. The Seller does not recommend that this Blackness be used while demanding. 9. The Seller does not recommend that this Blackness be used in Hollywood. 10. The Seller does not recommend that this Blackness be used by whites looking for a wild weekend. ©Keith Townsend Obadike ###

Bidding

 MENDI + KEITH OBADIKE (both born 1973, USA)

Blackness for Sale 2001

Screen capture from archived website

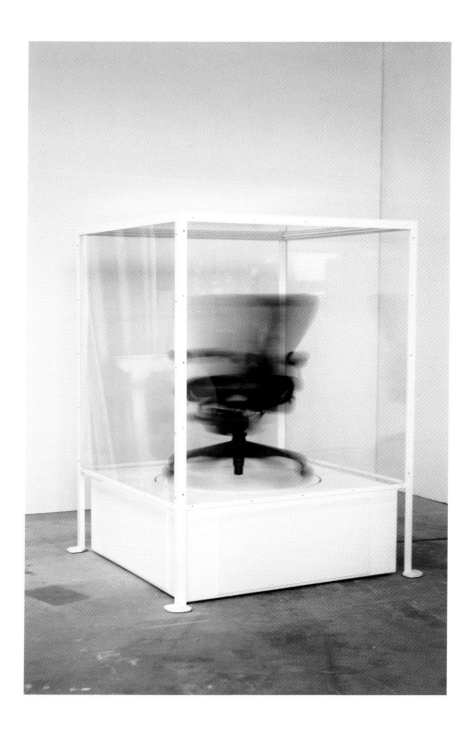

67 GLENN KAINO (born 1972, USA)
The Siege Perilous 2002

Aeron chair, Plexiglas, wood and steel base,
and mechanized component
65 × 49 × 49 in. (165.1 × 124.5 × 124.5 cm)
Collection of Bill Cisneros

Selected Chronology

FRANCES JACOBUS-PARKER

ART IN THE 1990s

CULTURE AND SOCIETY IN THE 1990s

1989

Exhibitions

China/Avant-garde, The National Art Gallery, Beijing, Feb. 5–19, curated by a committee led by Gao Minglu. Conceived as a national showcase for experimental art in opposition to state-sponsored art, the exhibition includes artists such as Cai Guo-Qiang and Xu Bing who later become prominent internationally, and help to raise the global profile of Chinese contemporary art.

American artist Cady Noland debuts at American Fine Arts, New York, Apr. Noland's use of scattered, found materials and conceptual approach to sculpture will influence major artists of the 1990s. Colin de Land's SoHo gallery, American Fine Arts (1984–2004), will become legendary on the basis of such groundbreaking exhibitions.

A Forest of Signs: Art in the Crisis of Representation, Museum of Contemporary Art, Los Angeles, May 7–Aug. 13, curated by Ann Goldstein and Mary Jane Jacob. This benchmark survey of neo-conceptual and appropriation art of the 1980s includes works by thirty American artists, half of whom are connected to the California Institute of the Arts (CalArts).

Les Magiciens de la terre, Centre Georges Pompidou and Grande Halle de la Villette, Paris, May 18–Aug. 14, curated by Jean-Hubert Martin. Conceived as a response to the stereotyping of non-Western art by Western museums, and in particular to MoMA's 1984 *"Primitivism" in 20th Century Art: Affinity of the Tribal and Modern*, *Magiciens* consists of contemporary works by 100 artists, half from the world's "centers" and half from its "margins." The exhibition claims to be the "first world-wide exhibition of contemporary art," and is groundbreaking for placing Western and non-

National and International Events

Jan. 20: George H. W. Bush is sworn in as the 41st president of the United States.

Mar. 24: *Exxon Valdez* runs aground and spills 11 million gallons of oil into Alaska's Prince William Sound, destroying wildlife.

Mar. 26: The Soviet Union holds parliamentary elections; the Communist Party is defeated and Boris Yeltsin, leader of the non-Communist opposition, gains power.

June 3–4: In China, government tanks open fire on students protesting for democracy in Beijing's Tiananmen Square. One million people demonstrate, and at least a thousand are killed.

June 4: Iranian religious and political ruler Ayatollah Khomeini, the leader of the 1979 Iranian Revolution, dies.

July 3: The Supreme Court upholds a Missouri abortion law, allowing states to place restrictions on funding and performing abortions.

Oct. 30: Massachusetts becomes the second state to ban discrimination on the basis of sexuality.

Nov. 9: The Berlin Wall falls. East Germany opens the border to West Berlin. In the months before and after communism loses ground in Poland, Czechoslovakia, Romania, Bulgaria, and Hungary.

Dec. 2–3: President Bush and U.S.S.R. leader Mikhail Gorbachev meet in Malta Summit, marking the end of the Cold War.

Dec. 20: U.S. forces invade Panama with the aim of deposing General Manuel Noriega.

Western objects in conversation; it is criticized for its emphasis on the spiritual and for reiterating neo-colonial divides.

Electronic Print, Arnolfini Centre for Contemporary Arts, Bristol, UK, Oct. 14–Nov. 26, curated by Martin Rieser. The exhibition is considered the first international survey of digital printmaking.

Witnesses: Against Our Vanishing, Artists Space, New York, Nov. 16–Jan. 6, curated by Nan Goldin. *Witnesses* is the first substantial exhibition of works to address the AIDS crisis, including work by and about those suffering from the virus. The National Endowment for the Arts (NEA) revokes a $10,000 grant to Artists Space on the basis of a catalogue essay by David Wojnarowicz that is deemed to violate new congressional restrictions on the funding of "obscene" material, but the decision is overturned in the face of widespread protest.

Annuals, Biennials, and Others

Bienal de La Habana, Havana, Cuba, Nov. 1–Dec. 31, curated by a team from the Wifredo Lam Center led by Lilian Llanes Godoy and Gerardo Mosquera. The 3rd Havana Bienal includes works by artists from Latin America, the Caribbean, Africa, Asia, and the Middle East. The Bienal's thematic, transnational, and discursive curatorial approach will inform the exhibition of global contemporary art in the 1990s.

Other Arts

Two exhibitions of photography indirectly funded by the NEA generate controversy: U.S. Senators Alfonse D'Amato and Jesse Helms speak out against Andres Serrano's *Piss Christ.* In June, over 100 members of Congress write to the NEA to protest *Robert Mapplethorpe: The Perfect Moment,* a retrospective organized by the Institute of Contemporary Art, Philadelphia, on the grounds that it contains obscene and pornographic material. The Corcoran Gallery's subsequent decision not to host the Mapplethorpe exhibition prompts widespread outcry in the arts community. In July, Congress cuts $45,000 from the NEA budget. Senator Helms introduces an amendment banning NEA grants for art that is "indecent" or "offensive"; the amendment is defeated in Sep., but another bill passes that ban's support of work deemed legally

obscene, and establishes a commission to evaluate the NEA's funding standards.

Women's Health Action and Mobilization (WHAM!) forms in New York City in response to the U.S. Supreme Court ruling allowing states to bar the use of public money for abortions. In Dec., ACT UP (AIDS Coalition to Unleash Power) and WHAM! organize "Stop the Church" at St. Patrick's Cathedral, a protest against the Catholic church's stance on sex education, contraception, homosexuality, and abortion. Other collectives formed in the 1980s, such as Gran Fury and Group Material, continue to work at the intersection of art and activism.

Barbara Kruger creates a poster, *Untitled (Your Body is a Battleground)*, for a pro-choice march on Washington.

Thomas Krens is appointed director of the Solomon R. Guggenheim Museum, New York.

Richard Serra's *Tilted Arc* (installed 1981) is removed from Federal Plaza, New York, after a nine-year court case and a decade of heated debate over its merits as public art, Mar. 5. Art historians Rosalind Krauss, Douglas Crimp, and Benjamin Buchloh speak in favor of the sculpture's preservation at a public hearing, while the *New York Times* declares it the "ugliest outdoor work of art in the city."

Art-market prices continue to rise. Picasso's *Yo Picasso* (1901) sets a record for a work of twentieth-century art when it sells at auction for $47.85 million.

In Los Angeles, Stuart Regen (son of Barbara Gladstone) and his wife Shaun Caley Regen found the Stuart Regen Gallery in West Hollywood, opening with a show of the work of Lawrence Weiner, Dec. 1989–Jan. 1990. Renamed Regen Projects in 1993, the gallery becomes a central force in the city's contemporary art scene, representing artists such as Matthew Barney, Catherine Opie, and Lari Pittman.

Ralph Rugoff writes "Liberal Arts," an article about the CalArts scene in *Vogue*, launching a string of articles by other writers on Los Angeles MFA programs. (Dennis Cooper, "Too Cool for School," *Spin*, 1997; Andrew Hultkrans, "Surf and Turf," *Artforum*, 1998; Deborah Solomon, "How to Succeed in Art," *New York Times Magazine*, 1999).

ART

CULTURE AND SOCIETY

Film and TV

Steven Soderbergh's *sex, lies, and videotape* premieres at the Sundance Film Festival in Jan. Subsequently winning the Palme d'Or at the Cannes Film Festival, it is one of the first independent films to "cross over" as a mainstream hit, earning over $36 million worldwide and signaling a renaissance in American independent cinema.

The success of new TV shows such as Fox's *Cops* spurs programs that show extreme violence and rely on footage of real events.

In Los Angeles, Gary Kornblau founds the bimonthly journal *Art Issues* (1989–2001), in which Christopher Knight, David Pagel, and Dave Hickey will publish criticism throughout the 1990s.

Exhibitions

Contemporary African Artists: Changing Tradition, The Studio Museum in Harlem, New York, Jan. 21–May 6. Curator Grace Stanislaus's display of works by nine contemporary artists from six African countries seeks to break down monolithic conceptions of "African art" and bring formal and critical considerations to bear on non–Western contemporary art.

The Köln Show, various locations, Cologne, Apr. 24– May 26. Staged by nine Cologne-based galleries seeking to circumvent institutional channels, this show examines art production and commerce in Cologne in the 1980s.

The Decade Show: Frameworks of Identity in the 1980s, Museum of Contemporary Hispanic Art, New York; Studio Museum in Harlem; New Museum of Contemporary Art, New York; May 12– Aug. 19. This interdisciplinary retrospective of the 1980s, organized by a team led by Marcia Tucker, brings together over 200 works by 94 artists of Asian, African American, Native American, and European heritage with a focus on exploring discourses of multiculturalism and identity politics, while disrupting the institutional homogenization of the 1980s.

Just Pathetic, Rosamund Felsen Gallery, Los Angeles, Aug. 4–31. Critic and curator Ralph Rugoff's show both surveys and identifies a recent turn to abjection, failure, and embarrassment manifested by artists such as Mike Kelley and Cady Noland. In the same year in New York, *Work in Progress? Work?* at Andrea Rosen Gallery and Vik Muniz's *Stuttering* at Stux Gallery further establish this trend, with works by Karen Kilimnik, Sean Landers, Cary Leibowitz, Laurie Parsons, Liz Larner, Matthew McCaslin, Linda Montano, and others.

Die Endlichkeit der Freiheit (The Finitude of Freedom), various locations, Berlin, Germany, Sep. 1– Oct. 7. In an event co-organized by Rebecca Horn, Jannis Kounellis, and Heiner Müller, and

National and International Events

Jan. 1: David Dinkins takes office as the first African American mayor of New York City.

Jan. 2: The Dow Jones closes at a record high.

Jan. 3: Manuel Noriega surrenders to American authorities and is extradited to the U.S. to face charges of drug smuggling. He is tried and found guilty in 1992.

Feb. 11: Anti-apartheid leader Nelson Mandela is released after 27 years in prison. South Africa begins to dismantle the apartheid regime.

Mar. 15: Mikhail Gorbachev is confirmed as president of the U.S.S.R. in the first free elections.

May 21: ACT UP (AIDS Coalition to Unleash Power) pickets the National Institutes of Health (NIH), demanding expanded HIV treatment trials.

July: The Dow crashes, ushering in a recession that lasts until March 1991, and putting an end to the strong economic growth, low inflation, and modest unemployment of the mid–late 1980s.

July 26: President Bush signs into law the Americans with Disabilities Act (ADA), prohibiting discrimination against people with physical or mental disabilities.

Aug. 7: The Gulf War begins with Operation Desert Shield, in which the U.S. sends troops to Saudi Arabia as part of an international response to Iraq's invasion of oil-rich Kuwait.

Aug. 18: The Ryan White CARE (Comprehensive AIDS Resource Emergency) Act is passed to increase funding for care to victims of AIDS. The Act is named for an 18-year-old who died of AIDS April 8.

Aug. 31: East and West Germany sign a treaty of reunification.

Sep. 11: President Bush's speech, "Toward a New World Order," celebrates a global trend toward democracy.

described as a "moral action, not an exhibition," artists such as Hans Haacke and Christian Boltanski install works in various sites around Berlin, reconfiguring public art as a form of temporary, site-specific intervention.

Felix Gonzalez-Torres debuts at Andrea Rosen, New York, Jan. 20–Feb. 24. Works in which viewers can take away broadsheets or candy pave the way for what will become known as "relational aesthetics." (He will die of AIDS in 1996).

Annuals, Biennials, and Others

44th Venice Biennale (*Dimensione Futuro: The Artist and Space)*, directed by Giovanni Carandente. Jenny Holzer becomes the first woman artist to represents the U.S., and receives the Golden Lion to boot. Curator Grace Stanislaus's *Contemporary African Artists: Changing Traditions* travels here, increasing the visibility of contemporary African art (and especially sub-Saharan art) on the international circuit.

Other Arts

A grand jury indicts Dennis Barrie, the director of the Contemporary Arts Center in Cincinnati, for misdemeanor obscenity charges on the basis of opening *Robert Mapplethorpe: The Perfect Moment.* Barrie is eventually acquitted. In Dec., Congress rules that NEA-funded artists must return grant money if their works are deemed legally obscene.

In May, a Japanese businessman buys Vincent van Gogh's *Portrait of Dr. Gachet* at Christie's for $82.5 million, the most paid for a work of art at auction. The sale marks the zenith of the market boom of the late 1980s, and will be followed by a recession that lasts into the late 1990s.

Curator Paul Schimmel arrives at Museum of Contemporary Art, Los Angeles. From 1990 to 2012 he will organize over fifty-two exhibitions, including the first major museum retrospectives of Allen Ruppersberg (1985), John Baldessari (1990), Ad Reinhardt (1991), Jeff Wall (1997), and Barbara Kruger (1999).

The Armand Hammer Museum of Art and Culture Center opens in Los Angeles; UCLA will manage the museum from 1994 on.

Artist Keith Haring dies of AIDS.

Oct. 1: The Tutsi-led Rwandan Patriotic Front invades Rwanda from Uganda, increasing unrest between Hutu and Tutsi populations.

Nov. 28: Margaret Thatcher resigns as prime minister of Britain; John Major replaces her as prime minister and as leader of the British Conservative Party.

Dec. 9: Lech Walesa of the Solidarity Party is elected president of Poland by a landslide.

Health

Homosexuality is removed from the World Health Organization's list of mental disorders.

The National Institutes of Health and the Department of Energy launch the Human Genome Project, an international scientific collaboration to map and sequence the human genome.

Science and Environment

An international panel of over 2,000 scientists publishes a report officially recognizing global warming.

A public campaign forces McDonald's to switch from polystyrene to paper packaging, signaling a rise in corporate accountability for environmental impact.

Technology

Adobe Photoshop is launched.

Microsoft Office is launched. Microsoft releases Windows 3.0, which will sell almost 30 million copies in a year.

Text

Judith Butler's *Gender Trouble: Feminism and the Subversion of Identity* establishes a critique of identity and theory of performativity that will influence the development of feminist and queer theory in the 1990s.

bell hooks's essay "Postmodern Blackness" critiques how the discourses of postmodernism have addressed experiences of difference and otherness.

Film and TV

A number of TV shows debuting this year will become mainstays of 1990s television, including *Seinfeld, Beverly Hills 90210* (which starts a trend for

Art critic Lucy R. Lippard publishes *Mixed Blessings: New Art in a Multi-Cultural America*, a groundbreaking analysis of multicultural and cross-cultural contemporary art with a focus on works by women and people of color.

teen shows), *Twin Peaks, In Living Color, The Fresh Prince of Bel-Air, Law & Order*, and *The Simpsons*.

Music

Kathleen Hanna, Billy Karren, Kathi Wilcox, and Tobi Vail form the band Bikini Kill (1990–97) in Olympia, Washington. The band is a pioneer of the riot grrrl movement, which draws on punk rock and feminist politics, and will include bands such as Sleater-Kinney, Bratmobile, and Helium, and alternative zines such as *Riot Grrrl* (started in Washington, D.C., by Bratmobile's Allison Wolfe and Molly Neuman), *Girl Germs, SNARLA*, and *The Opposite*.

Other

Michael Jordan lands a $6 million endorsement contract with Nike for his Air Jordan sneakers, which retail at $125.

In the U.S., 1,148,702 people are in prison or jail. The rate of incarceration had increased steadily since 1970, accelerates from the mid-1980s on, in part due to the "war on drugs." The increase in prison population in the 1990s will be 16 times the average of previous decades this century.

1991

Exhibitions

The West as America: Reinterpreting Images of the Frontier, Mar. 15–July 28, at the Smithsonian's National Museum of American Art in Washington, D.C., includes images of racial violence, sparking controversy over public funding.

Metropolis, Martin-Gropius-Bau, Berlin, Apr. 20–July 21. Curated by Christos Joachimides and Normal Rosenthal, this showcase of 1980s German and American art presents Cologne and New York as hubs of the avant-garde, and positions artists as heirs to Andy Warhol, Joseph Beuys, or Marcel Duchamp. Of 70 artists, only 7 percent are women, a fact that earns the show the nickname "Machopolis."

Africa Explores: 20th-Century African Art, the New Museum of Contemporary Art and the Center for African Art, New York, May 11–Sep. 18. Susan Vogel's blockbuster presents 133 works by artists from 15 countries, including many from sub-

National and International Events

Jan. 16: Operation Desert Storm begins in January with the aerial bombardment of Baghdad, and in February 500,000 international troops launch a ground assault on Iraqi forces in Kuwait. President Bush declares victory and a ceasefire on Feb. 28. His approval rating reaches a record 91%. CNN becomes the main source for coverage of the war, causing its prime-time audience to spike from 560,000 to 11.4 million.

Feb. 14: A new law in San Francisco allows homosexual and unmarried heterosexual couples to register as "domestic partners."

Feb. 25: The countries of the Warsaw Pact agree to dissolve the military treaty that had bound Central and Eastern European communist governments to the Soviet Union since 1955.

Mar. 3: Police in Los Angeles beat Rodney King, a 25-year-old black driver, after a high-speed chase.

Saharan Africa, and is celebrated as New York's first major exhibition of contemporary African art.

Places with a Past: New Site-Specific Art at Charleston's Spoleto Festival, Charleston, South Carolina, May 24–Aug. 4. Curator Mary Jane Jacob commissions 23 international artists to create installations related to the history of Charleston, resulting in a groundbreaking sociohistorical approach to site specificity.

Matthew Barney, Gladstone Gallery, New York, Oct. 19–Nov. 16. Barney's New York debut includes weight training and climbing apparatuses and a video of the artist navigating the gallery ceiling with ice hooks and wearing only a harness. Together with two solo shows in Los Angeles and San Francisco, and an appearance on the Sep. cover of *Artforum*, the exhibition establishes Barney's importance, and notoriety.

Dis*locations,* The Museum of Modern Art, New York, Oct. 20–Jan. 7, 1992. For his curatorial debut at MoMA, Robert Storr invites seven politically engaged artists to create installations in the museum, resulting in the first group show of installation art there since 1969, and demonstrating the rise of museums working directly with contemporary artists.

The Hybrid State, "Parallel Histories" series, Exit Art, Nov. 2–Jan. 25, 1992. Curators Jeanette Ingberman and Papo Colo present interpretive installations of the work of eight artists, emphasizing transcultural and multimedia hybridity. Coco Fusco curates the accompanying film program.

Jeff Koons, *Made in Heaven*, Sonnabend Gallery, New York, Nov. 23–Dec. 21. Representations of Koons and his wife having sex create a sensation. His work is subsequently excluded from most major surveys the following year.

Culture in Action, various sites, Chicago, 1991–93. Mary Jane Jacob's project for Sculpture Chicago employs artists to create eight public works in collaboration with community members across low-income areas of the city. The two-year project will produce a new model for socially oriented, public urban art based on community participation.

Annuals, Biennials, and Others

The Carnegie International, Pittsburgh, is notable for the prevalence of installation art.

The release of a video taken by a bystander provokes outcry, and the officers are charged.

June 12: Boris Yeltsin is elected president of the Russian Republic. A Communist coup against Mikhail Gorbachev on August 19 is unsuccessful; on December 25 Gorbachev resigns and the U.S.S.R. dissolves into 15 independent states.

June 25: Slovenia and Croatia declare independence from Yugoslavia.

Oct. 11: At Clarence Thomas's Supreme Court Senate confirmation hearings, University of Oklahoma law professor Anita Hill accuses Thomas of sexual harassment. The Senate votes to confirm Thomas on October 15.

Nov. 21: The Civil Rights Act of 1991 becomes law, reinstating protection from discrimination for job applicants and workers that had been eroded by conservative Supreme Court decisions in 1989.

Economy

The Big Three auto companies (Chrysler, Ford, and General Motors) lose $7.5 billion; U.S. companies cut 2,400 jobs per business day. Unemployment is at 6.8%. The period of slow economic, employment, and wage growth lasts until 1995.

Health

According to the CDC, one million Americans are infected with HIV. Rates of growth are most rapid among the poor, African Americans, Hispanic Americans, women, and children.

Technology

Linus Torvalds, a student at the University of Helsinki, releases the Linux kernel, a free and open-source operating system.

The first public version of the Web becomes available.

Text

Douglas Coupland publishes *Generation X: Tales from an Accelerated Culture.* Subsequently "Gen X" is commonly used to identify the generation born between the early 1960s and early 1980s.

Bret Easton Ellis's *American Psycho* is published.

Fredric Jameson publishes *Postmodernism, or, the Cultural Logic of Late Capitalism*, a Marxist critique of modernism and postmodernism.

Other Arts

Jeff Koons's *Michael Jackson and Bubbles* (1988) fetches 5.6 million GBP at Sotheby's auction.

Jeff Koons is declared in breach of copyright for his appropriation of pictures of puppies from a greeting card, a ruling that the Supreme Court will uphold.

David A. Ross is appointed director of the Whitney Museum of American Art. In 1998 he will leave the Whitney for the San Francisco Museum of Modern Art where, by the time of his departure in 2001, he will have spent $140 million building the contemporary art collection.

In Los Angeles, artist Russell Crotty and designer Laura Gruenther open The Guest Room in a spare bedroom in their house in the Rampart neighborhood, Jan. 1991–Apr. 1992. The informal gallery will host such noteworthy shows as Frances Stark's 1991 installation (and L.A. debut) *Total Babe.*

Frieze magazine publishes its inaugural issue.

Australian art collective VNS Matrix produces the multimedia *Cyberfeminist Manifesto for the 21st Century*, drawing on Donna Haraway's *A Cyborg Manifesto* (1985) in order to theorize a feminist politics of digital technology.

Film and TV

Richard Linklater's film *Slacker* is released. The term "slacker" becomes a catchphrase to describe disaffected nineties' youth.

Other

Queen lead singer Freddie Mercury dies of AIDS, just one day after announcing he has the disease.

L.A. Lakers star Earvin "Magic" Johnson announces his retirement from basketball and his status as HIV positive.

1992

Exhibitions

Helter Skelter: L.A. Art in the 1990s, Museum of Contemporary Art, Los Angeles, Jan. 26–Apr. 26. Curator Paul Schimmel's showcase of early nineties L.A. art and culture includes work by 10 writers and 16 artists, and engages themes of nihilism, violence, and sexuality. Though criticized for its underrepresentation of women and minorities, and seen by some as sensationalist, the show helps to establish Los Angeles as a contemporary art hub rivaling New York.

Mark Dion debuts at American Fine Arts, New York, Apr.

Mining the Museum, curated by Lisa Corrin, Maryland Historical Society, with the Contemporary Museum, Baltimore, Apr.–Feb. 1993. Fred Wilson's historic installation presents objects relating to the history of slavery in the collection of the

National and International Events

Feb. 7: 12 European Community countries sign the Maastricht Treaty, creating the European Union (takes effect 1993).

Mar.: Fighting between Serbs, Croats, and Bosnian Muslims marks the start of the Bosnian War. In November the U.N. condemns Bosnian Serbs, backed by Serbia, for "ethnic cleansing," including the rape and massacre of civilian populations. On December 20 Slobodan Milošević is reelected president of Serbia.

Apr. 29: Three days of rioting in South Central L.A. follow the acquittal by a predominantly white, suburban jury of the police officers charged in the 1991 beating of Rodney King. Fifty die and over $1 billion in property is damaged.

June 28: An earthquake of 7.4 on the Richter scale strikes Southern California.

Maryland Historical Society, exposing troubling and repressed histories, and bringing institutional critique to bear on postcolonial and multicultural discourses.

Post Human, FAE Musée d'Art Contemporain, Lausanne, June 14–Sep. 13 (tours Turin, Athens, and Hamburg, 1992–93). New York curator-dealer Jeffrey Deitch's exhibition examines the impact of technology on the body and interactions between humans and machines, including machine-made images.

Rirkrit Tiravanija, *Untitled (Free)*, 303 Gallery, New York, Sep. 12–Oct. 10. In a now legendary solo show, Tiravanija relocates the gallery's business operations to the front of house and, with the help of assistants, serves free Thai curry for the duration of the show out of a kitchen in the back. This and subsequent restagings establish Tiravanija as a central figure in relational aesthetics.

Annuals, Biennials, and Others

2nd Dakar Biennale (*Dak'Art*), Dakar, Senegal, directed by Amadou Lamine Sall. The first edition of the biennale to focus on contemporary art launches *Dak'Art* into the burgeoning international art circuit. Its 1996 shift toward African and African Diaspora artists makes it the primary international showcase of contemporary African art.

First Taipei Biennial, Taipei Fine Arts Museum, Taiwan. While initially national in focus, the 1998 adoption of a pan-Asian model will bring the event to international attention.

Documenta IX, Kassel, Germany, directed by Jan Hoet. Though dominated by New York– and Cologne-based artists, this is the first *Documenta* to include artists from Africa. Jeff Koons's exclusion becomes notable when, in an exhibition curated by Veit Loers in nearby Arolsen, the popularity of the artist's 43-foot topiary *Puppy* (1992) overshadows *Documenta* itself. The infamous terrier will be re-created and reinstalled in various international locations over the 1990s.

Other Arts

Led by acting chief Anne-Imelda Radice, the NEA denies funding to the exhibitions *Corporeal Politics* at MIT's List Visual Arts Center and *Anonymity and Identity* at the Anderson Gallery of Virginia Commonwealth University. In protest, novelist Wallace Stegner refuses his National Medal of

Nov. 2: Democrat Bill Clinton (Governor of Arkansas, age 46) and Al Gore are elected president and vice president with 43% of the popular vote, beating out Republican incumbents George Bush and Dan Quayle.

Dec. 9: U.S. military sends humanitarian aid to Somalia, where famine has killed 300,000.

Economy

Unemployment is at 7.5%, the highest level in eight years.

Health

The Nicotine patch is invented.

Science and Environment

U.N. Framework Convention on Climate Change marks the first international legal attempt to address global warming. At the meeting of 107 countries in Rio de Janeiro, President Bush declares prosperity a priority over environmental protection.

Technology

Digitized video is launched.

Ten thousand cellular phones have been sold in the U.S.

Fifty websites exist globally (by 2001 there will be over 28 million).

CDs surpass cassette tapes as a music-recording medium.

Microsoft founder Bill Gates becomes the richest American, with a net worth of $6.3 billion.

Text

John Gray's *Men Are from Mars, Women Are from Venus* is published.

Erika Reinstein and May Summer start Riot Grrrl Press in Washington, D.C.

Film and TV

MTV broadcasts *The Real World*, a show whose popularity spurs the growth of the reality television.

Arts; composer Stephen Sondheim had done the same earlier in the year. The rock band Aerosmith and playwright Jon Robin Baitz provide the missing exhibition funding.

Outraged by Supreme Court Justice Clarence Thomas's confirmation hearings, a group of friends in New York form the Women's Action Coalition (WAC).

Guggenheim Museum SoHo opens in New York.

Artist David Wojnarowicz dies from AIDS.

Music

Seattle-based band Nirvana releases *Nevermind*, and by Jan. the single "Smells Like Teen Spirit" reaches number one on the Billboard charts. Nirvana's success spurs the rise of other Seattle bands, including *Pearl Jam, Alice in Chains, Mudhoney*, and *Soundgarden*, and their sound, influenced by '70s punk and '80s metal, becomes known as grunge. The music will assert a pervasive hold over 1990s' fashion and popular culture.

Fashion

Designer Marc Jacobs launches a line for spring '93 that draws heavily on grunge fashion.

1993

Exhibitions

Parallax View: New York-Köln, P.S.1 Contemporary Art Center, Long Island City, Queens, Apr. 18–June 20. Daniela Salvioni's exhibition brings together German and American artists working in the vein of Minimalism and Conceptualism, including Cosima von Bonin, Mark Dion, Andrea Fraser, and Jutta Koether.

In Los Angeles, Bliss, a space run by Art Center College of Design students Jorge Pardo, Kenneth Riddle, and Gayle Barklie in a house in South Pasadena, shows Diana Thater's installation, *Up to the Lintel* (1992), in which films of the inside of the space as seen from the windows are projected onto the inside of the house, June 15. Inaugurated in 1987 with *The Neighborhood Art Show*, Bliss becomes a hub for the Art Center's aesthetics of installation, DIY, and domesticity. Bliss is part of a broader trend of informal galleries in Los Angeles, which includes Domestic Setting (Bill Radawec), Nomadic Site project (Charles LaBelle) and Project X (Ellen Birrell).

Real Time, Institute of Contemporary Arts, London, June 19–July 18. Gavin Brown's show includes artists such as Gabriel Orozco, Rirkrit Tiravanija, and Andrea Zittel, and is one manifestation of the rise of relational aesthetics.

Abject Art: Repulsion and Desire in American Art, Selections from the Permanent Collection, Whitney Museum of American Art, New York, June 23–Aug. 29. Organized by Whitney Independent Study

National and International Events

Jan. 1: Czech Republic and Republic of Slovakia formed.

Jan. 3: President Bush and Boris Yeltsin sign agreement on nuclear disarmament.

Feb. 11: Janet Reno is appointed U.S. attorney general, the first woman to hold the position.

Feb. 26: Muslim extremists bomb World Trade Center in New York; six die and hundreds are injured.

Apr. 19: Waco siege ends as FBI storm the Branch Davidian compound after a 51-day standoff; 72 die (almost a third are children) including David Koresh, 34, the leader of the religious sect.

Apr. 25: 750,000 march on Washington for gay rights and protection from discrimination for homosexuals.

Sept. 13: After a period of secret peace talks in Oslo between the governments of Israel and Palestinian Liberation Organization, the Oslo I Accord is signed at a ceremony hosted by President Clinton. Israeli Prime Minister Yitzhak Rabin and PLO Chairman Yasser Arafat shake hands.

Oct. 3–4: Two U.S. Black Hawk helicopters are shot down by Somali militia in Mogadishu, leading to a battle in which 18 U.S. soldiers and between 800 and 1,000 Somali soldiers and civilians die.

Oct. 15: The Nobel Peace Prize is awarded to Nelson Mandela and Frederik Willem de Klerk for

Program fellows Craig Houser, Leslie C. Jones, and Simon Taylor, this survey of abject art draws on Julia Kristeva's 1980 essay "Powers of Horror: An Essay on Abjection" and on the slacker trend.

Toba Khedoori, Catherine Opie, Jennifer Pastor, Frances Stark: Invitational '93, Regen Projects, Los Angeles, Oct. 7–30. According to Shaun Regen, the exhibition was a response to the "bad-boy" ethos of *Helter Skelter*, although the gallery made a point of never explicitly describing it as an all-women show.

On Oct. 25, British artist Rachel Whiteread completes her *Untitled (House)*, a concrete cast of the interior of a condemned terrace house in East London. Though she is awarded the 1993 Turner Prize, her landmark work is destroyed in early 1994 by vote of the local council.

Gavin Brown organizes the debut of Elizabeth Peyton, consisting of figurative charcoal and ink drawings displayed in a room at New York's Chelsea Hotel, Nov. 14 to 28. Six months later Brown opens his own gallery in SoHo.

Annuals, Biennials, and Others

1993 Whitney Biennial, Whitney Museum of American Art, New York. Curator Elizabeth Sussman's "political biennial" generates a critical firestorm but is later hailed as historic. Alongside Daniel Joseph Martinez's infamous entry buttons announcing "I Can't Imagine Ever Wanting to Be White," are other works by Jimmie Durham, Andrea Frasier, Renée Green, Byron Kim, Gary Simmons, Fred Wilson, Lorna Simpson, Mike Kelley, and Matthew Barney that deal explicitly and theoretically with issues of race, gender, and class. Thelma Golden co-organizes the exhibition.

45th Venice Biennale (*Punti cardinali dell'arte*), directed by Achille Bonito Oliva. This year's exhibition demonstrates a broader geographical reach, and *Aperto '93* is hailed for its presentation of emerging and non-Western artists. Louise Bourgeois represents the U.S. and Hans Haacke wins the Golden Lion for reducing the floor of the German pavilion to rubble.

Sonsbeek '93, Arnhem, Holland. For Valerie Smith's edition of the *Sonsbeek* International Sculpture Exhibition, artists such as Mark Dion and Mike Kelley produce projects across the city that participate in the related rise of relational aesthetics and site- and socially-specific public art.

ending apartheid regime. A new South African constitution comes into effect in April 1994.

Sept. 22: President Clinton delivers his address on health care reform to Congress. His Health Security Act, aimed at reforming health care and providing universal coverage, encounters fierce opposition and is defeated in Sept. 1994, leaving 35 million Americans without health insurance.

Dec. 21: "Don't ask, don't tell, don't pursue" becomes the official U.S. policy on gays serving in the military. The legislation is Clinton's compromise between those who want to repeal the ban on homosexuality in the military and those who want it upheld.

Technology

The adventure computer game *Myst* is launched and becomes the best-selling PC game of all time. Games such as *Doom* and *Quake* also become popular.

The first blog is published on the Internet.

Illinois college student Marc Andreessen invents Mosaic, an early Internet browser, and will go on to invent Netscape.

Intel Pentium computer chip debuts.

Peter de Jager's article, "Doomsday 2000," warns about the possibility of widespread computer malfunctions at the end of the millennium.

Health

AIDS is now the leading cause of death among people ages 25 to 44 in the U.S.

Text

Toni Morrison becomes the first African American woman to win the Nobel Prize in literature.

Olu Oguibe's editorial, "In the Heart of Darkness," points to the Western-centric biases of much history writing, and critiques dominant narratives of the relation between modernity and notions of "Africanity."

Film and TV

Philadelphia, the first major Hollywood film on AIDS, is released.

The first Sharjah Biennial, United Arab Emirates, and the first Asia-Pacific Triennial, Queensland, Australia, demonstrate the rise of biennials of non-Western art and the expansion of the international contemporary art circuit into non-Western countries.

The first New York Digital Salon, School of Visual Arts, Dec. 6–17. SVA's exhibition of emerging digital art will become an important annual showcase for intersections of art and technology, and pioneers the use of 3-D software for exhibition design.

Other Arts

In Jan., Tracey Emin and Sarah Lucas open *The Shop* in east London, a venue in which they make and sell collaborative work.

In May, Jay Jopling opens White Cube, a gallery in London's West End based on a model of one-off solo shows and no artist contracts. The gallery will become the hub of Young British Artists (YBAs) such as Tracey Emin and Damien Hirst later in the decade.

An Oct. 3 *New York Times Magazine* cover showing Pace Gallery dealer Arnold Glimcher and his all-white, all-male "art world all-stars" prompts WAC to picket Pace brandishing gorilla masks and dildos.

Dave Hickey publishes *The Invisible Dragon: Four Essays on Beauty*, articulating a belief in a "turn to beauty" that is shared by his LA colleagues Christopher Knight, David Pagel, and Gary Kornblau.

Hal Foster publishes "Postmodernism in Parallax" (*October* 102, Winter 1993), a response to Frederic Jameson's 1984 article, "Postmodernism, or, the Cultural Logic of Late Capitalism."

The journal *October* publishes "The Politics of the Signifier: A Conversation on the Whitney Biennial," a roundtable discussion on the recent turn to overtly political art.

Steven Spielberg's *Jurassic Park* brings in $712 million worldwide, making it the highest-grossing movie of all time.

New TV programs include *The X-Files*, *Frasier*, and *Beavis and Butt-head*.

Music

Nirvana releases *In Utero*, their third and final studio album.

Fashion

Designers such as Calvin Klein turn to minimalist fashion, promoting simple cuts and palettes of black, white, and gray.

Calvin Klein's ads for the perfume Obsession feature a waif-thin, mostly nude Kate Moss. The ads help to establish what becomes known as "heroin chic," are criticized for promoting drug use and unhealthy body image, and are condemned by President Clinton among others.

Other

The Pew Research Center begins polling the public on gun control: 57% of Americans prioritized gun control over gun rights.

Tony Kushner's *Angels in America, Part One: Millennium Approaches*, an epic play about the AIDS crisis, debuts on Broadway and will win a Pulitzer Prize.

Exhibitions

Bad Girls, New Museum of Contemporary Art, New York, Jan. 14–Feb. 27 and Mar. 5–Apr. 10. Marcia Tucker assembles over 60 works by women artists in a range of media, focusing on gender, feminism, and the subversive potential of humor. A companion exhibition, *Bad Girls West*, organized by Marcia Tanner for the Wight Art Gallery, University of California, Los Angeles, runs Jan. 25–Mar. 20.

Sense and Sensibility: Women Artists and Minimalism in the 1990s, The Museum of Modern Art, New York, June 16–Sep. 11. Lynn Zelevansky assembles works by seven women artists engaged with the legacy of Minimalism and, to some extent, the women's movement.

Mike Kelley: Catholic Tastes, Whitney Museum of American Art, New York, June 30–Aug. 11. Elisabeth Sussman's mid-career survey introduces a broader public to Kelley's exploration of abjection and the human body.

Kara Walker, *Gone, An Historical Romance of a Civil War as It Occurred Between the Dusky Thighs of One Young Negress and Her Heart* in *Selections Fall 1994: Installations* at The Drawing Center, New York, Sep. 10–Oct. 22. Walker's New York debut consists of a panoramic narrative scene set in antebellum South, in her signature black paper silhouette.

Japanese Art After 1945: Scream Against the Sky, Guggenheim Museum SoHo, New York, Sep. 14–Jan. 18, 1995. Alexandra Munroe's survey of postwar avant-garde Japanese art is the first in the U.S., and is credited with launching the art-historical field. *Pure Beauty: Some Recent Work from Los Angeles*, Museum of Contemporary Art, Los Angeles, Sep. 25–Jan. 8, 1995. Ann Goldstein's survey of seven emerging artists in Los Angeles includes projection and multimedia installations.

Black Male: Representations of Masculinity in Contemporary American Art, Whitney Museum of American Art, New York, Nov. 10–Mar. 5, 1995. Thelma Golden's multimedia survey of representations of black masculinity interrogates the "black male" as cultural icon. The show is controversial, and some view it as reiterating stereotypes that it purports to deconstruct.

National and International Events

Jan.: Justice Department begins Whitewater investigation of Bill and Hillary Clinton, accused of improper involvement in land development in Arkansas; government special counsel Kenneth Starr investigates.

Jan. 1: North American Free Trade Agreement (NAFTA) goes into effect, phasing out tariffs and trade barriers between U.S., Canada, and Mexico. The treaty increases trade between the U.S. and its neighbors, but many manufacturing jobs move to Mexico.

Jan. 1: The Zapatista Army of National Liberation revolts in Chiapas, Mexico, issuing their First Declaration to the Mexican government and protesting the signing of NAFTA.

Jan. 17: Northridge earthquake in Los Angeles kills 61 people and causes over $20 billion in damage.

Feb. 28: NATO enters the conflict in Bosnia-Herzegovina when the U.S. shoots down four Serbian jets.

Feb. 28: The Brady Handgun Violence Prevention Act goes into effect, mandating a five-day waiting period and background checks for prospective gun buyers.

Apr. 27: Nelson Mandela is elected president of South Africa. Black South Africans are granted the vote, marking the official end of apartheid.

Apr.–June: In the Rwandan genocide, an estimated 800,000 people are killed in 100 days. The international community largely fails to respond. The U.S. refuses to get involved after the failed intervention in Somalia the year before.

Aug. 31: The IRA announces a truce in Northern Ireland.

Nov. 8: Republicans win control of the House and Senate for the first time in 40 years. Newt Gingrich is elected Speaker of the House, and delivers his "Republican Contract with America," which advocates for welfare and education reform, lower taxes, increased free trade, and reduced deficit and government spending. Nine of the ten proposed bills pass the House, but only two become law.

Annuals, Biennials, and Others

In a concerted effort to globalize the contemporary market, Art Basel invites dealers from all over the world, a move that leads to its rise to the top of the art fairs.

The Gramercy International Art Fair, organized by dealers Colin de Land, Pat Hearn, Matthew Marks, and Paul Morris at the Gramercy Park Hotel, attracts 10,000–15,000 people. The fair will become the Armory Show in 1999.

Bamako Encounters (*Rencontres de Bamako*), Bamako, Mali. The biennial becomes the foremost regular exhibition of contemporary African photography and video.

Other Arts

In Barcelona, Joan Heemskerk and Dirk Paesmans found JODI.org, a digital arts collective that explores abstraction using code and operating systems to generate buried images.

So-called net artists such as Antoni Muntadas, Alexei Shulgin, and Heath Bunting launch the first websites-as-art.

Curator Benjamin Weil founds äda'web (1994–98), an online gallery for showing and producing Internet-based art; the site will debut in 1995 with Jenny Holzer's *Please Change Beliefs*.

The anonymous art collective Bernadette Corporation (1994–present) forms in downtown New York as hosts of a club night called "Fun," but will extend its humorous subversion of commerce and popular culture into the realms of fashion, publishing, filmmaking, object making, and activism.

Artist Matthew Coolidge founds the Center for Land Use Interpretation, a nonprofit collective that researches the impact of humans on the land and landscape.

Three Day Weekend, artist Dave Muller's event and gallery space, opens in Angeleno Heights, Los Angeles, with an exhibition of works by Andrea Bowers. The space will migrate around the city and eventually internationally, part of a trend of informal gallery spaces in Los Angeles.

In France, paintings dating back over 30,000 years are discovered in the caves of Chauvet-Pont-d'Arc.

Dec. 11: Russia invades Chechnya in an attempt to quash the republic's move toward independence. 100,000 will die in the subsequent war, which lasts until August 1996.

Economy

The economy begins to recover from the downturn of the early 1990s. Unemployment rates fall, a trend that will continue throughout the decade. During 1994–98, the Dow Jones Industrial Average will increase fourfold.

Education

A proposal for new standards for U.S. history curricula that recommends more coverage of topics such as racism and McCarthyism generates intense backlash from conservatives. In 1995, the Senate denounces the standards by a vote of 99 to 1.

Technology

Netscape Navigator 1.0 is released, and within a year and a half is used by 65 million people. The company will achieve the highest initial public offering in Wall Street history.

Text

Charles Murray and Richard J. Herrnstein publish *The Bell Curve: Intelligence and Class Structure in American Life*, sparking debates about the relation between IQ and heredity, and garnering accusations of racism.

Kobena Mercer's *Welcome to the Jungle: New Positions in Black Cultural Studies* articulates his theory of the "stereotypical grotesque," a strategy through which artists such as Kara Walker critique stereotype through exaggeration.

Homi K. Bhabha publishes *The Location of Culture*, a collection of essays that articulate his influential theory of cultural hybridity and examine the intersection of postcolonial theory and postmodernism.

Film and TV

The programs *Friends, ER, Ellen, My So-Called Life* debut on television.

Music

British band Oasis releases *Definitely Maybe*, an album that helps raise the popularity in the U.S. of other Brit Pop bands such as Blur, Pulp, and Radiohead.

Nirvana's lead singer, Kurt Cobain, commits suicide in Seattle.

Fashion

The Wonderbra push-up bra is released and becomes an instant success.

Tom Ford becomes the creative director at Gucci, and is credited with turning around the company and inspiring a turn toward sleek, elegant lines.

Other

Former First Lady Jacqueline Kennedy Onassis dies.

Former President Richard Nixon dies.

1995

Exhibitions

Matthew Barney's 1994 film, *Cremaster 4*, debuts in Apr. alongside an accompanying exhibition at Gladstone Gallery. The film is the first chapter of Barney's epic, infamous *Cremaster Cycle*, consisting of five feature-length films and related objects made between 1994 and 2002.

Mirage: Enigmas of Race, Difference, and Desire, ICA, London, May 12–July 16. In an exhibition and catalogue organized around the theories of Frantz Fanon, curator Emma Dexter, writer Kobena Mercer and others present multimedia work by eight contemporary artists whose work engages with critical race theory and issues of migration.

Reconsidering the Object of Art: 1965–1975, Museum of Contemporary Art, Los Angeles, Oct. 15–Feb. 4, 1996. Curators Ann Goldstein and Anne Rorimer's exhibition is the first comprehensive survey of Conceptual art.

"Brilliant!" New Art from London, Walker Art Center, Minneapolis, Oct. 22–Jan. 7, 1996. Curated by Richard Flood, the first major survey of YBAs is dominated by the work of graduates of London's Goldsmiths College and the Slade School of Fine Art.

National and International Events

Jan. 23: In his State of the Union address, Clinton declares that "the era of big government is over." He agrees to "end welfare as we know it," implementing "workfare" training and time limits on benefits.

Apr. 19: The bombing of a federal office building in Oklahoma City kills 169 and injures 614. Timothy McVeigh, a Gulf War veteran with antigovernment beliefs, is convicted and sentenced to death in 1997. His co-defendant, Terry Nichols, is sentenced to life without parole.

July 19: The Truth and Reconciliation Commission is established under Mandela's new post-apartheid government with the aim of documenting incidents of violence under apartheid from 1960 to 94.

Sep. 5: Hillary Rodham Clinton delivers a speech called "Women's Rights Are Human Rights" at the United Nations Fourth World Conference on Women in Beijing.

Oct. 3: Former football star O. J. Simpson is found not guilty of the 1994 murder of his ex-wife, Nicole Brown Simpson, and her companion, Ron Goldman, in Los Angeles. The trial reveals racial divides in America; according to a CBS News poll,

Annuals, Biennials, and Others

1995 Whitney Biennial, Whitney Museum of American Art, New York. Klaus Kertess's biennial focuses on art that is sensuous and poetic and, in the wake of the scandal of the 1993 Biennial, is embraced for its subtlety.

Gwangju Biennale, *Beyond the Borders*, Gwangju, Korea. Inaugurated as a memorial to the victims of a 1980 democratic uprising, the Biennale rises to prominence through its use of star international curators.

The 46th Venice Biennale is curated by Jean Clair of the Musée Picasso, Paris. Bill Viola represents the U.S. with his installation, *Buried Secrets*. Clair's large exhibition for the Italian Pavilion, "Identity and Alterity: Forms of the Body, 1895–1995," generates debate with its thematic and historic survey of representations of the body in art.

Other Arts

Congress reduces the NEA budget by 40 percent and declares that all NEA funds will end by 1997.

In Britain, advertising executive Charles Saatchi buys works by YBAs, raising their prices and international profile.

In Melbourne, Australia, Sotheby's holds the first auction of Aboriginal art, marking the beginning of an international boom in works by Aboriginal artists (few of whom see the profits).

The Nettime listserv, a salon and platform for Internet art, is established by Geert Lovink and Pit Schultz at the Medien Zentral Kommittee at the Venice Biennale.

The San Francisco Museum of Modern Art (SFMOMA), designed by Mario Botta, opens.

Ralph Rugoff publishes *Circus Americanus*, a collection of articles drawn from his column in *LA Weekly*.

Hal Foster publishes "The Artist as Ethnographer?," an essay identifying, and critiquing, an "ethnographic turn" in art since the 1960s.

Lucy R. Lippard publishes *The Pink Glass Swan: Selected Feminist Essays on Art*, a collection of two decades of essays on art and feminism.

78% of blacks think Simpson is innocent, while 75% of whites think he is guilty.

Oct. 16: Nation of Islam leader Louis Farrakhan leads the Million Man March on Washington, D.C.

Nov. 4: Israeli Prime Minister Yitzhak Rabin is assassinated by a right-wing extremist during a peace rally in Tel Aviv.

Nov. 21: The Dayton Peace Agreement ends the war in Bosnia; leaders of Bosnia, Croatia, and Serbia sign the final version in Paris on December 14.

Health

The first protease inhibitor—an antiviral drug—becomes available to treat patients with HIV/AIDS.

Science and Environment

NASA's *Pathfinder* lands on Mars, allowing its rover to document and analyze the planet in detail.

1995 is the hottest year on record, a fact seen by many as proof of global warming.

Technology

Sun Microsystems introduces the Java programming language.

eBay, an online auction house, is launched.

Microsoft launches Windows '95.

Bill Gates's staff memo, "The Internet Tidal Wave," emphasizes the importance of the Internet to Microsoft's future, predicting that the next 20 years will be defined by "exponential improvements in communications networks."

Yahoo! Inc., founded by Stanford graduate students Jerry Yang and David Filo in 1994, is incorporated.

Text

Intellectual historian David Hollinger publishes *Postethnic America: Beyond Multiculturalism*, critiquing pluralist notions of multiculturalism and calling for a cosmopolitan model based on individual rights and an understanding of shifting identity.

Film and TV

Buffy the Vampire Slayer airs.

Pixar's *Toy Story*, the first feature-length computer-animated movie, is a hit.

Other

One in three black men between the ages of 20–29 are in prison, jail, parole, or probation.

Exhibitions

Traffic, CAPC Musée d'Art Contemporain de Bordeaux, France, Jan. 26–Mar. 24. Curator Nicolas Bourriaud brings together artists who engage in what he calls "relational aesthetics," a term he will go on to theorize.

Inside the Visible: An Elliptical Traverse of 20th Century Art in, of, and from the Feminine, Institute of Contemporary Art, Boston, Jan. 31–May 12. Catherine de Zegher's landmark survey examines objects made by 37 international women artists, focusing on the 1930s–40s, 1960s–70s, and the 1990s.

Can You Digit?, Postmasters Gallery, New York, Mar. 16–Apr. 13. One of the primary commercial venues for new media art organizes a seminal exhibition of digital art consisting of 30 screen-based works.

Hall of Mirrors: Art and Film since 1945, Museum of Contemporary Art, Los Angeles, Mar. 17–July 28. Curator Kerry Brougher examines the interrelated history of art and cinema through an ambitious chronological survey of 90 postwar artists and filmmakers.

Takashi Murakami has his first U.S. solo show at New York's Feature, Inc. (Apr. 4–May 11) and at Gavin Brown's enterprise in the same year.

Damien Hirst's largest solo show to date is at Gagosian Gallery, New York, May 4–June 15.

NowHere, Louisiana Museum of Modern Art, Humlebaek, Denmark, May 15–Sep. 8. In a utopian curatorial experiment, director Lars Nittve invites curators Laura Cottingham, Anneli Fuchs, Lars Grambye, Iwona Blazwick, and Ute Meta Bauer to install works throughout the museum as a "mini-*Documenta*" of contemporary art.

L'informe: mode d'emploi (Formless: A User's Guide), Centre Georges Pompidou, Paris, May 22–Aug. 26. Co-curators Yve-Alain Bois and Rosalind Krauss reframe modernism through four categories generated by the writings of Georges Bataille: Base Materialism, Pulse, Horizontality, and Entropy.

In/Sight: African Photographers, 1940 to the Present, Solomon R. Guggenheim Museum, New York, May 24–Sep. 22. Claire Bell, Danielle Tilkin, Octavia Zaya, and Okwui Enwezor curate the first major exhibition of work by photographers of Afri-

National and International Events

Apr. 3: Unabomber Ted Kaczynski is arrested by FBI agents in Montana, charged with killing three people and wounding 23 via mail bombs over 18 years. He will be given four life sentences.

May 20: In a landmark case, the Supreme Court strikes down Colorado's Amendment Two, a 1992 constitutional amendment that banned the recognition of gays and lesbians as a protected class. The Court's ruling paved the way for the 2013 overturning of Defense of Marriage Act.

July 3: Boris Yeltsin is reelected as Russian president.

July 17: TWA Flight 800 explodes over Long Island, killing 230.

July 27: In Atlanta, a pipe bomb explodes during the Summer Olympic Games, killing one and injuring 111.

Aug.: CIA releases "Usama bin Ladin: Islamic Extremist Financier," one of U.S. government's earliest public statements detailing bin Ladin's ties to and financial support of extremist acts. In 1998 bin Laden would be declared a "Specially Designated Terrorist" and al-Qaeda a "Foreign Terrorist Organization."

Aug. 22: President Clinton signs the Personal Responsibility and Work Opportunity Act, altering welfare rules for 13 million people, ending entitlement status of welfare and denying welfare to new immigrants.

Sep.: Taliban comes to power in Afghanistan.

Sep. 21: President Clinton signs the Defense of Marriage Act, denying federal benefits for married gay couples and granting states the right to disregard same-sex marriages from other states.

Sep. 30: Congress passes a far-reaching immigration reform act meant to tighten border control; the attempt to stem illegal immigration is later seen as unsuccessful.

Nov. 5: President Clinton and Vice President Al Gore are reelected for a second term, defeating Kansas senator Bob Dole. Clinton is the first Democratic president to win a second term since 1964.

Nov. 27: A federal judge blocks the dismantling of affirmative-action programs in California.

can descent, focusing on works that engage with representations of Africa and African identities.

Mediascape, Guggenheim Museum SoHo, New York, June 14–Sep. 15. Curators John Hanhardt and Jon Ippolito display contemporary interactive media art alongside historic video art from the 1960s and '70s.

Contemporary Art of Asia: Traditions/Tensions, Asia Society, New York, Oct. 3–Jan. 5, 1997. Apinan Poshyananda curates one of the first major exhibitions to explore Asian art in the 1990s.

Serious Games: Art, Technology and Interaction, Laing Art Gallery, Newcastle upon Tyne, UK. Nov. 16–Feb. 9, 1997. Curator Beryl Graham assembles work by artists from the UK, Japan, and North America that is interactive in both low-tech and high-tech ways, suggesting a pre-computer history to the contemporary interest in technological interactivity and game theory.

Annuals, Biennials, and Others

A number of biennials debut on the international circuit: the Berlin Biennale, founded by Klaus Biesenbach; the Shanghai Biennial, and the Mercosul Biennial in Porto Alegre, Brazil.

Rotterdam hosts the first *Manifesta*, a roving biennial with the aim of increasing dialogue between eastern and western Europe, to be held in a different European city deemed socially and politically relevant.

Other Arts

In Jan., Congress cuts NEA funding under pressure from conservatives.

Artist Felix Gonzalez-Torres dies of AIDS.

Jeffrey Deitch opens Deitch Projects in New York after working as an art advisor at Citibank and independently.

Mark Tribe founds Rhizome.org, a public online forum for new media art.

Peter Halley and Bob Nickas launch *index* (in print Feb. 1996–Nov. 2005). Initially a fanzine, the magazine's interviews of up-and-coming artists, musicians, filmmakers, and designers quickly make it an influential chronicle of '90s' indie culture.

In his essay "Obscene, Abject, Traumatic" (*October* 78, Autumn 1996), Hal Foster assesses the present and future of abject art, suggesting a distinction

Health

The AIDS death rate peaks. Highly active antiretroviral therapy (HAART) becomes widely available, leading to the first decline in the number of newly diagnosed AIDS cases in the U.S. and a decline in the number of deaths among those with AIDS (from 1995 to 2001 the annual number of AIDS-related deaths falls 70%). AIDS remains the leading cause of death for African Americans ages 25 to 44.

Technology

Palm Inc. releases the PalmPilot, a handheld personal digital assistant (PDA) that will dominate the market.

For the first time, personal computer sales surpass that of televisions.

The free Internet e-mail service Hotmail debuts.

Microsoft releases Internet Explorer 3.0 in an attempt to compete with Netscape Navigator, a rivalry known as the "browser wars."

Nintendo 64 video game goes on sale in the U.S.

Text

Arjun Appadurai's *Modernity at Large: Cultural Dimensions of Globalization* examines the cultural ramifications of globalization, arguing for the replacement of a center-periphery model with one of intersecting and fluid "scapes."

Film and TV

The Rosie O'Donnell Show debuts on television.

Music

The Fugees album *The Score* sells 18 million copies, demonstrating the mass-market popularity of hip-hop.

Jonathan Larson's musical *Rent* opens. The rock musical about artists and musicians living in the Lower East Side during the AIDS crisis will go on to win a Pulitzer Prize and a Tony Award.

Fashion

Narciso Rodriguez's design for Carolyn Bessette Kennedy's wedding dress makes headlines for its simplicity and bias cut.

between the postmodernism of the 1980s and that of the 1990s.

Other

Starbucks invents the Frappuccino, capitalizing on the 1990s' coffee craze.

Oprah Winfrey introduces Oprah's Book Club, a discussion segment of her talk show that will determine many future best sellers.

1997

Exhibitions

PORT: Navigating Digital Culture, MIT List Visual Arts Center, Cambridge, Jan. 25–Mar. 29. Robbin Murphy and Remo Campopiano curate the first museum exhibition of collaborative and performative Internet-based art, showing time-based projects online and in the gallery.

Sharon Lockhart, Laura Owens, and Frances Stark, Blum & Poe, Los Angeles, June 7–July 12. The exhibition derives from and builds on the discourse between the three friends, who work in separate media but produce related works for the show.

Scene of the Crime, The Armand Hammer Museum of Art and Culture Center, Los Angeles, July 23–Oct. 5. Ralph Rugoff's exhibition assembles art that engages a "forensic aesthetic" of close looking and discovery, drawing on West Coast art made in the past 35 years.

Present Tense: Nine Artists in the Nineties, San Francisco Museum of Modern Art, Sep. 13–Jan. 6, 1998. Curators Janet C. Bishop, Gary Garrels, John S. Weber assemble nine artists whose work is characterized by fragility and engagement with materials. (Janet Cardiff, Iran do Espírito Santo, Felix Gonzalez-Torres, Jim Hodges, Charles LeDray, Gabriel Orozco, Jennifer Pastor, Kathryn Spence, Steve Wolfe).

Sensation, Royal Academy of Art, London, Sep. 18–Dec. 28. The display of Charles Saatchi's collection of artworks, many by Young British Artists, attracts public outcry, tabloid coverage, and 300,000 visitors, a national record for an exhibition of contemporary art.

Cities on the Move, Secession, Vienna, Nov. 26–Jan. 18, 1998. Hans-Ulrich Obrist and Hou Hanru curate an exhibition of works by Asian-based artists and architects, organized around the theme of

National and International Events

Jan. 23: Madeleine Albright becomes the first woman secretary of state in the U.S.

Feb. 22: The first cloned mammal, a sheep named Dolly, is presented by researchers in Scotland.

May 1: In Britain, the Labour Party wins a majority and Tony Blair is elected Prime Minister. During its tenure in government (1997–2000), New Labour will increase public funding for the arts.

June: Under Mayor Rudolph Giuliani, New York City establishes a program of 24-hour remote surveillance of various public spaces, including Central Park and subway stations.

July 2: The Asian economic crisis begins, sparked by currency devaluation in Thailand. The Asian markets will crash in 1998.

July 19: IRA announces ceasefire in Northern Ireland.

Aug. 31: Diana, Princess of Wales, her boyfriend Dodi al-Fayed, and their driver are killed in a car crash in Paris. Her televised funeral is the most watched event in history, with 2.5 billion viewers.

Oct. 2: Luke Woodham, 16, kills his mother and then shoots nine of his classmates, killing two, in Pearl, Mississippi, the first in a spate of classroom shootings.

Nov. 7: The jobless rate is reported at 4.7%, the lowest since 1973.

Dec.: The Kyoto Protocol on climate change is drawn up at the U.N. Convention and signed, but the U.S. refuses to ratify it.

Economy

Economic growth continues steadily, thanks in part to the growth in information technology. Wage inequality also grows: the average CEO

the rapid transformation of Asian cities as a result of capitalism and globalization.

Annuals, Biennials, and Others

47th Venice Biennale (*Futuro presente passato*), curated by Germano Celant. Robert Colescott represents the U.S.

Documenta X (Politics/Poetics), Kassel, Germany. Catherine David, notably the first female director, centers her "retroperspective" around emerging European artists whose work engages with a critical, social turn; some critics find the show overly political and theoretical. The exhibition is also host to the first Cyberfeminist International Meeting.

The 1997 Whitney Biennial, Whitney Museum of American Art, New York. Curated by Lisa Phillips and Louise Neri, artists include Vija Celmins, Zoe Leonard, Gabriel Orozco, Chris Burden, Louise Bourgeois, and Kara Walker.

Skulptur Projekte Münster, Münster, Germany. Kasper König's site-specific sculpture exhibition, held every 10 years, includes work by Douglas Gordon, Rachel Whiteread, and Andrea Zittel.

The 2nd Johannesburg Biennale, Africus Institute for Contemporary Art, Johannesburg and Cape Town. Okwui Enwezor's edition of the biennale, *Trade Routes: History and Geography*, focuses on postcolonialism and globalization. Though the biennale is discontinued due to debates about its relevance in South Africa, the 1997 edition sets the stage for discourse on global exchange and non-Western art.

Other Arts

Frank Gehry's $100 million Guggenheim Museum Bilbao opens in Spain, ushering in a new era of the museum as spectacle.

The Getty Center, designed by Richard Meier, opens on a hilltop outside of Los Angeles, California.

A vote to abolish the NEA is overturned, but six Congress members are added as nonvoting members to the NEA's National Council.

ZKM, the first museum of interactive art, opens in Karlsruhe, Germany.

Artist Martin Kippenberger dies of cancer.

makes 324 times what the average factory worker earns; in 1990, the CEO made 85 times what the average factory worker earned.

Technology

Digital cameras and DVD players become widely available.

Amazon.com goes public, making its CEO Jeff Bezos a billionaire.

In Japan, Toyota releases the Prius, the first hybrid-electric car on the mass market.

Interest in "green" energy alternatives such as wind turbines and solar panels takes off.

Film and TV

Actress Ellen DeGeneres comes out both off- and on-screen, making her character on the sitcom *Ellen* the first openly gay lead on network television.

Trey Parker and Matt Stone's *South Park* debuts.

Titanic becomes the most expensive film in history and the highest grossing, earning $2 billion by the end of decade.

Music

The inaugural all-women's music festival Lilith Fair grosses $16 million in 38 shows, despite gloomy predictions.

Sports

Tiger Woods, 21, becomes the youngest golf Masters champion and the first African American to win a major tournament in the sport.

Other

J. K. Rowling publishes *Harry Potter and the Philosopher's Stone*, the first in a series of children's novels that will become wildly popular with readers of all ages.

Mother Teresa dies.

Kara Walker, 27, becomes one of the youngest-ever recipients of a MacArthur "Genius" Fellowship. Controversy ensues over whether her work reiterates or critiques racial stereotypes. Artist Betye Saar initiates a campaign against the exhibition of Walker's work, while theorist Henry Louis Gates, Jr., makes a statement in support.

Deep River (1997–2002), a collaborative, artist-run gallery in Los Angeles is co-founded by Glenn Kaino, Daniel Joseph Martinez, Rolo Castillo, and Tracey Shiffman.

1998

Exhibitions

Out of Actions: Between Performance and the Object, 1949–1979, Museum of Contemporary Art, Los Angeles, Feb. 8–May 10. Paul Schimmel's exhibition explores the relation between art making and performance in the postwar period through works by 150 international artists and collaboratives.

Bill Viola: A 25-Year Survey, Whitney Museum of American Art, New York, Feb. 12–May 10. Peter Sellars curates Viola's video exhibition, which tours museums until 2000 and helps to establish video as a medium.

Beyond Interface: net art and Art on the Net, Walker Art Center, Minneapolis, Apr.–Nov. Steve Dietz curates a landmark online exhibition of 24 web-based works incorporating an online forum.

Vanessa Beecroft, *Show*, Solomon R. Guggenheim Museum, New York, Apr. 23. This legendary one-night performance in which 20 models, naked or wearing Gucci bikinis, stare blankly at the audience, provokes debate about the status of feminism, and postfeminism, in the arts.

The Art of the Motorcycle, Solomon R. Guggenheim Museum, New York, June 26–Sep. 20. Curated by Thomas Krens and sponsored by BMW, the exhibition generates controversy over the role of the public museum and funding; it also breaks admissions records.

Rachel Whiteread's *Water Tower*, her first public sculpture in New York, is erected on a rooftop in SoHo.

National and International Events

Jan. 17: Matt Drudge breaks the story of President Clinton's affair with White House intern Monica Lewinsky on his Internet news site the Drudge Report, scooping the traditional media.

Apr. 10: Good Friday Agreement is signed between Great Britain, Ireland, and the Irish Republican Army.

May 11: India conducts nuclear weapon tests; Pakistan tests nuclear weapons on May 28.

Aug. 5: Iraq announces it will suspend cooperation with U.N. weapons inspectors.

Aug. 17: President Clinton admits in a televised address to his affair with Monica Lewinsky. On Dec. 19, the House of Representatives impeaches Clinton for obstruction of justice and perjury relating to his affair with Lewinsky. On Feb. 12, 1999, he is acquitted by the Senate.

Aug.: The Dow collapses as a result of the Asian economic crisis, but recovers in 1999 to a high of 11,497 points.

Oct. 12: Matthew Shepard, age 21, dies after being tortured and beaten in Wyoming on suspicion of being gay. President Clinton urges the expansion of hate-crime laws to include the protection of homosexuals.

Oct. 28: President Clinton signs the Digital Millennium Copyright Act, criminalizing technologies that evade digital rights management and increasing penalties for Internet copyright infringement.

Nov. 3: Ross Perot's Reform Party candidate Jesse "the Body" Ventura, a former professional wres-

Annuals, Biennials, and Others

La Biennale de Montréal is founded by the Centre international d'art contemporain de Montréal (CIAC).

The Liverpool Biennial of Contemporary Art is founded, and is the largest in the UK.

Other Arts

The Jewish Museum, designed by Daniel Libeskind, opens in Berlin.

At a Christie's London auction, Charles Saatchi sells 130 works from the 1990s for prices far higher than those charged by galleries, dramatically illustrating the money-making potential of contemporary art collecting and speculation. London's *Daily Telegraph Art 100 Index* reports that from Jan. to Nov. 1998, prices for works by the world's 100 top artists rose by 26 percent, double the increase of the previous year.

Curator Nicolas Bourriaud publishes *Relational Aesthetics* (English translation, 2000), in which he expands upon his theory of the turn to participation and engagement in recent art.

tler, is elected governor of Minnesota. His success attests to voter discontent.

Economy

In April, the Department of Labor reports an unemployment rate of 4.3 percent, the lowest since 1970.

Health

According to the U.S. Centers for Disease Control and Prevention (CDC), African Americans account for 49% of U.S. AIDS-related deaths, a rate of almost 10 times that of whites and three times that of Hispanics.

Viagra is invented to treat erectile dysfunction.

Technology

Apple releases the iMac.

Over half of the nation accesses the Internet via America Online (AOL).

Larry Page and Sergey Brin found the Internet search engine Google.

MP3 players enter the consumer market.

81 million e-mail users send 3.4 trillion e-mails this year.

Film and TV

The final episode of Jerry Seinfeld and Larry David's *Seinfeld* airs to an audience of over 76 million people, having become the most popular syndicated TV show in history.

Sports

Snowboarding becomes an official Olympic sport.

1999

Exhibitions

The Museum as Muse: Artists Reflect, The Museum of Modern Art, New York, Mar. 14–June 1. Curator Kynaston McShine surveys 200 artworks that take the museum and its collecting activities as subject.

The Shock of the View: Museums, Artists, and Audiences in the Digital Age, Walker Art Center, Minneapolis, in collaboration with the Davis Museum and Cultural Center, Wellesley, MA; San Jose Museum of Art; Wexner Center for the Arts, Columbus, OH; and Rhizome; Sep. 22–Mar. 2000.

National and International Events

Jan. 1: Twelve European countries adopt the Euro as a single currency.

Mar. 12: Czech Republic, Poland, and Hungary join NATO.

Apr. 20: Two armed students at Columbine High School in Littleton, Colorado, kill 12 students and one teacher, and wound 23 others before taking their own lives. Some blame violent video games.

Steve Dietz organizes a six-month series of exhibitions and listserv discussions examining the relation between digital media and museum practice.

net_condition, hosted by ZKM, Karlsruhe, Germany, Sep. 23–Feb. 27, 2000. Curated by Peter Weibel and others, and taking place at institutions in Graz, Tokyo, and Barcelona, the online and on-site exhibition is the first major museum-based assessment of the impact of the Internet on art practice.

Sensation: Young British Artists from the Saatchi Collection, Brooklyn Museum, Oct. 2–Jan. 9, 2000. In Sep., Mayor Rudolph Giuliani threatens to withhold $7.2 million from the museum, demanding the show be cancelled on the grounds of Chris Ofili's *Holy Virgin Mary* and other works he deems profane and blasphemous.

Annuals, Biennials, and Others

Ann Hamilton represents the U.S. at the 48th Venice Biennale. Directed by Swiss curator Harald Szeemann, *dAPPERTutto* is notable for the prevalence of contemporary Chinese art. Rirkrit Tiravanija participates in the first-ever Thai pavilion by planting a Thai tree.

Other Arts

In response to an international *ARTnews* poll, museum directors, curators, and art critics name Matthew Barney, Louise Bourgeois, Jasper Johns, Ilya Kabakov, Agnes Martin, Bruce Nauman, Sigmar Polke, Gerhard Richter, Cindy Sherman, and Jeff Wall "the top ten artists working today."

In Los Angeles, Giovanni Intra and Steve Hanson open the gallery China Art Objects, pioneering the "Chinatown Scene" as other contemporary galleries such as Pruess Press move nearby.

Activist and artist Mark Napier makes *Riot* (1999), an alternative web browser that aggregates recent URLs accessed by its visitors using HTML, Javascript, and Perl.

June 10: Following 78 days of NATO air strikes, Yugoslavian president Slobodan Milošević withdraws troops from Kosovo, ending Serbia's repression of the Albanian minority.

Aug. 11: The Kansas Board of Education decides to stop testing students on evolution.

Aug.–Sep.: Russia bombs Chechnya.

Nov.: Protests break out in Seattle at the World Trade Organization meeting. Protestors unite around anti-globalization, workers' rights, and environmental, economic, and social issues.

Dec. 31: Boris Yeltsin resigns and Vladimir Putin takes over as acting president of the Russian Republic.

Dec. 31: In accordance with the Torrijos-Carter Treaties, the U.S. hands over control of the Panama Canal to Panama.

Health

The World Health Organization (WHO) announces that HIV/AIDS is the 4th leading cause of death worldwide and the number one cause of death in Africa. An estimated 33 million people are living with HIV worldwide, while 14 million have died of AIDS.

Technology

The volume of e-mail surpasses snail mail.

Shawn Fanning, John Fanning, and Sean Parker launch Napster, a service that enables peer-to-peer sharing of MP3 music and other digital files. The site is shut down by court order in 2001.

Apple releases Mac OS X, the first version of a new operating system that replaces the "classic" one Apple used since 1984.

Eighty million Americans use personal computers. Twenty million Americans work from home. Seventy million Americans have cell-phone service.

The U.S. government files an antitrust suit against Microsoft, leading to a 2000 mandate that the company be split in half.

As the millennium approaches, hysteria increases over the threat of the "Y2K bug," a computer systems glitch caused by two-digit dating systems.

Text

French sociologists Luc Boltanski and Ève Chiapello publish *Le Nouvel esprit du capitalisme*

(trans. 2005), identifying the emergence, post-1968, of a "new spirit" of capitalist structure based on the network.

Joseph Pine and James Gilmore's *The Experience Economy* proposes that "goods and services are no longer enough," and that businesses must consider "experience" a key category of economic value.

Thomas Friedman's *The Lexus and the Olive Tree* posits globalization as a system in which modernization and development are set in conflict with tradition.

Film and TV

The political drama *The West Wing* debuts.

The Blair Witch Project, made for a production cost of just $30,000, grosses over $140 million, becoming the most profitable movie of all time and sparking a rise in low-budget indie movies.

Televangelist and conservative pundit Jerry Falwell warns that the children's television character Tinky Winky of *The Teletubbies* promotes homosexuality.

Fashion

Calvin Klein withdraws ads for children's underwear that many view as pornographic.

Sports

Wayne Gretzky retires from ice hockey.

Lance Armstrong wins the Tour de France at age 27 following his recovery from testicular cancer, and is hailed as a hero.

Michael Jordan retires from basketball.

Other

Martha Stewart's company goes public, giving her an estimated worth of $1.15 billion and making her the wealthiest self-made woman in the U.S.

Sales of SUV's hit 3.1 million, a threefold increase since 1990, as mammoth vehicles such as the 9-person Ford Expedition replace minivans and station wagons as America's family vehicle of choice.

Exhibitions

Outoaly: Alien Intelligence, Jan. 18–Mar. 3, Museum of Contemporary Art Kiasma, Helsinki, Finland. Curated by media theorist Erkki Huhtamo, the exhibition includes robotic sculptures and other uses of artificial intelligence in art.

Art Entertainment Network and *Let's Entertain,* online and at Walker Art Center, Minneapolis, Feb. 12–Apr. 30. One of the largest surveys of Internet-based art to date, curated by Steve Dietz who also designed the web portal that serves as entrance to the exhibition.

Apocalypse: Beauty and Horror in Contemporary Art, Royal Academy of Arts, London, Sep. 23–Dec. 15. Norman Rosenthal and Max Wigram's sequel to *Sensation* garners some controversy, but not as much as its predecessor.

Rachel Whiteread's 1997 design for Vienna's Judenplatz Holocaust Memorial, a concrete cast of the interior of a library, is installed in Oct. after years of debate.

Shift-CTRL: Computers, Games & Art, online and at the Beall Center for Art and Technology, Irvine, CA, Oct. 17–Dec. 3. Antoinette Lafarge and Robert Nideffer curate one of the first major exhibitions of computer games, and the first to examine the intersections of art and computer games.

Other Arts

Andrea Zittel establishes A-Z West near Joshua Tree National Park. The new arm of her A-Z Administrative Services, founded in New York in 1990, continues her experimental investigations into the routines and structures of everyday life.

Tate Modern opens in London in a former power station converted by Swiss architectural firm Herzog & de Meuron.

Tate begins commissioning Internet-based artworks for its website; the first two pieces are by Simon Patterson and Harwood@Mongrel.

Lowery Stokes Sims is appointed president of Studio Museum in Harlem.

Ralph Rugoff is named director of the CCAC Institute at the California College of Arts and Crafts.

National and International Events

Jan. 1: The Y2K bug fails to produce the massive shutdowns predicted.

Jan. 9: Chechen rebels attack Grozny. Russian repression of Chechnya continues.

Feb. 7: First Lady Hillary Rodham Clinton announces her candidacy for New York State Senate.

May 7: Vladimir Putin takes office to begin his first term as president of Russia.

Mar. 11: After closing at a record high the day before, the NASDAQ plunges and many tech start-up companies go bankrupt as the dot-com bubble of the late 1990s bursts.

June 16: Israel ends its occupation of Lebanon; the 2nd Intifada in Jerusalem begins.

Sep. 6–8: Millennium Summit is held at the U.N. in New York to address global poverty and disease. The U.N. adopts the Millennium Development Goals, which include reversing the spread of HIV/AIDS, malaria, and TB.

Sep. 26: Anti-globalization protests break out at IMF and World Bank meetings in Prague.

Nov. 7: The presidential election between George W. Bush and Al Gore is too close to call. On Dec. 12, the Supreme Court declares Bush the winner, preventing the recount of votes of Florida. Bush is elected the 43rd president of the U.S.

Oct. 5: Slobodan Milošević is pushed out as the leader of Yugoslavia.

Health

23.3% of American adults are smokers, a marginal decrease over the decade.

Environment

The 1990s measured as the hottest decade on record in 1,000 years.

Text

Michael Hardt and Antonio Negri's *Empire* articulates a post-Marxist theory of the political order of globalization in which power and sovereignty belong not to nation states but to a global network, or "empire."

Other

31.1 million Americans live in poverty.

The average floor area for a new home is 2,310 square feet, up from 1,905 in 1990 and 1,595 in 1970.

The incarceration rate is three times that of 1980, primarily as a result of the "war on drugs": in 1980 23% of federal prisoners are incarcerated for drug offenses, while in 2000 the proportion is 60%. 1.4 million African American men (13% of the adult population) cannot vote as a result of a history with the criminal justice system.

2001

Exhibitions

Superflat, Museum of Contemporary Art Pacific Design Center, Jan. 14–May 27. Japanese artist Takashi Murakami articulates his theory of the two-dimensionality of Japanese cultural forms, from seventeenth-century Edo techniques to postwar manga and anime, through an exhibition of contemporary Japanese art.

Lateral Thinking: Art of the 1990s, Museum of Contemporary Art San Diego, Jan. 23–Apr. 30. Toby Kamps's early survey of international art of the 1990s' circles around themes of the body, identity, and the everyday.

Short Century: Independence and Liberation Movements in Africa, 1945–1994. Museum Villa Stuck, Munich, Feb. 15–Apr. 22. Okwui Enwezor surveys a broad range of cultural forms produced in Africa during the period between independence movements and the end of apartheid, challenging the colonial discourse that traditionally frames the representation of non-Western art. (The show will travel to Chicago and New York in 2002.)

010101: Art in Technological Times, at San Francisco Museum of Modern Art and online, Mar. 3–July 8. This online and on-site multimedia exhibition curated by Aaron Betsky, Janet Bishop, Kathleen Forde, and John S. Weber, explores the impact of the digital on art, architecture, and design.

BitStreams and *Data Dynamics*, Whitney Museum of American Art, New York, Mar. 22–June 10. Lawrence Rinder and Debra Singer's early pair of related exhibitions of art that relies on digital technology receives mixed reviews.

National and International Events

Jan. 20: Colin Powell is appointed Secretary of State under President Bush; Powell served as Chairman of Joint Chiefs of Staff from 1989 to 1993 during the Persian Gulf War, and is the first African American in both positions.

Feb.: Human DNA is decoded.

March: The longest period of economic expansion in U.S. history comes to an end; the recession lasts until November 2001.

July 20–22: Violent anti-globalization protests accompany the G8 Summit in Genoa, Italy.

Sep. 11: Terrorists hijack four planes and crash them into the World Trade Center Towers in New York City and the Pentagon, while an aircraft intended to hit the White House is brought down in Pennsylvania. Almost 3,000 people die. On September 14, President Bush signs a Declaration of National Emergency, a military order. The NYSE closes for four days after the attacks; when it reopens, the Dow falls 684.81 points, the steepest one-day point decline in history.

Sep. 25: Deputy Assistant Attorney General John Yoo sends memos that outline an expanded view of presidential power and explore changing the laws on wiretapping and warrantless searches.

Oct. 23: A memo from Yoo and Robert Delahunty asserts that the protections of the Fourth Amendment "would not apply" to military operations in the U.S. A Nov. 2 memo by Yoo states that the Foreign Intelligence Surveillance Act (FISA) does

Public Offerings, Geffen Contemporary at Los Angeles Museum of Contemporary Art, Apr. 1–July 29. Paul Schimmel assembles the key early works of 25 artists who emerged and rose to stardom in the 1990s, including Matthew Barney, Damien Hirst, Gary Hume, Takashi Murakami, Rirkrit Tiravanija, and Jorge Pardo.

Freestyle, The Studio Museum in Harlem, New York, Apr. 28–June 24. Thelma Golden's groundbreaking survey of 28 emerging African American artists ushers into discourse the term "post-black," denoting an engagement with definitions of blackness but a resistance to the label "black artist."

In *Blackness for Sale*, Aug. 8–Aug. 18, the artist duo Mendi + Keith Obadike sell Keith's "blackness" on eBay's Collectibles/Culture/Black Americana section until the item is taken down by management.

Into the Light: The Projected Image in American Art, 1964–1977, Whitney Museum of American Art, New York, Oct. 18–Jan. 27, 2002. In one of the first exhibitions to historicize media art, curator Chrissie Iles re-creates and documents historic but ephemeral installations and sculptures that pioneered the use of the moving image in art.

Annuals, Biennials, and Others

Robert Gober represents the U.S. at the 49th Venice Biennale, which is directed by Harald Szeeman under the title, *The Plateau of Humankind*.

Other Arts

The Guggenheim Hermitage Museum opens in Las Vegas, Nevada.

Okwui Enwezor is appointed to direct the 2002 *Documenta XI*, which will become known as the "postcolonial" *Documenta*.

Plans are announced for the construction of the National Museum of African American History and Culture in Washington, D.C.

In Paris, a five-year cataloguing and conservation initiative begins on objects from the Musée national des Arts d'Afrique et d'Océanie and the Musée de l'Homme in preparation for their move to a new museum. First proposed in 1996 by Jacques Chirac, the Musée du quai Branly will open in 2006 in a building designed by Jean Nouvel.

Works by Andy Warhol and Maurizio Cattelan set record prices at auction.

not regulate government surveillance of its citizens, including warrantless wiretapping.

Oct. 7: The U.S. orders air strikes on Afghanistan, targeting Taliban and Osama bin Laden on suspicion of planning the 9/11 attacks. President Bush declares a "war on terror" and says he wants bin Laden "dead or alive."

Oct. 26: As a response to 9/11, President Bush signs the Patriot Act, expanding government powers of surveillance and detention.

Nov. 13: President Bush issues a military order allowing for indefinite detention of prisoners in the war on terror.

Dec. 2: Enron energy corporation files for bankruptcy, the largest such filing in U.S. history.

Dec. 18: Congress passes the No Child Left Behind education reform law.

Health

Of 40 million people with HIV/AIDS worldwide, 95% are in developing countries. In the U.S., 816,149 cases of AIDS and 467,910 deaths among those with AIDS have been reported to the CDC (through December). AIDS is increasingly an epidemic of non-white populations, women, heterosexuals, and injecting drug users. The rate of reported adult/adolescent AIDS cases per 100,000 is 76.3 among blacks, 28.0 among Hispanics, 11.7 among American Indians, 7.9 among whites, and 4.8 among Asians/Pacific Islanders.

President Bush refuses to sign a U.N. declaration on children's rights that includes sex education for teenagers.

Text

Lev Manovich's *The Language of New Media* provides an influential theory of new media, situating digital media in relation to the conventions of older technologies such as film and photography.

Film and TV

PBS premieres series *Art21—Art in the 21st Century*, the only television program in the U.S. to focus on contemporary art.

Technology

Wikipedia, a peer-populated encyclopedia, is launched.

Apple releases the first generation iPod.

Other

With nearly two million people in prison or jail, the U.S. rate of incarceration (686 per 100,000 people) is now the highest in the world, followed by the Cayman Islands and the Russian Federation: 12% of black males, 4% of Hispanic males, 1.8% of white males in their 20s and early 30s are in prison or jail. In total, 6,594,000 people are under the control of the penal system (prison, jail, probation, and parole).

Selected Bibliography: General Sources

Appadurai, Arjun. *Modernity at Large: Cultural Dimensions of Globalization.* Minneapolis: University of Minnesota Press, 1996.

Armstrong, Richard, et al. *1989 Biennial Exhibition.* New York: Whitney Museum of American Art, 1989.

———. *1991 Biennial Exhibition.* New York: Whitney Museum of American Art, 1991.

Ashcroft, Bill, Gareth Griffiths, and Helen Tiflin. *The Post-Colonial Studies Reader.* New York and London: Routledge, 1995.

Auping, Michael, et al. *Whitney Biennial: 2000 Exhibition.* New York: Whitney Museum of American Art, 2002.

Bailey, David A., Kobena Mercer, and Catherine Ugwu. *Mirage: Enigmas of Race, Difference, and Desire.* London: Institute of Contemporary Arts, 1995.

Balk, Dennis, ed. *Colin de Land/American Fine Arts.* Brooklyn: Powerhouse Books, 2008.

Berger, Maurice, et al. *White: Whiteness and Race in Contemporary Art.* Issues in Cultural Theory, 7. Baltimore: Center for Art and Visual Culture, University of Maryland, Baltimore County, 2004.

Bhabha, Homi K. *The Location of Culture.* New York and London: Routledge, 1994.

Birnbaum, Daniel, et al. *Defining Contemporary Art—25 Years in 200 Pivotal Artworks.* London and New York: Phaidon Press Ltd., 2011.

Bishop, Claire. "Antagonism and Relational Aesthetics." *October* 110 (Autumn 2004): 51–79.

———. *Artificial Hells: Participatory Art and the Politics of Spectatorship.* London and New York: Verso, 2012.

Bishop, Janet C., Gary Garrels, and John S. Weber. *Present Tense: Nine Artists in the Nineties.* San Francisco: San Francisco Museum of Modern Art, 1997.

Bois, Yve-Alain, and Rosalind E. Krauss. *Formless: A User's Guide.* New York: Zone Books, 1997.

Boltanski, Luc, and Ève Chiapello. *The New Spirit of Capitalism.* Trans. Gregory Elliott. London and New York: Verso, 2005.

Bonami, Francesco. *L.A. Times: Arte da Los Angeles nella Collezione Re Rebaudengo Sandretto.* Torino, Italy: Fondazione Sandretto Rebaudengo per l'Arte, 1998.

Bourriaud, Nicolas. *Relational Aesthetics.* Trans. Simon Pleasance, Fronza Woods, and Mathieu Copeland. Dijon, France: Les presses du réel, 2002.

Butler, Judith. *Gender Trouble: Feminism and the Subversion of Identity.* New York: Routledge, 1990.

Carandente, Giovanni, et al. *XLIII esposizione internazionale d'arte, la Biennale di Venezia. Il luogo degli artisti.* Venice: La Biennale di Venezia; Milan: Gruppo editoriale Fabbri, 1988.

———. *XLIV esposizione internazionale d'arte, la Biennale di Venezia. Dimensione futuro: l'artista e lo spazio.* Venice: La Biennale di Venezia; Milan: Gruppo editoriale Fabbri, 1990.

Celant, Germano, et al. *XLVII esposizione internazionale d'arte, la Biennale di Venezia.* Venice: Biennale di Venezia; Milan: Electa, 1997.

Chevrier, Jean-François, and Catherine David, et al. *Politics-Poetics: Documenta X—The Book.* Ostfildern, Germany: Cantz Verlag, 1997.

Chiu, Melissa. *Breakout: Chinese Art Outside China.* Milan: Edizioni Charta, 2006.

Clair, Jean, et al. *La Biennale di Venezia, 46, esposizione internazionale d'arte. 1895/1995 centenario.* Venice: La Biennale di Venezia, Marsilio Editori, 1995.

Clark, T. J. *Farewell to an Idea: Episodes from a History of Modernism.* New Haven and London: Yale University Press, 1999.

Copeland, Huey. *Bound to Appear: Art, Slavery, and the Site of Blackness in Multicultural America.* Chicago and London: University of Chicago Press, 2013.

Cusset, François, ed. *Une histoire (critique) des années 1990.* Paris: Éditions La Découverte, 2014.

Daftari, Fereshteh, Homi Bhabha, and Orhan Pamuk. *Without Boundary: Seventeen Ways of Looking.* New York: The Museum of Modern Art, 2006.

Darling, Michael, et al. *Red Eye: L.A. Artists from the Rubell Family Collection.* Miami: Rubell Family Collection, 2006.

Decter, Joshua, et al. *Exhibition as Social Interaction: "Culture in Action" 1993.* Afterall Exhibition Histories series. London: Afterall Books, 2014.

Deleuze, Gilles, and Félix Guattari. *What Is Philosophy?* Trans. Hugh Tomlinson and Graham Burchell. New York: Columbia University Press, 1994.

Dezeuze, Anna, ed. *The "Do-it-Yourself" Artwork: Participation from Fluxus to New Media.* Rethinking Art's Histories series. Manchester, UK, and New York: Manchester University Press, 2010.

Ellegood, Anne, and Johanna Burton, eds. *Take It or Leave It: Institution, Image, Ideology.* Los Angeles: Hammer Museum; London: Prestel Press, 2014.

English, Darby. *How to See a Work of Art in Total Darkness.* Cambridge, Mass. and London: The MIT Press, 2007.

Enwezor, Okwui, et al. *Trade Routes: History and Geography: the 2nd Johannesburg Biennale.* Johannesburg, South Africa: The Greater Johannesburg Metropolitan Council; The Hague, The Netherlands: The Prince Claus Fund for Culture and Development, 1997.

———. *Documenta 11_Platform 5.* Ostfildern-Ruit, Germany: Hatje Cantz, 2002.

Faludi, Susan. *Backlash: The Undeclared War Against American Women.* New York: Crown, 1991.

Ferguson, Russell, et al., eds. *Out There: Marginalization and Contemporary Cultures.* Documentary Sources in Contemporary Art series, v. 4. New York: The New Museum of

Contemporary Art; Cambridge, Mass. and London: The MIT Press, 1990.

———. *Discourses: Conversations in Postmodern Art and Culture.* Documentary Sources in Contemporary Art series, v. 3. New York: The New Museum of Contemporary Art; Cambridge, Mass. and London: The MIT Press, 1990.

Foster, Hal. *The Anti-Aesthetic: Essays on Postmodern Culture.* Seattle: The Bay Press, 1983.

———. "Obscene, Abject, Traumatic." *October* 78 (Fall 1996): 107–24.

———. *The Return of the Real: The Avant-Garde at the End of the Century.* Cambridge, Mass., and London: October Books/The MIT Press, 1996.

Foster, Hal, ed. *Discussions in Contemporary Culture*, no. 1. Seattle: The Bay Press, 1987.

Foster, Hal, et al. "The Politics of the Signifier: A Conversation on the Whitney Biennial." *October* 66 (Autumn 1993): 3–27.

———. "The Politics of the Signifier II: A Conversation on the 'Informe' and the Abject." *October* 67 (Winter 1994): 3–21.

———. "Questionnaire on 'The Contemporary.'" *October* 130 (Fall 2009): 3–124.

Friedman, Thomas L. *The World Is Flat: A Brief History of the Twenty-First Century.* 3d ed. New York: Picador, 2007.

Fukiyama, Francis. *The End of History and the Last Man.* New York: Free Press, 1992.

Fuss, Diana, ed. *Inside/Out: Lesbian Theories, Gay Theories.* New York and London: Routledge, 1991.

Gamble, Sarah, ed. *The Routledge Companion to Feminism and Postmodernism.* New York and London: Routledge, 2001.

Gates, Henry Louis, Jr. *The Signifying Monkey: A Theory of African-American Literary Criticism.* Oxford and New York: Oxford University Press, 1988.

Gioni, Massimiliano, et al. *NYC 1993: Experimental Jet Set, Trash, and No Star.* New York: New Museum of Contemporary Art, 2013.

"The Global Issue." *Art in America* 77 (July 1989).

Golden, Thelma, et al. *Black Male: Representations of Masculinity in Contemporary American Art.* New York: Whitney Museum of American Art, 1994.

———. *Freestyle.* New York: The Studio Museum in Harlem, 2000.

Goldstein, Ann, and Mary Jane Jacob. *A Forest of Signs: Art in the Crisis of Representation.* Los Angeles: The Museum of Contemporary Art and Cambridge, Mass. and London: The MIT Press, 1989.

González, Jennifer A. *Subject to Display: Reframing Race in Contemporary Installation Art.* Cambridge, Mass. and London: The MIT Press, 2008.

Greene, Rachel. *Internet Art.* World of Art series. London and New York: Thames & Hudson, 2004.

Grynsztejn, Madeleine, et al. *Supernova: Art of the 1990s from The Logan Collection.* San Francisco: San Francisco Museum of Modern Art, 2005.

Halley, Peter, et al. *Index A to Z: Art, Design, Fashion, Film, and Music in the Indie Era.* New York: Rizzoli, 2014.

Hardt, Michael, and Antoni Negri. *Empire.* Cambridge, Mass. and London: Harvard University Press, 2000.

Hou Hanru, and Hans-Ulrich Obrist, eds. *Cities on the Move.* Ostfildern-Ruit, Germany: Hatje, 1997.

Hickey, Dave. *The Invisible Dragon: Four Essays on Beauty.* Los Angeles: Art Issues Press, 1993.

Hinderliter, Beth, et al. *Communities of Sense: Rethinking Aesthetics and Politics.* Durham, North Carolina, and London: Duke University Press, 2009.

Hollinger, David A. *Postethnic America: Beyond Multiculturalism.* New York: Basic Books, 1995.

hooks, bell. "Postmodern Blackness." In *Yearning: Race, Gender, and Cultural Politics*, 23–31. Boston: South End Press, 1990.

Hoptman, Laura. *Drawing Now: Eight Propositions.* New York: The Museum of Modern Art, 2003.

Ingraham, Jeanette, and Papo Colo. *The Hybrid State.* Parallel Histories series. New York: Exit Art, 1992.

Jacob, Mary Jane, et al. *Culture in Action: A Public Art Program of Sculpture Chicago.* Seattle: Bay Press, 1993.

Jameson, Fredric. *Postmodernism, or, the Cultural Logic of Late Capitalism.* Durham, North Carolina, and London: Duke University Press, 1991.

Jameson, Fredric, and Masao Miyoshi, eds. *The Cultures of Globalization.* Durham, North Carolina, and London: Duke University Press, 1998.

Kamps, Toby. *Lateral Thinking: Art of the 1990s.* La Jolla, Calif.: Museum of Contemporary Art San Diego, 2002.

Kee, Joan. "What Is Feminist about Contemporary Asian Women's Art?" In *Global Feminisms*, edited by Maura Reilly and Linda Nochlin, 106–21. Brooklyn: Brooklyn Museum; London and New York: Merrell, 2007.

Kertess, Klaus, et al. *1995 Biennial Exhibition.* New York: Whitney Museum of American Art, 1995.

Kleeblatt, Norman L., et al. Special section: "Identity Roller Coaster." *Art Journal* 64 (Spring 2005): 61–94.

Kraus, Chris, Jan Tumlir, and Jane McFadden. *L.A. Artland: Contemporary Art from Los Angeles.* London: Black Dog Publishing, Ltd., 2005.

Lee, Pamela M. *Forgetting the Art World.* Cambridge, Mass. and London: The MIT Press, 2012.

Lewis, Reina, and Sara Mills, eds. *Feminist Postcolonial Theory: A Reader.* New York: Routledge, 2003.

Lippard, Lucy R. *Mixed Blessings: New Art in a Multicultural America.* Rev. ed. New York: Pantheon, 2000.

Lyotard, Jean-François. *The Postmodern Condition: A Report on Knowledge.* Trans. Geoff Bennington and Brian Massumi. Theory and History of Literature series, v. 10. Minneapolis: University of Minnesota Press, 1984.

Manovich, Lev. *The Language of New Media.* Cambridge, Mass. and London: The MIT Press, 2002.

Martin, Jean-Hubert, et al. *Magiciens de la terre.* Paris: Editions du Centre Pompidou, 1989.

McLuhan, Marshall. *The Global Village: Transformations in World Life and Media in the 21st Century.* Oxford and New York: Oxford University Press, 1989.

Mercer, Kobena. *Welcome to the Jungle: New Positions in Black Cultural Studies.* New York and London: Routledge, 1994.

Meyer, Richard. *What Was Contemporary Art?* Cambridge, Mass. and London: The MIT Press, 2013.

Mirzoeff, Nicholas, ed. *The Visual Culture Reader.* New York and London: Routledge, 1998.

Molesworth, Helen, et al. *This Will Have Been: Art, Love, and Politics in the 1980s.* Chicago: Museum of Contemporary Art; New Haven and London: Yale University Press, 2012.

Morley, David, and Kuan-Hsing Chen, eds. *Stuart Hall: Critical Dialogues in Cultural Studies.* New York and London: Routledge, 1996.

Nittve, Lars, and Helle Crenzien. *Sunshine & Noir: Art in L.A., 1960–1997.* Humlebaeck, Denmark: Louisiana Museum of Modern Art, 1997.

Oliva, Achille Bonito, et al. *XLV esposizione internazionale d'arte, la Biennale di Venezia. Punti cardinali dell'arte.* Venice: Marsilio, 1993.

Patterson, James T. *Restless Giant: The United States from Watergate to Bush v. Gore.* Oxford History of the United States series. Oxford and New York: Oxford University Press, 2007.

Paul, Christiane. *Digital Art.* 2d ed. World of Art series. London and New York: Thames and Hudson, 2008.

Peraza, Nilda, et al. *The Decade Show.* New York: Museum of Contemporary Hispanic Art, The New Museum of Contemporary Art, The Studio Museum in Harlem, 1990.

Phillips, Lisa, and Louise Neri. *1997 Biennial Exhibition.* New York: Whitney Museum of American Art, 1997.

Relyea, Lane. *Your Everyday Art World.* Cambridge, Mass., and London: The MIT Press, 2013.

RETORT (Iain Boal et al.). *Afflicted Powers: Capital and Spectacle in a New Age of War.* London and New York: Verso, 2005.

Rinder, Lawrence, et al. *Whitney Biennial 2002: 2002 Biennial Exhibition.* New York: Whitney Museum of American Art, 2002.

Rinder, Lawrence, and Debra Singer. *BitStreams.* New York: Whitney Museum of American Art, 2001. Exhibition brochure.

Rush, Michael. *New Media in Art.* 2d ed. World of Art series. London and New York: Thames and Hudson, 1999, 2005.

Salvoni, Daniela. *Parallax View: Köln—New York.* Long Island City, N.Y.: PS1 Contemporary Art Center, 1993.

Schimmel, Paul, et al. *Helter Skelter: L.A. Art in the 1990s.* Los Angeles: The Museum of Contemporary Art, 1992.

Sedgwick, Eve Kosofsky. *Epistomology of the Closet.* Berkeley: University of California Press, 1990.

Smith, Terry. *What Is Contemporary Art?* Chicago and London: University of Chicago Press, 2009.

Solomon-Godeau, Abigail, and Constance Lewallan. *Mistaken Identities.* Santa Barbara, Calif.: University Art Museum, University of California, Santa Barbara, 1992.

Spector, Nancy, et al. *theanyspacewhatever.* New York: Solomon R. Guggenheim Foundation/Guggenheim Museum Publications, 2008.

Spivak, Gayatri Chakravorty. "Can the Subaltern Speak?" In *Marxism and the Interpretation of Culture*, edited by Cary Nelson and Lawrence Grossberg, 271–313. Urbana, Ill., and Chicago: University of Illinois Press, 1988.

Stallings, Tyler, et al. *Whiteness: A Wayward Construction.* Laguna Beach, Calif.: Laguna Art Museum and Los Angeles: Fellows of Contemporary Art, 2003.

Steeds, Lucy, et al. *Making Art Global, Part 2: Magiciens de la Terre 1989.* Afterall Exhibition Histories series. London: Afterall Books, 2013.

Storr, Robert. Dis*locations.* New York: The Museum of Modern Art, 1991.

Sussman, Elisabeth, et al. *1993 Biennial Exhibition.* New York: Whitney Museum of American Art, 1993.

Szeemann, Harald, et al. *La Biennale di Venezia, 48a esposizione internationale d'arte. dAPERTutto.* Venice: Biennale di Venezia, Marsilio, 1999.

——. *La Biennale di Venezia, 49 esposizione internazionale d'arte. Platea dell'umanità.* Venice: La Biennale di Venezia; Milan: Electa, 2001.

Taylor, Brandon. *Contemporary Art: Art Since 1970.* London: Laurence King Publishing, Ltd., 2004.

Tribe, Mark, Reena Jana, and Uta Grosenick. *New Media Art.* Taschen Basic Art Series. Cologne: Taschen, 2006.

Tucker, Marcia, et al. *Bad Girls.* New York: The New Museum of Contemporary Art; Cambridge, Mass. and London: The MIT Press, 1994.

Varnedoe, Kirk, and Adam Gopnik. *High and Low: Modern Art and Popular Culture.* New York, The Museum of Modern Art, 1993.

Wallace, Michelle. *Black Macho and the Myth of the Superwoman.* London and New York: Verso, 1999.

Wallis, Brian, ed. *Art After Modernism: Rethinking Representation.* Documentary Sources in Contemporary Art series, v. 1. New York: The New Museum of Contemporary Art; Boston: David R. Godine, Publisher, Inc., 1984.

——. *Blasted Allegories: An Anthology of Writings by Contemporary Artists.* Documentary Sources in Contemporary Art series, v. 2. New York: The New Museum of Contemporary Art; Cambridge, Mass. and London: The MIT Press, 1989.

Wallis, Brian, Marianne Weems, and Philip Yenawine, eds. *Art Matters: How the Culture Wars Changed America.* New York and London: New York University Press, 1999.

Weber, John, et al. *010101: Art in Technological Times.* San Francisco: San Francisco Museum of Modern Art, 2001.

Weibel, Peter, and Timothy Druckrey, et al. *net_condition: art and global media.* Electronic Culture: History, Theory, and Practice series. Cambridge, Mass. and London: The MIT Press; Karlsruhe, Germany: Center for Art and Media Technology (ZKM), 2001.

Weiss, Rachel, et al. *Making Art Global, Part 1: The Third Havana Biennial 1989.* Afterall Exhibition Histories series. London: Afterall Books, 2011.

Wilentz, Sean. *The Age of Reagan: A History, 1974–2008.* New York: Harper/Harper Collins, 2008.

Wolf, Naomi. *The Beauty Myth: How Images of Beauty Are Used Against Women.* New York: William Morrow & Co., 1991.

Zelevansky, Lynn. *Sense and Sensibility: Women Artists and Minimalism in the Nineties.* New York: The Museum of Modern Art, 1994.

Acknowledgments

Come as You Are: Art of the 1990s historicizes a period in which almost all of the artists represented are not only still working, but are in the prime of their careers. I would like to start, therefore, by thanking the artists in the exhibition; their goodwill has been extraordinary, and this exhibition is a testament to the innovation and endurance of their work.

Numerous individuals and institutions worked closely with us to realize this exhibition. I am deeply grateful to the lenders for their tremendous generosity and cooperation. Enormous thanks are due to the catalogue authors, whose insightful essays are an integral part of the exhibition, and with whom I had many fruitful exchanges on this period. It has been a pleasure to work with the museums on the exhibition's tour, and our warmest thanks go to the Telfair Museums, especially Lisa Grove, director, and Courtney McNeil, curator of fine arts and exhibitions; the University of Michigan Museum of Art, especially Joseph Rosa, director, and Katharine Derosier, exhibitions manager; and the Blanton Museum of Art at the University of Texas at Austin, especially Simone J. Wicha, director, Veronica Roberts, curator of modern and contemporary art, and Gabriela Truly, director of collections and exhibitions.

This exhibition would not have been possible without the hard work of the board and staff of the Montclair Art Museum. I am indebted to our board of trustees and MAM Contemporaries, for their dedication to the contemporary program in general, and this exhibition in particular. My special thanks go to Ann Schaffer, whose support of *Come as You Are* at every turn helped make this exhibition happen, and Carol Wall, to whose vision we owe MAM's contemporary art program. Director Lora S. Urbanelli has been an unwavering advocate for this exhibition from the very beginning, and I am enormously thankful for her willingness to take on this ambitious project; her determination, resourcefulness, and generosity in making sure that it was realized in the way that we envisioned; and her unflagging encouragement along the way. My colleagues on MAM's senior staff, Chief Financial Officer Mike Frasco, Director of Marketing and Communications Michael Gillespie, former Deputy Director Gary Schneider, Chief Curator Gail Stavitsky, and Director of Development Susan Wall have been extraordinarily supportive and creative in bringing this exhibition to fruition. Curatorial Assistant Kimberly Fisher was intimately involved with every aspect of the exhibition, handling myriad responsibilities and numerous challenges with tremendous skill, unflappable professionalism, and good cheer; she has my unending thanks. Associate Registrar Osanna Urbay orchestrated MAM's presentation of the exhibition and the tour with resourcefulness, aplomb, and humor; my heartfelt thanks to her and Registrar Renée Powley for their department's deft coordination of this complicated project. Exhibition Designer and Head Preparator Karl Allen developed an exciting and dynamic exhibition design with great creativity and enthusiasm, and led a crack team of preparators. Dan Muller, chief of security and building operations, made sure that everything ran smoothly. Interns Lindsay Barnes, Marley Lewis, Alexis Pierro, and Samantha Stathis provided invaluable research and administrative help. I am indebted to the entire staff of the Montclair Art Museum, with special thanks to Pamela Goldsteen, interim assistant director of corporate, foundation and government relations; Martha Kelshaw, manager of adult programs; Catherine Mastrangelo, marketing and communications manager; Petra Pankow, director of education; Michele Shea, assistant director of corporate, foundation and government relations; and Emily Nso Washington, assistant director, campaign and development operations. Great thanks also go to Fred Schroeder and his team at Resnicow Schroeder Associates.

It has been a privilege to work with the University of California Press and Marquand Books on this catalogue, and I thank both their staffs, especially Kari Dahlgren, former art editor at UC Press, and Ed Marquand, Adrian Lucia, Jeff Wincapaw, and Donna Wingate at Marquand Books. Holly La Due's editing was graceful and meticulous, and Zach Hooker developed a thoughtful and beautiful book design; my hearty thanks to them both.

I would like to extend my particular thanks to the many people at museums, galleries, and studios who offered special assistance with the exhibition, especially Isha Welsh, 1301PE Gallery; Cristian Alexa and Kathryn Erdman, 303 Gallery; Rachel Funari and Teneille Haggard, Andrea Rosen Gallery; Steve Sachs and Laura Blereau, bitforms gallery; Lynda Bunting, Blum & Poe, Los Angeles; P. Andrew Spahr and Nina Gara Bozicnik, Currier

Museum of Art; Castelli Gallery; Marcia Acita and Rachel von Wettberg, Center for Curatorial Studies, Hessel Museum of Art; David Zwirner, Justine Durrett, Ales Ortuzar, Poppy Pulitzer, Hanna Schouwink, and Kelly Schroer, David Zwirner Gallery; Nick Lesley, Electronic Arts Intermix; Kristy Bryce, Eykyn MacLean Gallery; Vance Lupher, Erie Art Museum; John Connelly, Felix Gonzalez-Torres Foundation; Ian Berry and Elizabeth Karp, The Frances Young Tang Teaching Museum; Bob Monk and Sarah Hoover, Gagosian Gallery; Gavin Brown, Eleonore Hugendubel, and Laura Mitterrand, Gavin Brown's Enterprise; Molly Epstein, Alexandra Hays, Augusta Joyce, Caroline Luce, and Allyson Spellacy, Gladstone Gallery; Angela Robins, Honor Fraser Gallery; Lisa Freiman and Sherry Peglow, Indianapolis Museum of Art; James Cohan and Laura Pinello, James Cohan Gallery; Lisa Erf, JPMorgan Chase Art Collection; Roland Augustine, Kristin Becker, and Natalia Sacasa, Luhring Augustine Gallery; Marc Foxx and Rodney Hill, Marc Foxx Gallery; Andrew Richards and Lissa McClure, Marian Goodman Gallery; Jeff Rosenheim, The Metropolitan Museum of Art; Anne Barrett Breckenridge and Leah Singsank, Museum of Contemporary Art, Chicago; Naomi Abe, The Museum of Contemporary Art, Los Angeles; Edward Saywell, Jen Mergel, Kim Pashko, and Anna Siedzik, Museum of Fine Arts, Boston; Peter Reed and Barbara London, The Museum of Modern Art; Gwen Hill, Norton Family Office; Cay Rose, Pace Gallery; Kat Parker, Petzel Gallery; Corinna Durland, Elizabeth Peyton studio; Irene Taurins, Philadelphia Museum of Art; Shaun Regen and Lindsay Charlwood, Regen Projects; Julie Roberts and Mary Skarbek, Roberts & Tilton Gallery; Michael Jenkins and Meg Malloy, Sikkema Jenkins & Co.; Susan Inglett, Susan Inglett Gallery; Renée Coppola, Tanya Bonakdar Gallery; Miriam Katzeff, Team Gallery; Darsie Alexander, Walker Art Center; and Adam Weinberg, Donna De Salvo, and Dana Miller, the Whitney Museum of American Art.

I am indebted to a number of art-historical colleagues whose insights helped me develop *Come as You Are*. I was an art history student during the nineties, and the seeds of this exhibition were unwittingly sown by some wonderful professors, especially Yve-Alain Bois, Maria Gough, Ewa Lajer-Burcharth, and Molly Nesbit. A brainstorming Scholars Day at MAM in February 2012 helped chart the course of the exhibition, and I would like to thank its participants: Huey Copeland, Jennifer González, Suzanne Hudson, Joan Kee, Nora Lawrence, Jen Mergel, Zabet Patterson, Gary Schneider, Anne Swartz, Kirsten Swenson, Andrew Uroskie, and Margie Weinstein. I felt privileged to count Huey Copeland and Adrian Sudhalter as my closest interlocutors on this show; both offered invaluable feedback on everything from the initial idea to my catalogue essays, and I owe them a debt of gratitude. I am thankful for formative conversations about the 1990s with many colleagues in the field, including Darsie Alexander, Matt Biro, Claire Bishop, Julia Bryan-Wilson, Lisa Corrin, Darby English, Jennifer Field, Claire Gilman and her students at the School of Visual Arts, Thelma Golden, Eleanor Heartney, Suzanne Hudson and her students at the University of Southern California, Janet Kraynak, Pamela Lee, Helen Molesworth, Kristin Romberg, Trevor Schoonmaker, Lowery Stokes Sims, Franklin Sirmans, and Elisabeth Sussman. A dinner with former colleagues from the Museum of Modern Art gave rise to the exhibition's title, and I thank them for that lively and productive night. Special thanks go to Jenny Tobias of the MoMA Library, for years of help with research matters large and small. My cohorts at the 2012 Contemporary Art Think Tank and the 2012 and 2013 Contemporary Curators Conferences offered valuable food for thought. I would like to extend my warm thanks to my students in an MFA seminar on the 1990s at Montclair State University during spring 2012, who provided exciting and unexpected perspectives on this material.

Finally, I would like to thank my friends and family, especially my parents, Kay and Andy Schwartz; my brother, sister-in-law, niece, and nephew, Peter, Kaia, Lola, and Charlie Schwartz; and my aunt, Susan Ray, for their love and encouragement; and my husband David Edgcomb, for a transformative year, and for being the best partner I can imagine in all of it.

ALEXANDRA SCHWARTZ
Curator of Contemporary Art
Montclair Art Museum